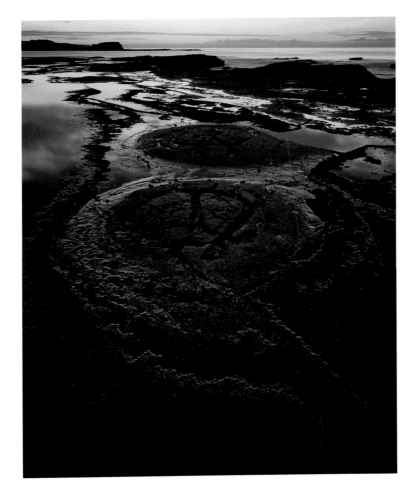

WORKING THE LIGHT
A LANDSCAPE PHOTOGRAPHY MASTERCLASS

Joe Cornish Charlie Waite David Ward

Edited by

Eddie Ephraums

ARGENTUM

First published in 2006 by Argentum, an imprint of Aurum
Press Limited, 7 Greenland Street, London NW1 0ND

A catalogue record for this book is available from the
British Library.

ISBN-13 978 1 902538 46 4

6 5 4 3
2011 2010 2009 2008

Working the Light edited and designed by Eddie Ephraums.
Editorial assistant Anna Alderson.
Printed in Singapore.

An Envisage Books/Light & Land special Limited Hardback
Edition in a slipcase and a Collector's Edition with an
original print are available at www.workingthelight.com or
by email: info@workingthelight.com

For information about Light & Land tours and workshops,
go to www.lightandland.co.uk

Title page photograph: Saltwick Shield Reef, Saltwick Bay,
North Yorkshire, England. Joe Cornish.

This page: Puttenham Heath, Surrey, Southeast England.
Simon Miles.

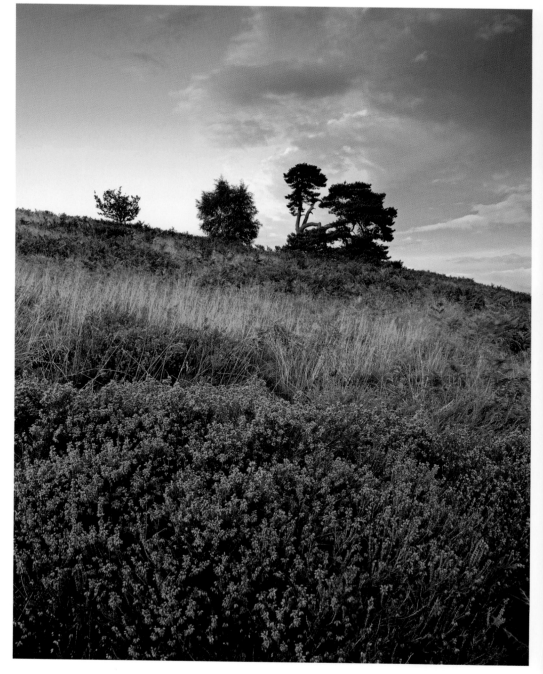

ACKNOWLEDGEMENTS

We want to offer our sincere thanks to everyone who has submitted images for possible inclusion in *Working the Light*. The book would not have been possible without those people having the courage to permit open and constructive criticism of their work. It is a sign of enormous trust on their part and we are humbled by this. By sharing their wonderful images with a wider audience, they are contributing to the exchange of ideas, something that we at Light & Land are passionate about. Charlie, David, Joe and Eddie.

Lesley Aggar	www.lesleyaggar.com	Peter Lewis	peterlewis@onetel.com
Debs Allan	www.debsallan.co.uk	Bruce Lloyd	brucelloydg@aol.com
Christopher Andrews	cjandrews@tiscali.co.uk	Roger Longdin	roger.longdin@agripower.co.uk
Benjamin F Bailar	bbailar@mba1959.hbs.edu	Jane Macklam	j.macklam@yahoo.com
Philip Banfield	www.venturefield.com	Nick Mansell	nwm10@aol.com
Julian Barkway	www.jbarkwayphotography.com	Paul Marsch	www.pbase.com/marschp
Mike Bradbury	mvbradbury@aol.com	Laura Mastick-Hayward	www.lauramastickphotography.co.uk
Neil Brayshaw	www.neilbrayshaw.co.uk	Nick Mclaren	nick.mclaren@btinternet.com
Michael James Brown	www.michaeljamesbrown.com	Patrick Medd	www.patrickmedd.com
Henrietta Byrne	henrietta.byrne@hrpct.nhs.uk	Simon Miles	simon@southwestimage.com
Bruce Cairns	www.brucecairns.com	Irma Mokkenstorm	icm@hetnet.nl
Eliseo J Carmona	www.fotoaficion.net	Hiroyuki Mori	heyhiz@hotmail.com
Robert H Cassen	rhcassen@dsl.pipex.com	Iksung Nah	inah@lineone.net
Richard Childs	www.rchilds.co.uk	Paul Ng	www.paulngimages.com
Adrian Chitty	adrian.chitty@yahoo.co.uk	Andrea Norrington	www.andrea-norrington.com
Hazel Coffey	hazelcoffey@eircom.net	Eli Pascall-Willis	www.elipascall-willis.com
Roger Creber	www.rwcimages.co.uk	Adam Pierzchala	www.scenequest.co.uk
Jane Davies	jdavies@alder.dudley.gov.uk	Lisa Pitchford	www.lisa.pitchfordphotography.com
Gert ten Dolle	gert_1@hetnet.nl	Peter Rand	www.peterrand.co.uk
Pete Downing	www.petedowning.com	Veronica Read	veronicaread@compuserve.com
John J Egan	www.jjegans.smugmug.com	Dylan Reisenberger	www.dylan.reisenberger.net
Chris Elliot	elliot40@btinternet.com	David Richman	david.richman@tesco.net
Frederick Fearn	frederickfearn@mac.com	Graham Robinson	www.clicksandclicks.com
Barbara Fleming	flemings@maryot.wanadoo.co.uk	David Rowland	www.one-image.com
Keith Folly	keith.folly@btinternet.com	Peter C Roworth	peter@roworth715.freeserve.co.uk
Melanie Foster	www.melaniefoster.co.uk	Edward Rumble	www.edwardrumble.com
Louise Govier	louisegovier4@hotmail.com	Richard Santoso	www.richardsantoso.com
Jan-David Hartsuijker	http://members.home.nl/imago-jd	Keith Schubert	keithschubert@mailauth.co.uk
Ian Harvey	www.the-tomahawk-kid.com	Paul Sharratt	strobesync@hotmail.com
Rupert Heath	rdmheath@yahoo.co.uk	Tony Shaw	apshaw@beeb.net
Andrew Hollebone	bones500@tiscali.co.uk	David Silver	www.davidsilverphotography.com
Adrian Hollister	www.hollisterimages.com	Alan Simpson	www.alansimpsonphotography.co.uk
Richard Holroyd	www.richardholroydphotography.com	Keith Suddaby	kandm.10suddaby@virgin.net
Jonathan Horrocks	www.jhorrocks.com	Adrian Swales	www.adrianswales.co.uk
Chris Howe	www.howe.uk.net	Lynn Tait	www.thelynntaitgallery.com
Nadia Isakova	www.photosbest.com	Colin Turner	www.solidair.org.uk
David Jackman	davidjackman4@btinternet.com	Keith Urry	urryb@aol.com
Malcolm Jones	malcolm@limestreet.demon.co.uk	Matthew White	www.mh-white.com
Peter Karry	peter.karry@breathe.com	Graham Whitwham	www.allscape.co.uk
Hugh Kavanagh	h.andj.kav@btinternet.com	Tony Whyte	twhytehot@hotmail.com
Alan Kinroy	alan.kinroy@tesco.net	Roy Woodcock	roy@woodcock108.fsnet.co.uk
David Knott	d.knott@virgin.net	Tanya Wrey	www.tanyawrey.org.uk
Despina Kyriacou	destinak@aol.com	Robert Wright	www.robertwrightphotography.co.uk

Great photography is always the result of courage and conviction. This is not the same as knowing what is right for a given situation, but trusting in one's ability to make the very best of what is on offer. CW

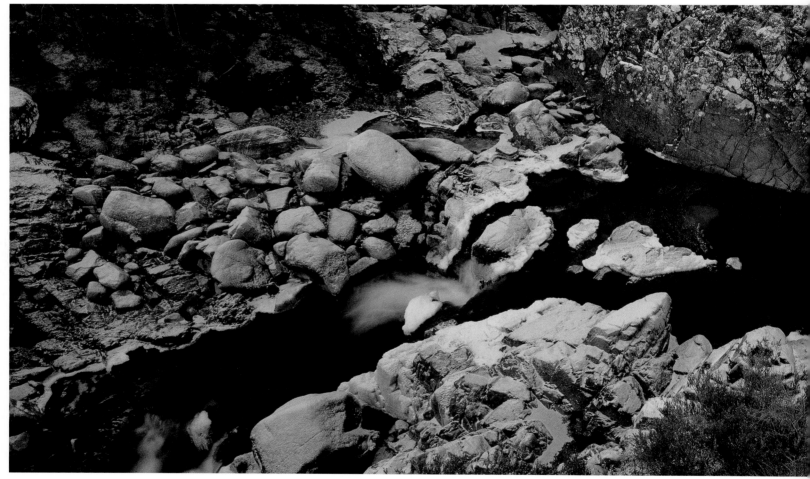

Winter in Glen Coe
Richard Santoso

CONTENTS

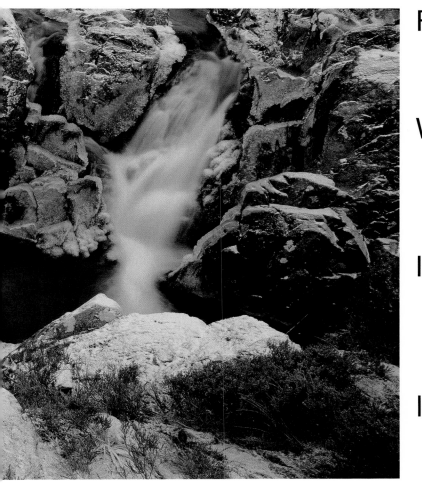

FOREWORD
Eddie Ephraums

Welcome to *Working the Light*

Working the Light is the first of a planned series of books exploring key themes of landscape photography and drawing on the wide experience of three renowned photographers: Joe Cornish, Charlie Waite and David Ward. Many of you will know them through the workshops they lead for Light & Land. My aim for this book was to get all three together to give a combined Light and Land-style photography masterclass, but in a way that would continue to educate and inspire long after camera bags would have been packed following an inspirational course in the field.

Workshops are a fantastic opportunity to meet great teachers and like-minded photographers: to share ideas, discuss one's work, offer mutual support, discover inspiration, improve technique, and to find the impetus to go further with one's photography. For these reasons, it was crucial to the success of this book that aspiring photographers should participate alongside the workshop leaders. When selecting the images, we weren't looking for winners, as in a competition to find the so-called 'best' photographer, rather we wanted to choose a selection of great images that would act as useful teaching aids and companions to the leaders' many useful hints and tips in the Gallery Workshop sections. These pictures are also the subject of constructive feedback in the Critiques sections.

Grateful thanks must go to all those who have submitted their pictures for possible inclusion. It takes courage to put forward one's work for potential criticism, albeit of the constructive variety, and especially when what is said will be committed to print. In that same workshop spirit, David, Joe and Charlie must be thanked, not only for including examples of their very best work, but, as a further teaching aid, for showing pictures they feel don't quite make the grade – and sharing with us their reasons why. They've gone further, too, by critiquing each other's work. The result is a book that I hope really does educate and inspire, and, as such, I like to think that it will enjoy a special place on your bookshelf – in between frequent re-readings, of course.

Boulder Colours
Roger Longdin

WILDERNESS LANDSCAPES

Joe Cornish

Contours in blue – a revelation in working the light

By the year 2000 I had been shooting landscape on 5x4 for a few years and was growing in confidence with it. Shooting at Dunraven Bay in Wales one winter afternoon I came across an extraordinary combination of reflected colours in the shade of a cliff. I made a composition and, as was my habit at the time, filtered the image to balance the colour cast. But that evening as I reflected on the day I realized that the essence of the scene's impact on me was in the colour cast itself. I returned to the same spot the following afternoon. I was able to improve on the composition, and left it unfiltered. The result vindicated my decision, and was to prove a turning point in my understanding of light and colour. All the light in the image is indirect, and the colours are all 'borrowed' from outside the picture space, the blue of the clear sky dominating the dry rock and warm sunlight reflected from a cliff mirrored in the pools and the wet rock. Contours in blue remains one of my favourite pictures. JC

Joe Cornish

Sandstone strata, Eigg
I worked long and hard on this picture, anxious to make the most of the almost perfect pattern of pyramids that seem to grow from the bottom right hand corner. The mineral sequencing and the pressure ridges in the rock offered a game of colour and texture which I tried to play. The ridge of Rum in the far distance, with its pointed profile, provides an echoing foil for the foreground. Perhaps though the link is too tenuous, or the middle distance zone too dominant. Perhaps the lighting is too bright. It just doesn't do it for me.

MY FAVOURITE SUBJECT at school was art. I drew pictures all the time, and in terms of ability it was by far my best subject. I also enjoyed physics and geography (the geomorphology part), and was always fascinated by maps. Even on a map, I thought coastlines looked wonderful, perhaps an early sign of my enduring passion for coastal landscapes!

Photography came later, while studying fine art at university. I suffered an obsessive preoccupation with it, almost from the moment I bought my first SLR. Looking through its viewfinder gave me a whole new way of seeing the world. Most of my paltry student budget went on darkroom gear, new lenses and the next roll of film (fortunately I didn't drink beer). My art degree course proved painful in some ways, but I did learn that I had a passion for photography. I loved taking pictures, and I much preferred being outside to indoors. This was later brought forcibly home to me when I spent a number of years as an assistant, sometimes cooped up in the studio for weeks at a time.

While at university I discovered the photographs of Ansel Adams, Edward Weston, Paul Strand and Walker Evans, and read about the ideas and philosophy of the f64 Group. Their work convinced me of the tremendous artistic potential of landscape photography. Although documentary photographers such as Henri Cartier-Bresson and W. Eugene Smith inspired me too, I knew I was not really cut out to cover wars, revolutions and other social upheavals. After assisting, I tried my hand at social and portrait photography for a while. I was rubbish at it. But on free days I explored the countryside with my camera. The dream of being a landscape photographer was being forged. Yet in the early 1980s it seemed almost impossible to make a living from it.

I got a break, shooting some black and white landscapes for a book on the founders of the National Trust. This led to my first travel book assignments, bringing some opportunities to shoot landscapes. The money was awful, but being poor didn't matter if I was taking pictures. I met a certain Charlie Waite, whose unique photolibrary, Landscape Only, brought together a group of aspiring young landscape photographers in the late 1980s. Seeing my pictures succeed in the marketplace with Landscape Only encouraged me to believe I might one day make it as a landscape photographer.

Bay of Laig, Eigg
This was one of those rare occasions when an awesome location and incredible lighting converged. I distinctly remember thinking at the time, 'Your whole life has led to this point. Don't blow it!' After a long journey and a physically demanding day I was feeling the pressure. But I kept the composition as simple as I could and let the place and the light do the work. The space, the colour, the small individual foreground details and the spectacular profile of Rum in the distance all work together because of the quality of light. There is no direct sunlight, just big clouds overhead, acting as celestial reflectors, filling the scene with warm light that enhances the colour of the sandstone shore. I don't think there's anything I would do to change this photo. I have a couple of other sheets shot earlier than this one. If I hadn't been running out of film at the time I would have shot more. I only wish I could have had more film with me at the time!

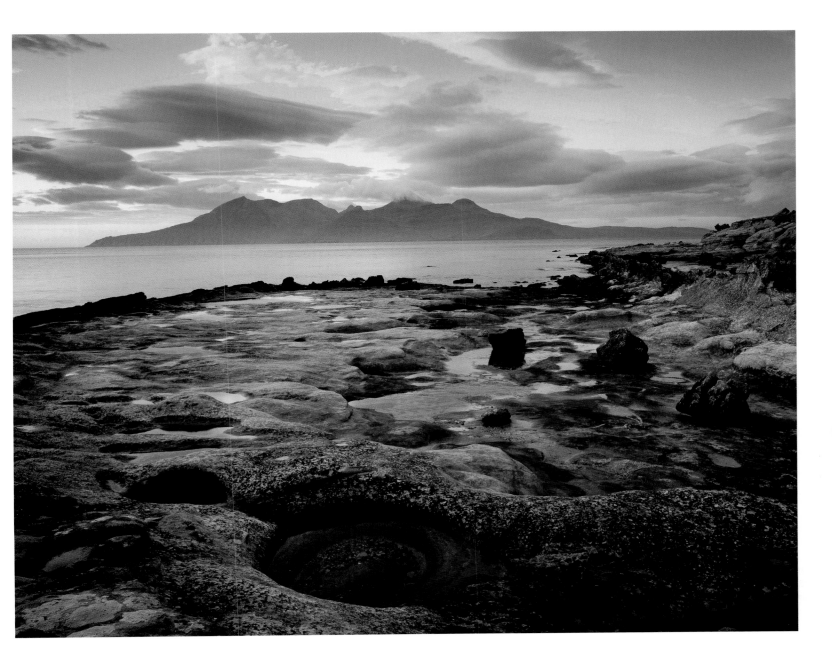

Landscape photographers would in general love not to have to use filters,
but the reality of light means that they are virtually indispensable for much
of the time. A well filtered photograph is one where the filter's use is invisible,
to the untrained eye at least, and all the viewer sees is the subject matter,
beautifully exposed.

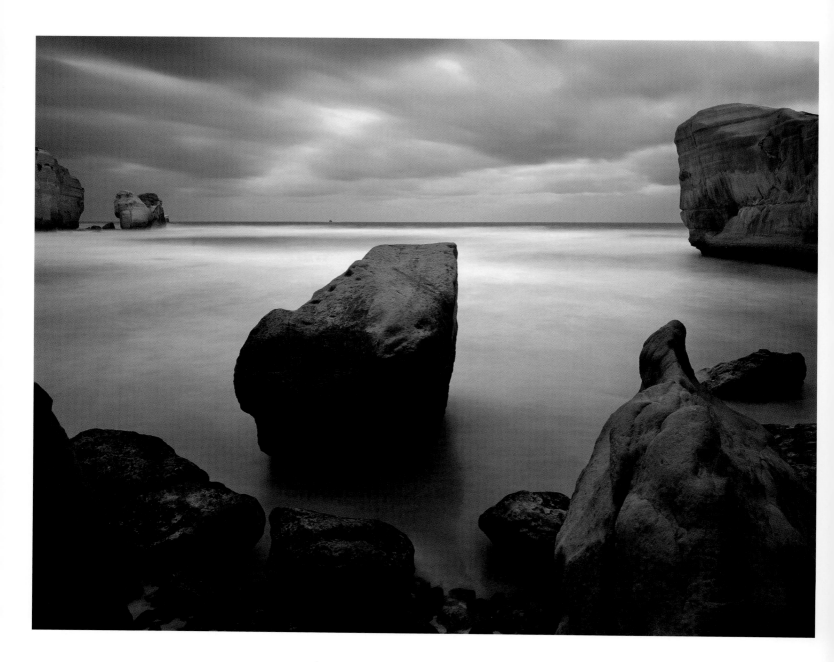

Digital photography offers an alternative to the graduated filter in the form of blending different files using the Graduate tool and Blending modes. It's a sophisticated piece of digital darkroom practice. Yet it has its drawbacks too, and for traditional film shooters looking to get it right in camera, nothing beats the perfection of a transparency created with a graduated ND filter.

PARTICIPATING IN *WORKING THE LIGHT* is not a noble act of altruism. I am grateful for the opportunity to do my own picture selection, and to justify it. I also thoroughly enjoy looking at other people's work. Over the years of leading workshops for Light & Land I have gained great pleasure and inspiration from seeing the photographs brought in for the critique process we usually do. That's especially true when Light & Land 'alumni' (or perhaps illumini would be more appropriate) return, and as leaders we are able to see the progress made. While my own motivation for being a landscape photographer remains essentially the need to make a personal journey, workshop involvement has both expanded my own photographic horizons, and allowed me to share and participate in the wider community of photographic enthusiasts. Since landscape photographers were once regarded as isolated, uncommunicative individuals, this has been an unexpected and enriching aspect of my life.

The appreciation of looking at photographs is a matter of art and opinion, not a science. But while I am not keen on an excessively reductionist form of analysis, the effort to articulate and understand photographs is a necessary and important learning experience. Like David, I have never understood the secretive approach of some professional photographers to the discussion of technique. 'Trade secrets' are a futile concept. I believe that what makes photography special is the unique vision which we all possess, and plagiarism is inherently doomed to fail anyway, so why worry about it? While some people have more natural talent than others, everyone can develop their technique, and learn that photography is a question of passion and inspiration. There is photographic technique, there is artistic style, and there is the heart and soul of the photographer. Great landscape pictures are a successful fusion of these three elements, as *Working the Light* so convincingly illustrates.

MY ATTRACTION TO WILDERNESS and wild places is both aesthetic and philosophical. I love the forms of raw energy that can be found in nature, whether that be the rhythmic patterns of sand, snow or ice, the sculpted power of weathered rock, or the dynamic vitality expressed in the shapes of plants, trees and flowers. I have long tried to capture the essence of this energy with my camera, and these phenomena can be found in abundance in places that remain largely untouched by the hand of humankind.

An expedition to Alaska in 1991 had a profound influence on me. I spent nearly three months in a kayak on the waters of Prince William Sound, or living and climbing in the surrounding mountains. Living simply with a few companions in these pristine places convinced me of the value of being close to nature. In addition, the unspoilt perfection of this landscape was to permanently affect my understanding of the aesthetic of landscape generally. Composed by the rhythms of geological time and fine tuned by the millennia since the last Ice Age, the Alaskan wilderness set a benchmark of beauty in my mind that has informed my views ever since.

Philosophically, I believe that many of our human problems are the result of urbanization, and an excessively ethnocentric view of the world. Our cultures, societies, laws, religions, industries and enterprises are all arranged for the benefit of human beings. The other inhabitants of this

Certain lighting qualities, of course, create mood, but the photographer must be sensitive to them to recognize their potential.

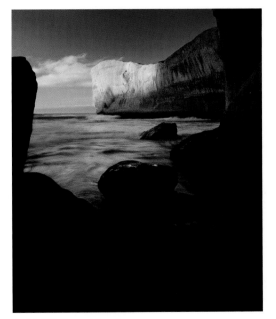

Gold cliff, Tunnel Beach
When the sun struck the cliff on this particular morning, I was desperate to capture the extreme colour contrast, of orange cliff against blue sky. But I quickly realized that would be impossible as the colour was cooling rapidly as the sun rose. By the time the whole cliff was lit the colour would be much less striking. So I rushed. My main mistakes were to use a polarizer, and to compose too wide. The contrast was too high already and the polarizer made it worse. The sky is unsubtly too dark, the framing rocks are a black silhouette, and the composition is disjointed. It is a technical and aesthetic failure.

Tunnel Beach, Dunedin, New Zealand
Although just a few miles from Dunedin city centre, Tunnel Beach is as wild a place as you could wish for. I have been there many times, always aiming to capture dawn sunlight on its spectacular cliff headland. But ironically my most successful photo of it was made in the dying light of a cloudy afternoon. There was a glimmer of colour in the sky that encouraged me to make this one photograph. By the time the exposure of twenty seconds had been made I couldn't see the point of shooting another one. The flat light helps the film see into the shadows, and the passage of time has allowed the clouds and sea to move extensively during the exposure, imparting an energy to the composition which I confess I had not anticipated. This is not an easy or a commercial picture, but I have one friend who was moved to tears on seeing it exhibited. Such an emotional response is perhaps the biggest compliment a photographer can be paid. Oh, and she bought the print too!

Getting to know more about a landscape, its geology, natural history, environmental pressures on it and so on, is all part of the joy of landscape photography. Knowing about the tides on the coast, or the potential of flash flooding in a slot canyon could also save your life!

planet suffer terribly in our shadow. But, just as importantly, we too appear to face an uncertain future because of our merciless exploitation of the natural environment. I believe we need to realign our relationship with nature and rediscover our sensitivity to natural phenomena. Given these views it is perhaps inevitable that I seek the inspiration and wonder of wild places, to celebrate their survival, and to campaign for their continued existence.

There is nothing terribly original about these sentiments. In my experience, most people when exposed to the luminous beauty of the sunrise, the power of the raging sea, the silent space of the desert, or the awesome presence of a giant redwood, will feel inspired and engaged by nature. I believe photographers, both professional and amateur, can provide powerful advocacy for the natural world.

MANY PHOTOGRAPHERS HAVE INFLUENCED me through their images, and their thinking about light. I have mentioned Weston and Adams already, but I should also mention John Blakemore. Among colour photographers, I particularly admire the Tasmanian, Peter Dombrovskis, the Americans Michael Fatali and Jack Dykinga, and, in England, Paul Wakefield. Galen Rowell's book *Mountain Light* had a huge affect on my understanding of natural light. But I probably take just as much inspiration from painting as I have done from photography. The English painters Turner and Constable are favourites. I love some of the old Dutch masters of the seventeeth century such as Albert Cuyp and Jacob Van Ruisdale, and I also enjoy looking at many twentieth century painters like Ivon Hitchens, Graham Sutherland, Paul Nash and Wassily Kandinsky. I also think it is no coincidence that I love the sculpture of Henry Moore, for my fascination with geology springs largely from its sculptural energy.

AT THE VERY BEGINNING of my love affair with photography I took a black and white picture of an old beech trunk in Sonning Woods near the River Thames. Much more by luck than good judgment this had that certain something, a feeling of light, which I (unsuccessfully) tried to reproduce subsequently. A couple of years later I made a sequence of pictures on a beach in Anglesey that were to become the main element of my degree show. One of these, of a rivulet running through sand, utilized soft sunlight reflected directly off the sand. It was the first time I understood that it was light I was photographing, not the landscape itself. Fast forward to 1984, and I was experimenting with filters and Kodachrome film. By breaking some of the rules of filter deployment I discovered that I could achieve more successful colour effects and harmonies than without filters. One particular image made on the Palace Pier at Brighton gave me the confidence to believe in the validity of filter use with colour materials.

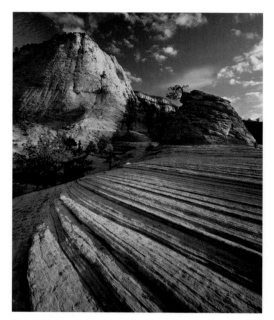

White Mesa
Shot not far from Waterholes Canyon, this is a popular photo subject in the Mount Carmel part of Zion National Park. The ingredients are all there, but the composition is a disaster that falls flat on its face in the middle, where the miniature orange mesa with its funny little tree gets lost against the shadowy background. I was so caught up with the focusing (an interesting challenge with a view camera) and catching the light before the foreground dropped into the shadow of a mountain, that I forgot to ask myself if the composition worked. Simple answer, no. Over-polarized too. A waste of good film.

Waterholes Canyon, Zion
Shot on a cloudy afternoon in a remote side canyon of Zion, this image works for me because of its complex, subtle lighting. The sun's reflection appears partially obscured in the foreground pool, like a window onto another world. The soft light in the canyon allows the eye to flow easily through the composition without the distraction of black shadows or bright highlights. In the distance, a high mesa catches a flash of the afternoon sun, which lifts the mood, and helps draw attention to the geologically surreal skyline. I would prefer it if the sun's reflection were a little more central in the pool. At times I have thought the lighting a little too cool, but I have come to terms with this.

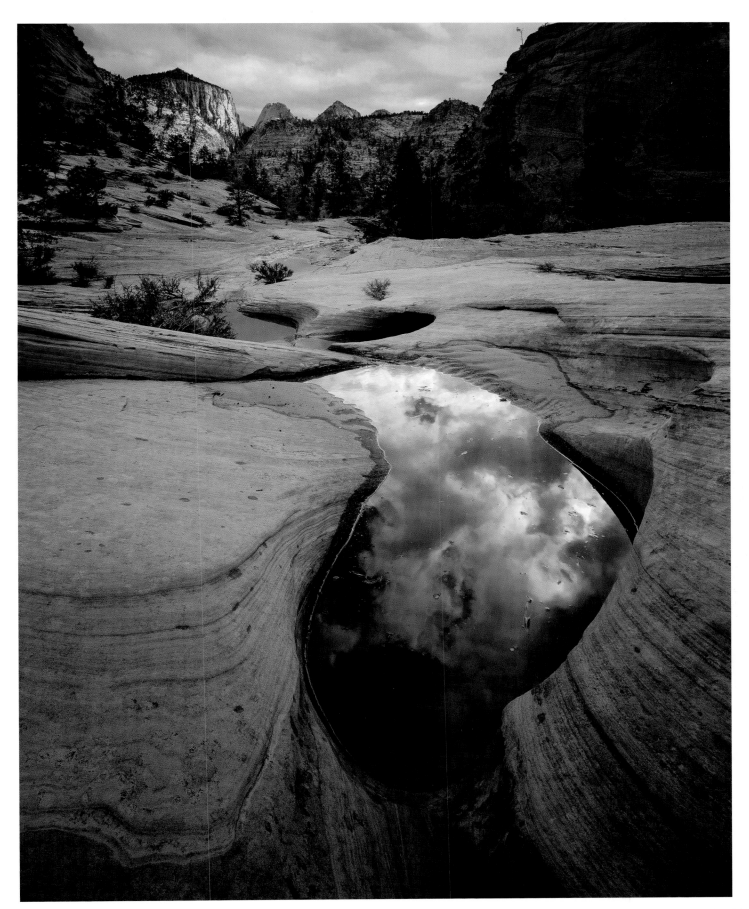

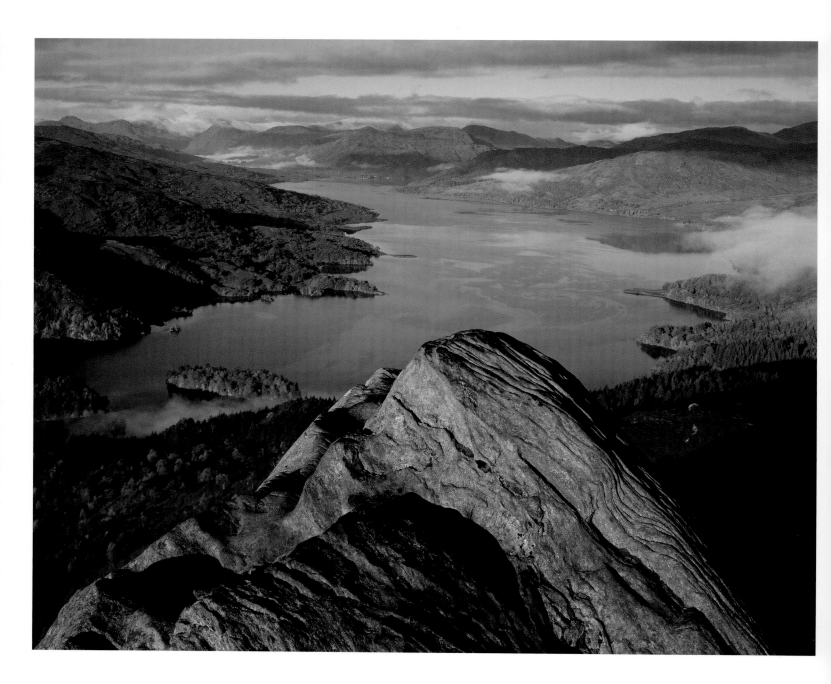

Dawn has a special appeal because it is usually quieter than at other times of the day. Watching the sun rise over the landscape, and having that experience to yourself, feels like a privilege. At certain times of year, too, the phenomenon of valley mist may be observed. The combination of the rising sun and mist is perhaps the most seductive of all lighting conditions.

My top five tips for working the light

1. Buy a spot meter and learn to use it properly.

2. Realise that the cycle of the seasons has an enormous effect on the position of sunrise and sunset, and learn to anticipate the effect of the sun's path through the course of the seasons.

3. Try and respond emotionally to light. But be scientific enough to do your response justice by getting the exposure right!

4. Use a tripod. Most light interesting enough for a landscape photo can't be hand-held anyway, and most photographers compose their pictures better with a tripod than without.

5. Get out more. But take fewer pictures.

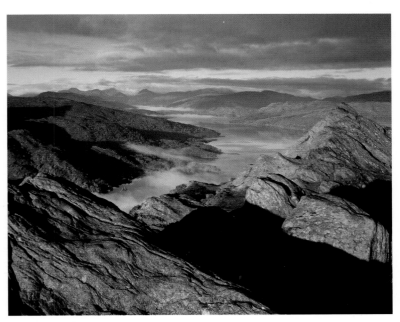

Ben A'an summit, Trossachs

This is not one of my best pictures, but is probably the best I shot on that particularly memorable dawn. I had climbed Ben A'an a week earlier to find out how long it would take to reach the summit for sunrise. So I knew I had to set off from my base two hours before sunrise to reach the bottom of the mountain an hour before dawn in order to be on the summit in good time. Early mist covered Loch Katrine, but started to clear rapidly as the sun got to work. My problem was that all the clouds were below me, and the sun was not far off being directly behind me. I was constantly in danger of having deep cast shadows (or my own shadow), dominating the picture. By using this miniature summit pyramid as a compositional device I was able to avoid those problems. The tripod ended up almost ridiculously perched while I wobbled around on one and a half feet, trying to focus the camera! I would have changed numerous things about the morning could I have done so. A lift to the summit would have been nice, and though the morning was a beauty, I was slow coming up with this solution, meaning the prettiest light had long gone by the time I made the exposure.

Loch Katrine from Ben A'an

This image was made before the final 'summit pyramid' picture. It was earlier in the morning and in some ways the presence of more mist over the loch, and the sun lower in the sky meant that, overall, the light was better. Although the composition features strong and balanced diagonals, the black hole of shadow in the middle is a fatal flaw. My spot meter told me that black was inevitable, but I shot it anyway, hoping that the rest of the image was strong enough to compensate. A clear example of the misleading power of wishful thinking…

GALLERY WORKSHOP
Wilderness landscapes

Defining wilderness

Wilderness is a place that is unchanged by human activity. The only such places in Britain are tiny fragments, such as Scottish mountain summits, some small islands, sea stacks and steep sea cliffs. And of course the intertidal zone of the coast, flooded twice a day by the tide. For the purpose of Working the Light *we include those places that we could describe as wild in character, such as moorlands, riverbanks, and ancient woodland.* JC

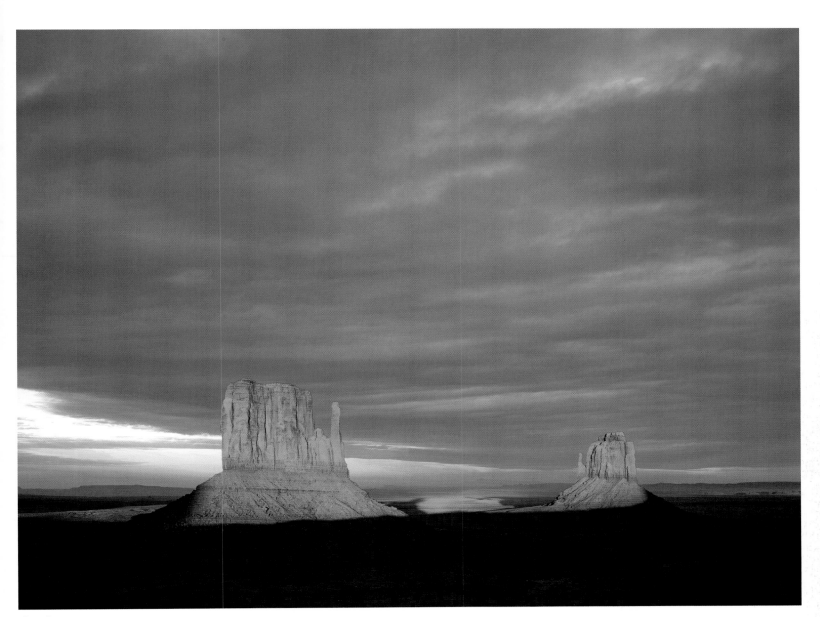

The Mittens
Simon Miles

The theatre of light

If one did have to define an ideal light then, for me, it would be a sky full of powerful-looking cloud, with breaks through which the rising/setting sun could shine. Such a skyscape forms the perfect 'theatre of light', gracing any scene with a sense of drama. It also provides manageable contrast and great colour quality. JC

The grass is greener

Ironically, since it is the dominant colour of vegetation across the earth, green is a colour which many of us struggle with. Arguments used to rage about which film gave the most natural greens, and even digital cameras respond to green quite variably. Love it or hate it, green is here to stay, with or without global warming! JC

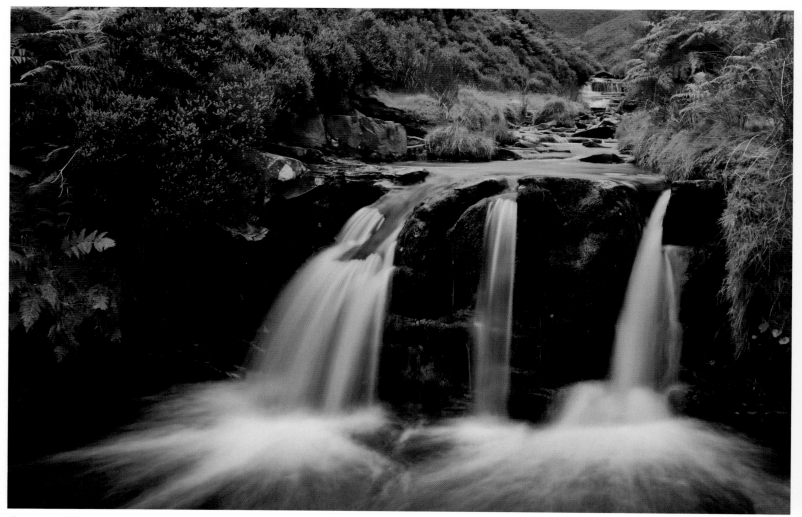

Three waterfalls
Jonathan Horrocks

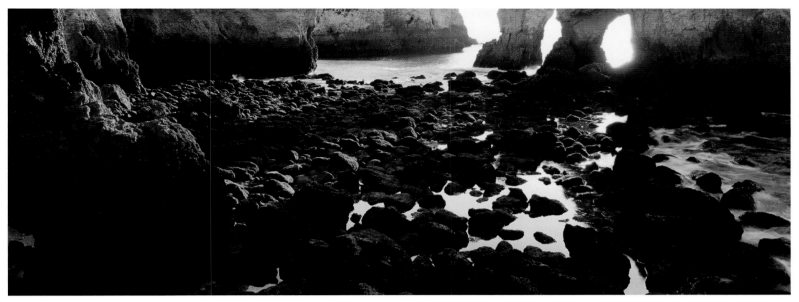

Ponte De Piedade
Peter Karry

Coping with flare

Flare is an issue because it is an artefact of the photographic process that detracts from the main purpose of the picture. Apart from those times when the sun is in the composition, it can be easily avoided in most situations by casting a shadow over the lens (and any system filter attachments). Be careful to avoid including the shading agent in the picture. Most accessory lens shades are little better than useless. JC

Advocating the hand-held meter

When we take responsibility for exposure, we stay directly in touch with our goals for rendering the look of the image. This can be done with the camera's internal meter manually, but the ultimate level of control is to use an independent hand-held meter. JC

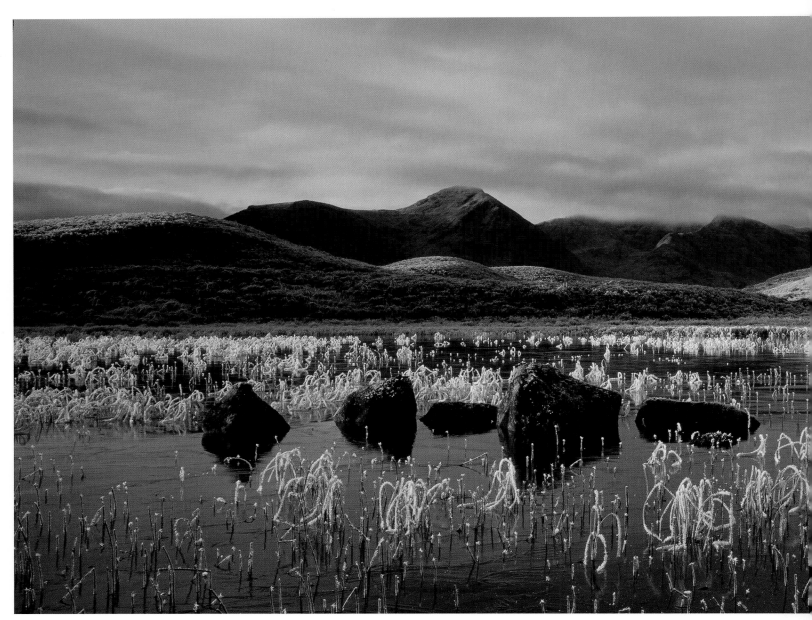

Winter in Glen Coe
Richard Santoso

Composition isn't just for composers

Whatever the theme, the primary aesthetic responsibility of all photographers is to make a good composition, and balance is the primary aspect of composition. JC

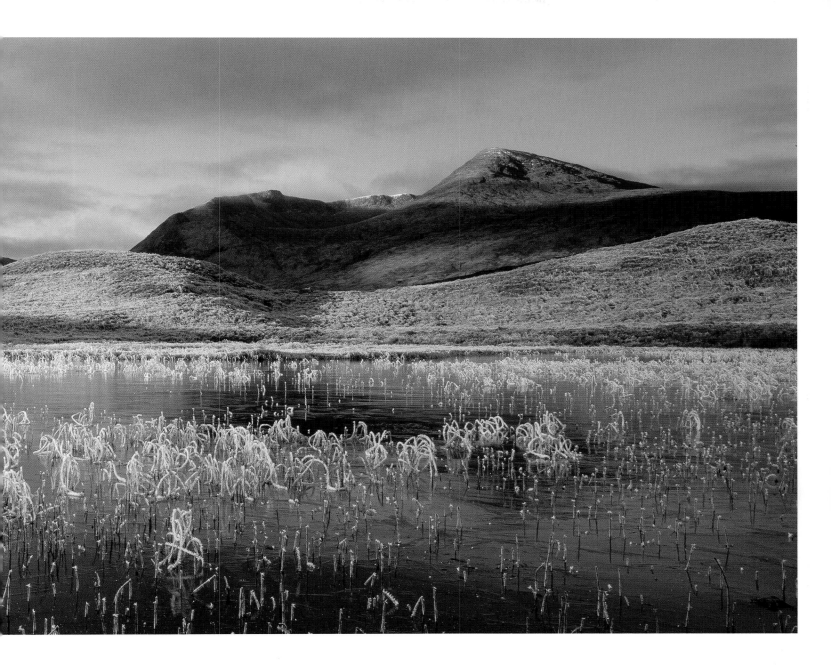

Photography's limitation is its strength

While painters have unchecked freedom to interpret light as they wish, photographers can only use the light that is there at the time. Yet it is that limitation that creates photography's credibility, and it is this 'believe-ability' which makes photography powerful. JC

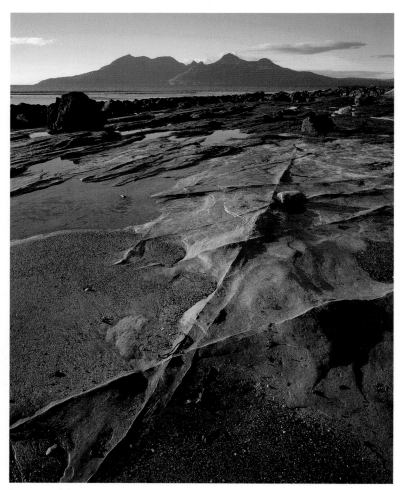

From a portfolio:
Land of mountain and flood
Richard Childs

Perspective on landscape

Consciously or otherwise, all landscape photographers use elements of perspective in their pictures. Broadly speaking, wthese can be defined as diagonal lines, or visual links, which help define the space and draw the eye into the scene. JC

The more we practice, the luckier we get

Luck plays its part in landscape photography. But being in the right place at the right time is not really about luck. If the location itself is spectacular, then the place, to an extent, will do the work. But the good photographer has the determination, skill and sensitivity to make photographic sense of it all, and the sense to witness these wonders when the light is at its most magical. JC

Buachaille Etive Mor
Richard Childs

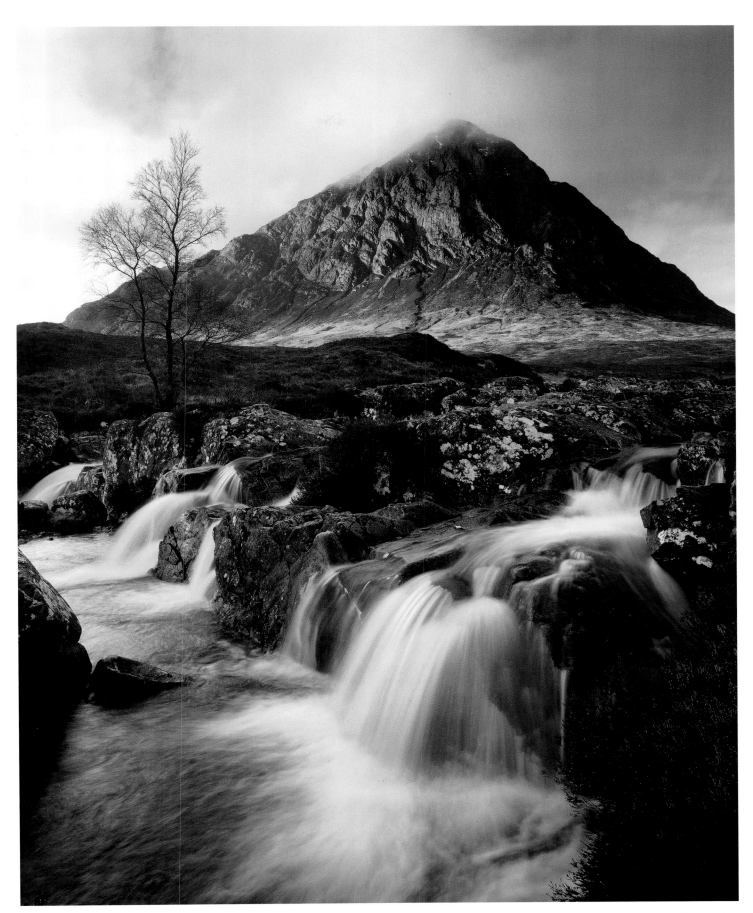

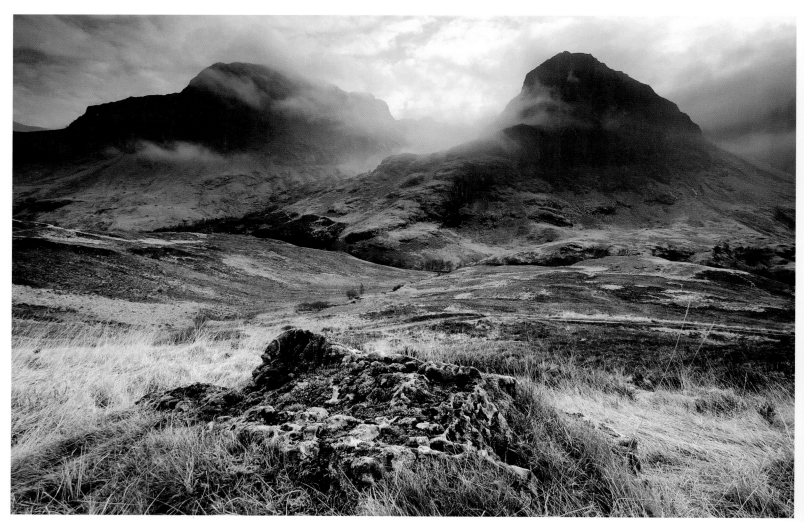

Glen Coe
Paul Marsch

The expressive potential of light

Sometimes the light itself determines which way we should point the camera, and it is our response to its emotive potential that will determine our success. We may have to wait patiently for the light to improve, or accept that we need to return on another day or in another season. These decisions reflect our response to the creative potential of the light. JC

**Allt Chailleach,
Rannoch Moor**
Neil Brayshaw

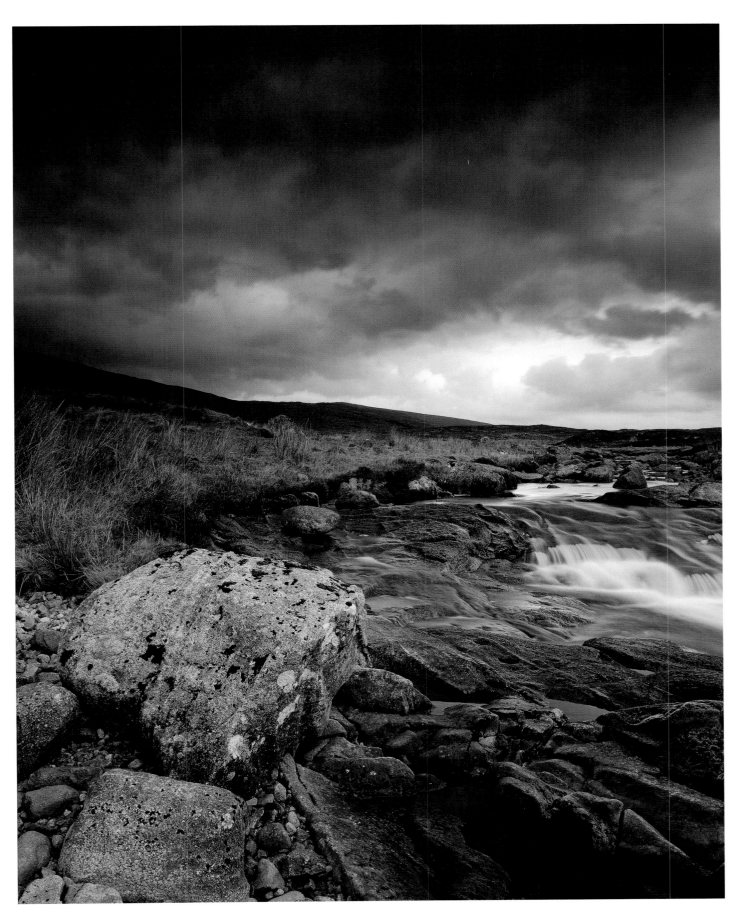

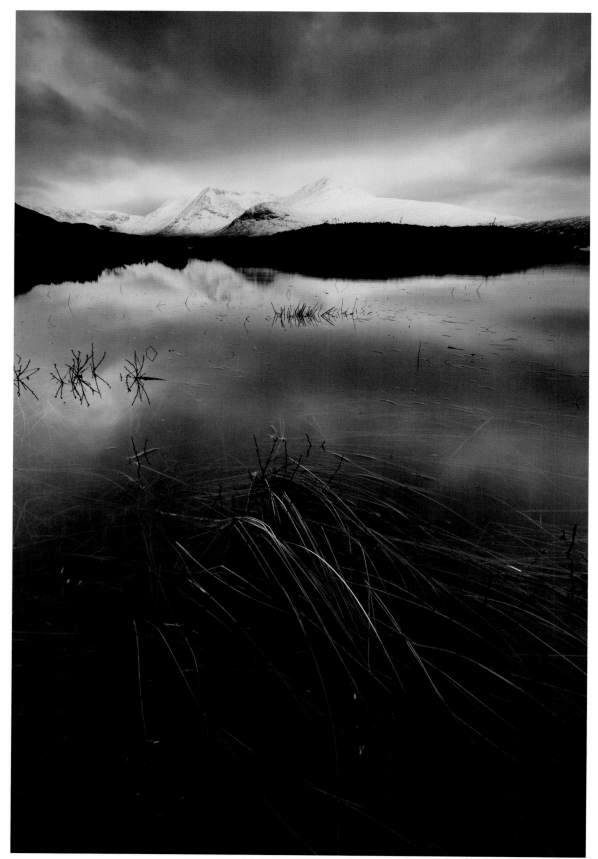

Composition, control, containment

Intimate images typically work best without 'edge action' (visual distractions drawing the eye to the frame edges). Although the internal structure of the picture may be dynamic, contained energy retains the intimacy of the composition, confirming the notion of a world within a world. JC

Came the cold
Graham Robinson

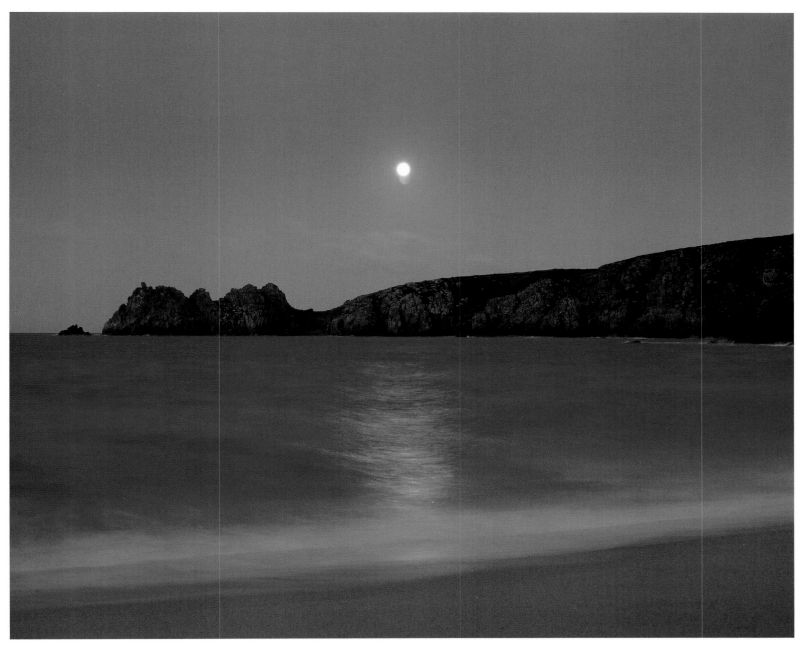

Moonscape
Keith Folly

Automatically less creative

I am not going to be popular with certain camera manufacturers when I say that their extremely cunning systems of automation, especially for exposure, are ultimately incompatible with creative control for the photographer. Automation undermines creativity by detaching the photographer from the fundamentals of the process. JC

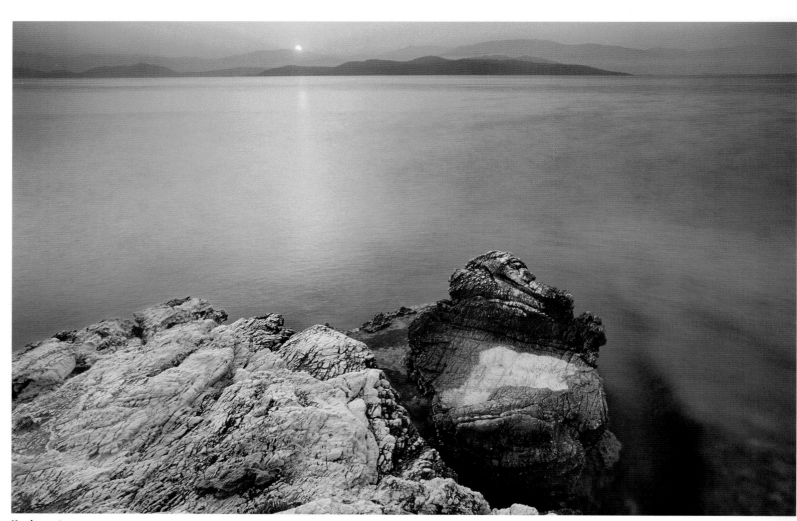

Kouloura 1
Patrick Medd

Graduates and warm-up filters

Neutral density graduates are the main tools in the filter box, they allow us to balance exposure so making film/sensor vision more like our own. Warming filters can be useful, but should be used sparingly and with the utmost care. The colours of nature are often more appealing with the natural colour cast of the lighting retained. JC

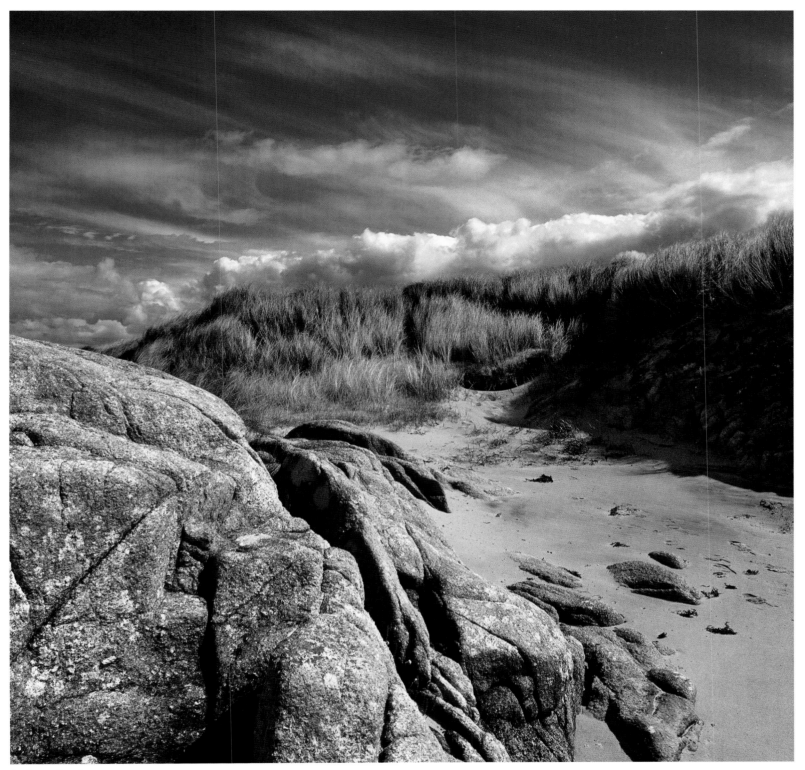

Rock, sand and grass
Julian Barkway

Lessons from art

There's a classic rule in art: warm colours come forward and cool colours recede. JC

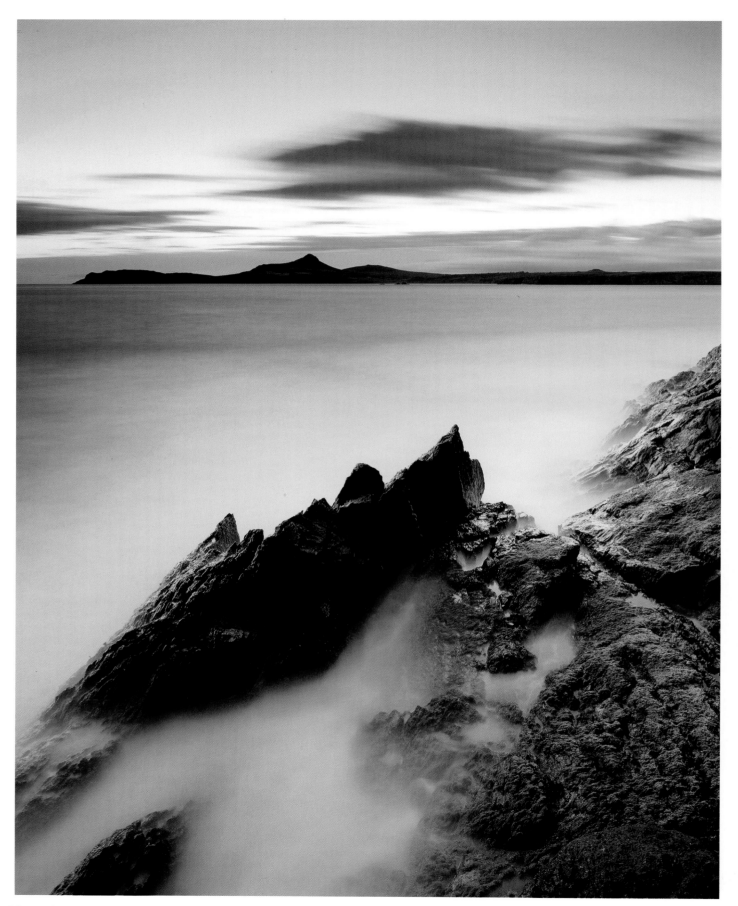

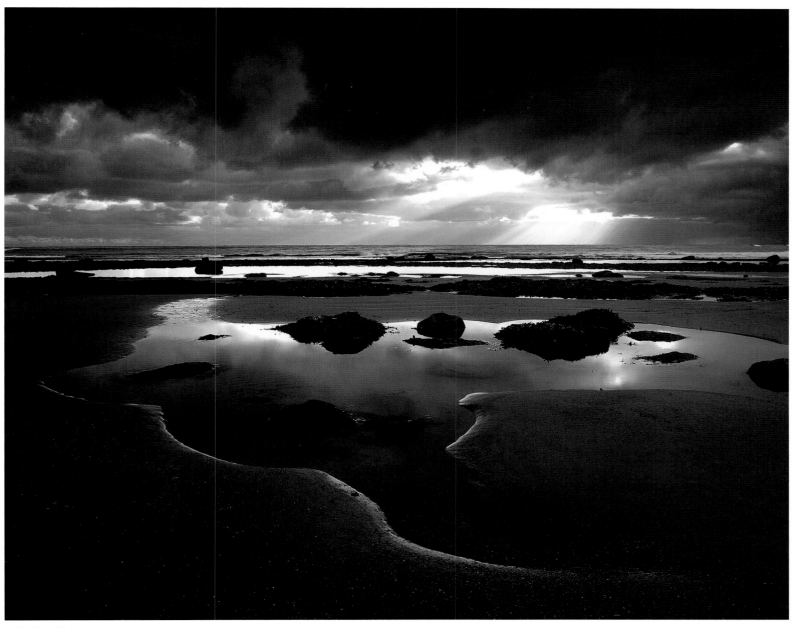

Robin Hood's Bay
Peter Rand

Painting with light

Understanding the idea that light levels can be measured and understood in relation to one another is as important to a photographer as understanding the difference between lighter and darker coloured paints is to a painter. JC

David's Head from Ramsey Island
Rupert Heath

Ideas about ideal light

There is no such thing as ideal light, just different light (although it might be argued that some lights are more 'different' than others!). When lighting conditions are disappointing for some subjects they may prove ideal for others. JC

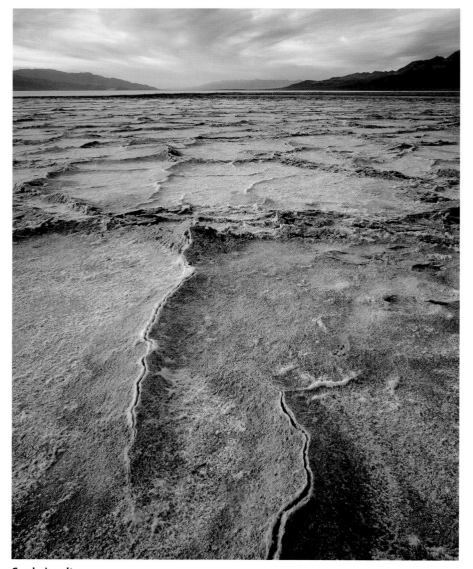

Cracks in salt pan
Despina Kyriacou

Pay attention to detail

A fundamental of all photography is to develop an accurate knowledge of everything in the viewfinder, and especially around the edges. A strong landscape photograph can be understood as an accumulation of well-resolved details, where everything works together, and everything has a place. JC

'Fossilized' tree trunks
Despina Kyriacou

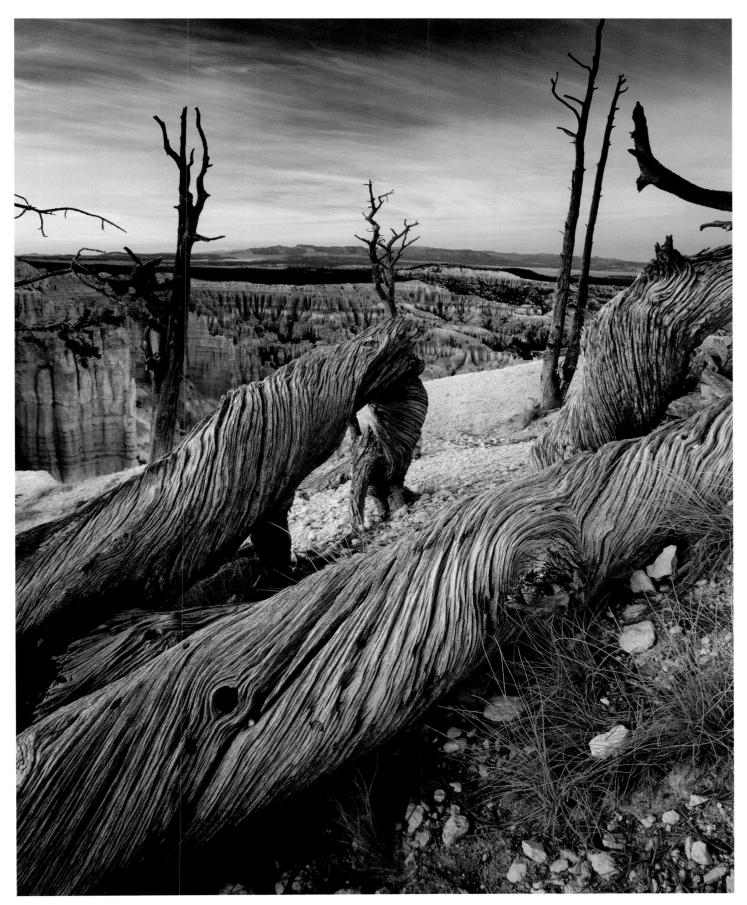

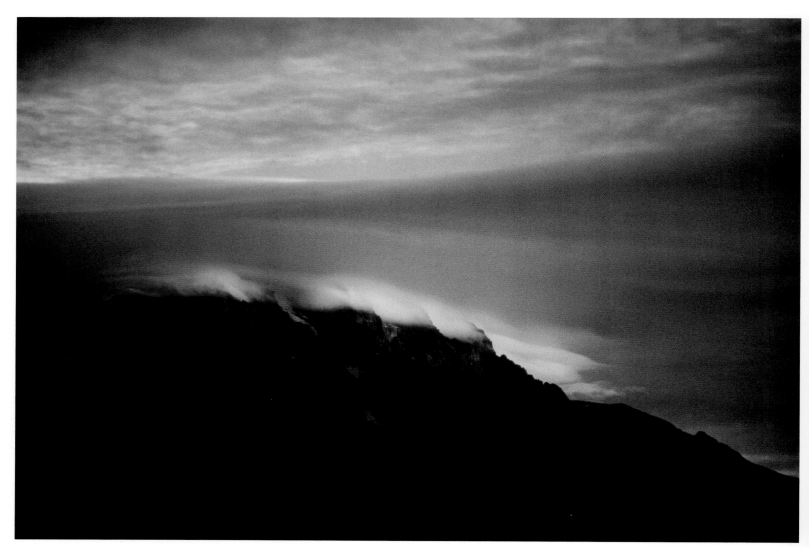

Dents du Midi
Graham Whitwham

Seeing photographically

Photographic seeing involves learning the limitations of the film or the sensor, and of developing strategies to cope with these limitations. Compared with human vision, colour transparency materials especially have a narrow total contrast range. Yet this limitation is also a form of strength. In soft or flat lighting, certain films can be relied upon to produce beautiful, intense colours and tones, which still look natural. In these conditions, pictures can seem to be an improvement on the reality. JC

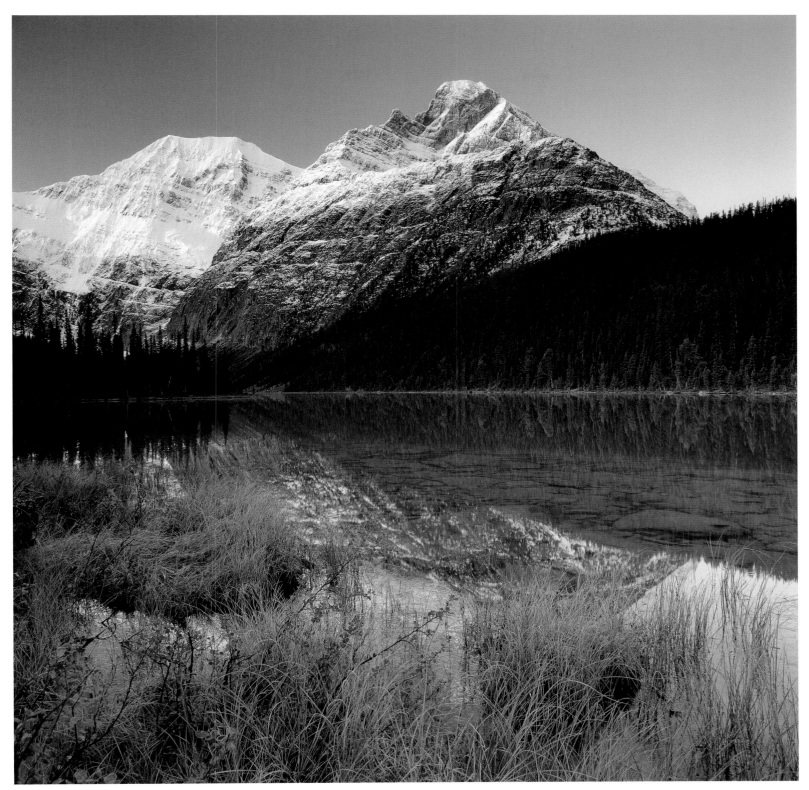

Mount Edith Cavell
Gert ten Dolle

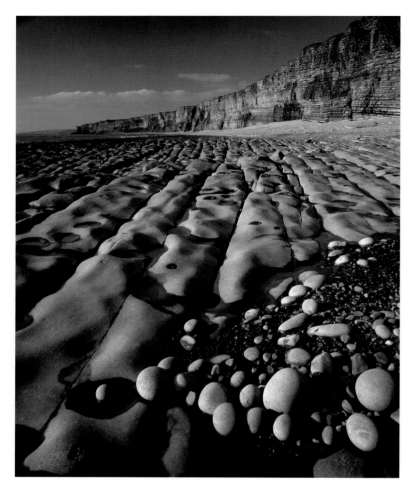

Treath Mawr
Richard Holroyd

Use of polarizers

Polarizers are often over-used, and should never be left on the camera as an all-purpose filter. They are effective for reducing reflections on water, when photographing rock pools, for example, and help to saturate the colour of vegetation, again by cutting reflections. The blue skies associated with their use are often unnecessarily dark. JC

Develop a positive latitude

Anywhere nearer the equator than 35° North or South is impossible. The sun rises and sets too quickly. Therefore the light can't be that photogenic, or if it is, I don't want to know! High latitudes nearer the poles have both the clearer air and the shallow solar path (so the sun rises and sets slowly) beloved by landscape photographers, especially by slow-moving, large-format ones. Too bad the weather is often rather dodgy. JC

Budle Bay
Richard Holroyd

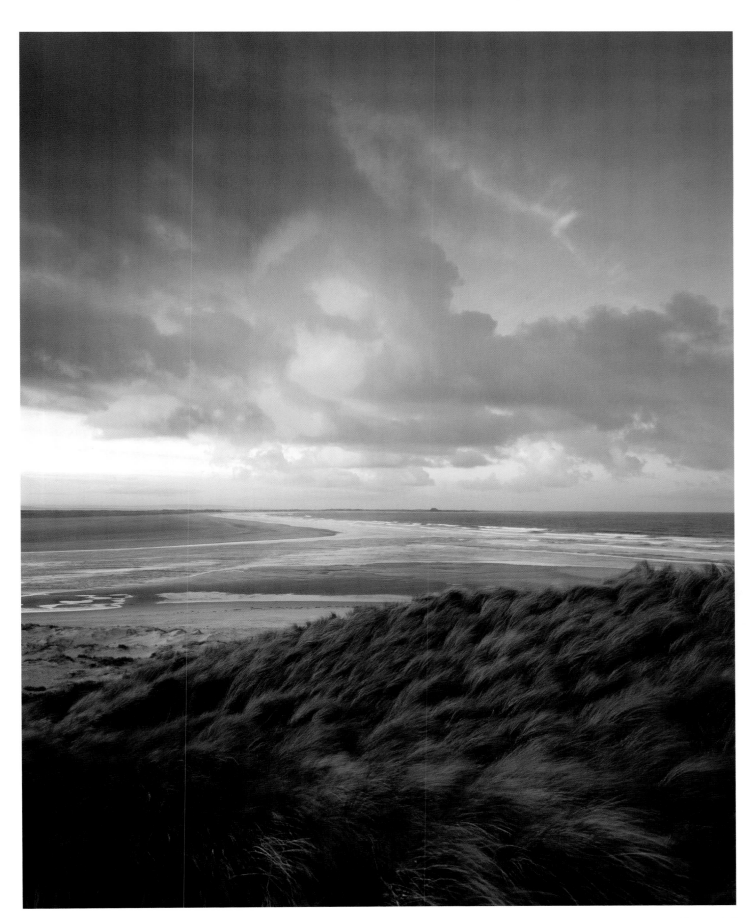

The digital darkroom

Photoshop and other photo-editing programmes can also be used to enhance the light in a picture and so better reveal the content of the photograph. However, I believe we should always see them as subsidiary to our in-camera technique. A great original transparency/negative/digital file is always the best starting point. Most photographers will derive more satisfaction getting it right in camera rather than spending hours recovering a poor original in a computer. However, subtle use of Photoshop can also make a fine original even better. JC

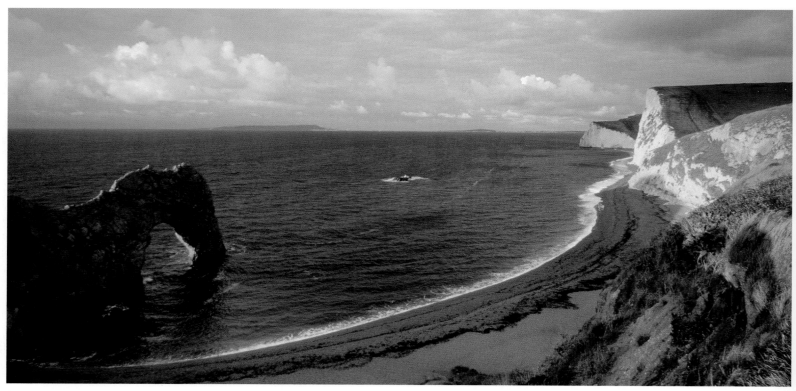

Sunrise in Dorset
Adam Pierzchala

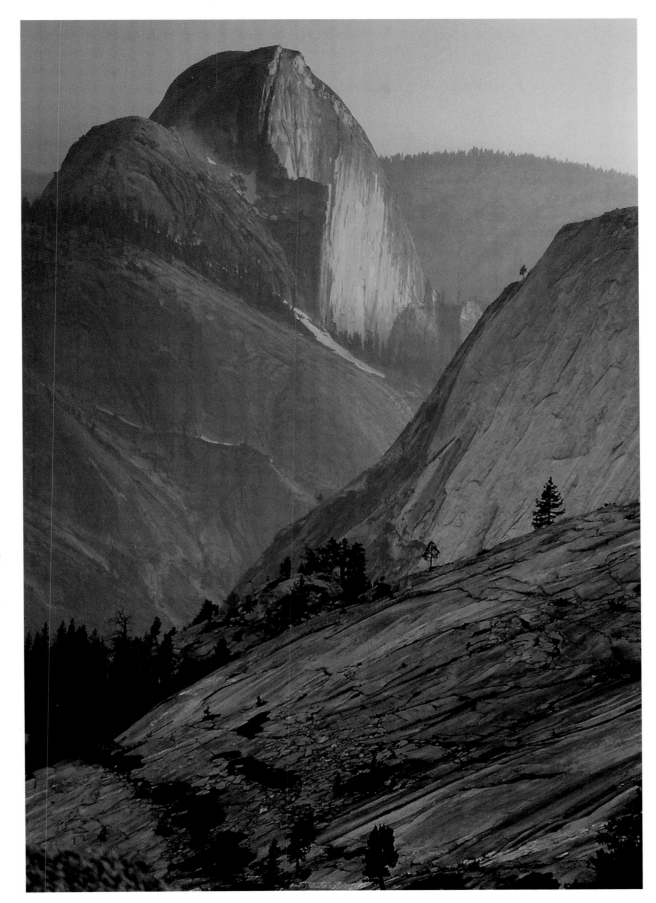

Wildness vs sterility

Untamed landscapes combine visual order and visual chaos. Photographers naturally want to create well-seen, orderly compositions, but it is especially important in photographing the wild to be sensitive to the raw edge of the subject matter. Too much order can become clinical. JC

Yosemite
Chris Andrews

Learning from the masters

The painter John Constable saw the sky as the main event of a landscape picture, and his compositions often reflect that by devoting more than half the picture space to it. Agree with him or not, we can learn from his ideas, and those of other artists. JC

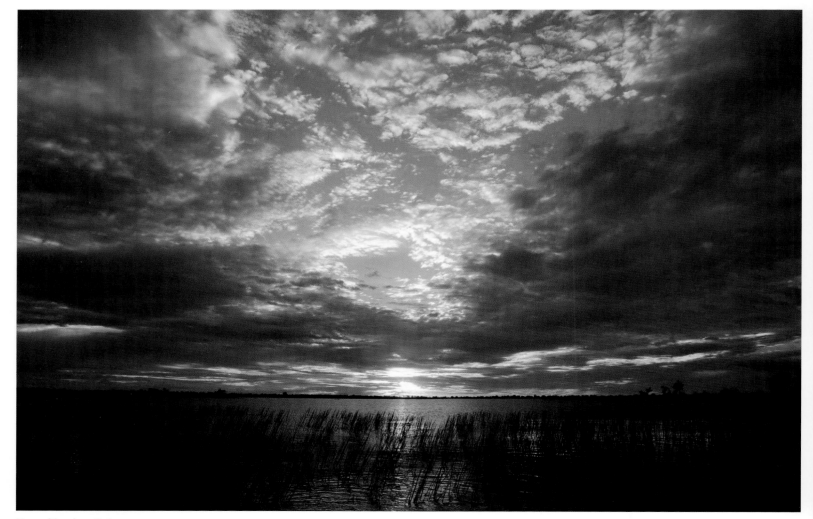

Monachira river, Botswana
Benjamin F Bailar

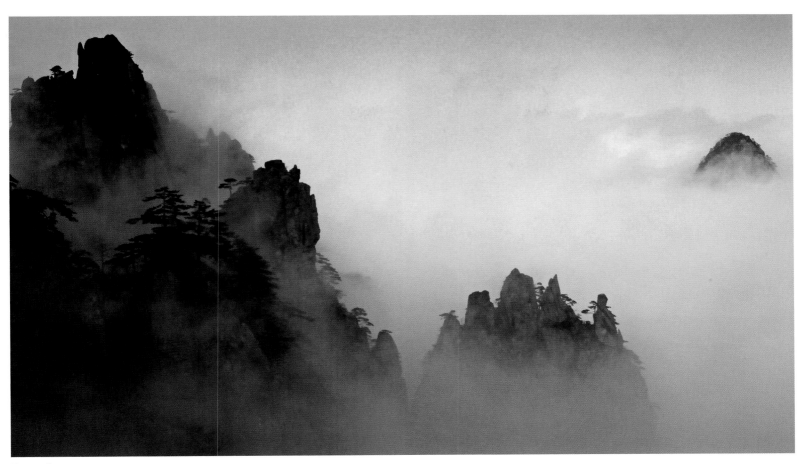

Haungshan
Paul Ng

Sky studio

Clouds are interesting subject matter in their own right, infinitely varied forms and shapes in the sky, and they are also a majestic enhancement to lighting. The studio photographer can understand clouds as gigantic reflectors, diffusers and light-shapers, and they also influence colour. They are our studio in the sky. Too bad we can't put them where we want them! JC

Dawn or dusk?

An attempt to analyse the difference between dawn and dusk light, sunrise and sunset light is fraught with difficulty. What they have in common is more important, and that is the sun is low in the sky, or just below the horizon. Warmed by atmospheric dust and haze, and dramatized by the weather conditions, which are sometimes exceptional at these times of the day, this is the light universally favoured by colour landscape photographers. JC

Camera position

Ansel Adams said that a big part of landscape photography was knowing where to put the camera. He was right. But how do we know where to put it? With a bit of luck, studying this book will help us to figure it out! JC

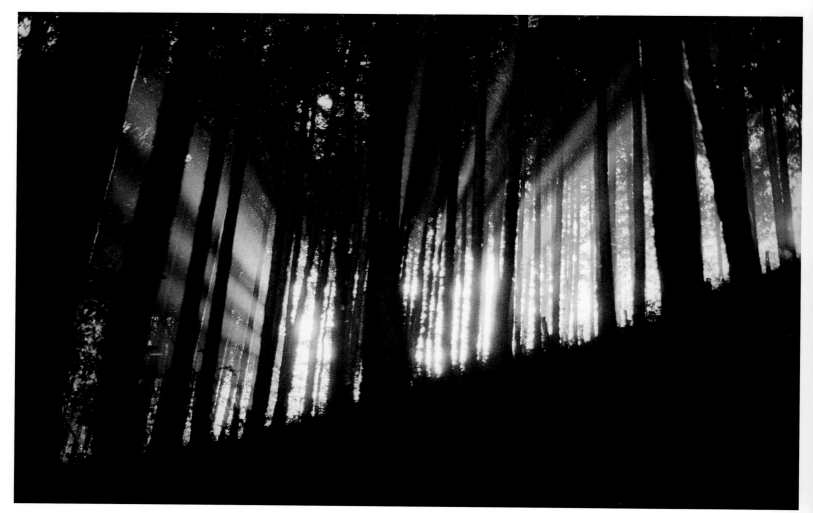

Small mountain, Hatakeda
Hiroyuki Mori

The photograph as document

I am still devoted to the idea of the photograph as a document. Much of photography's power lies in its ability to convince you that what you see in the picture is what was in front of the camera at that moment; the facts of light, so to speak. Removing things, or adding them, or changing their position is something I am not really comfortable with. JC

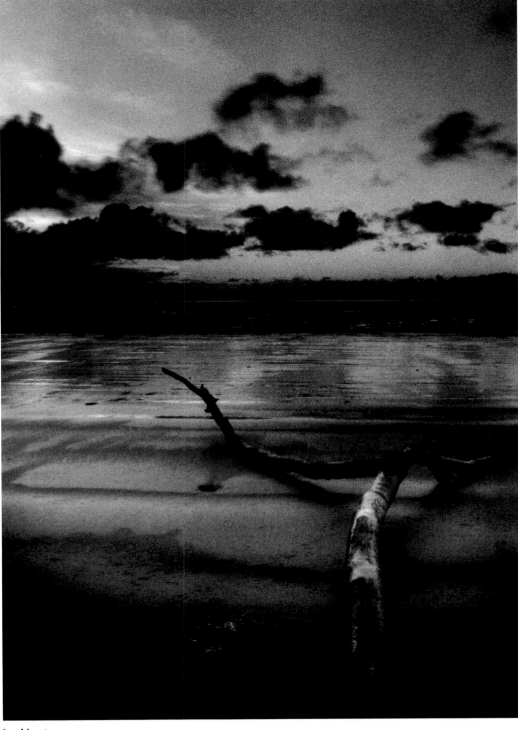

Looking to sea
Eli Pascall-Willis

Recipes for success

We may favour particular environments or habitats, but the essence of good landscape photography cannot be formulated like a recipe. As we enjoy many different types of food, so we can find inspiration in various landscapes. Variety is the spice of life (and landscape photography). JC

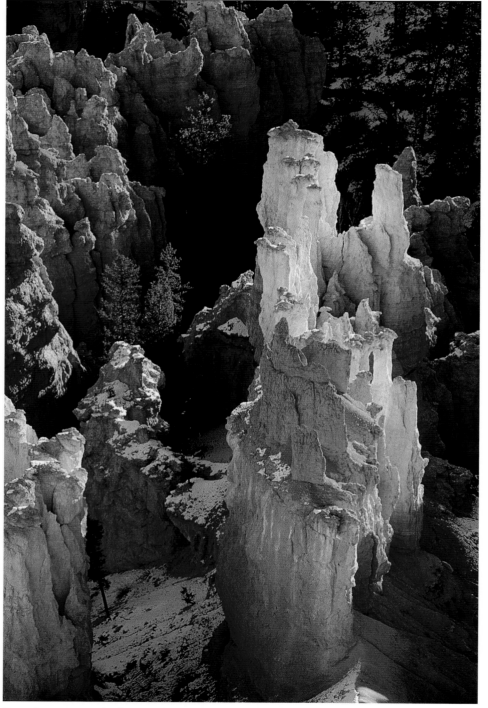

Working with reflectors

Apart from clouds, we can find natural reflectors in the form of canyon walls, and chalk, sandstone or limestone cliffs. These can help provide beautiful modelling light and shadow detail on a much larger scale than most handheld reflectors can, or may become a reflected element in the photograph itself. JC

Bryce Canyon at sunrise from Inspiration Point
David Jackman

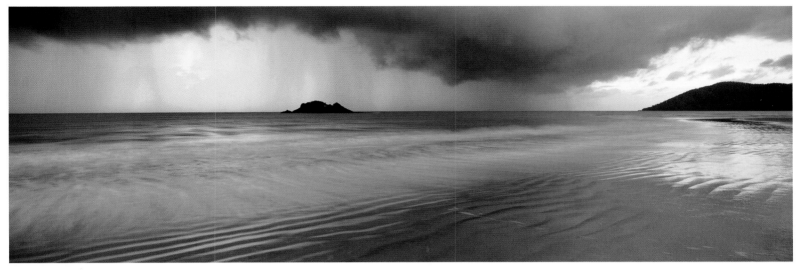

Cape Tribulation
Michael James Brown

Practice, practice, practice

Practice is fundamental to success. It deepens our understanding of the different qualities of light. Without practice, we will never get to grips with light. JC

The eye of the camera

The human eye sees differently to the eye of the camera. The need to tune in to the capabilities, and limitations of the camera, may be the biggest single lesson most aspiring photographers must learn. JC

An invisible approach/technique

For me, the subject matter is the star of the picture, not the photography. I want the photographic technique to become invisible. JC

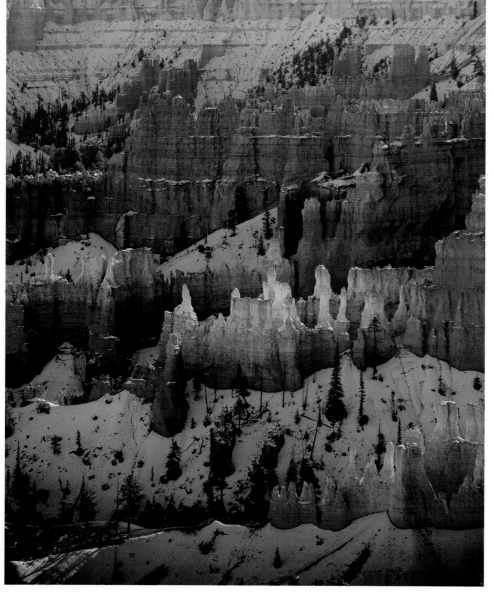

Backlit spires, Bryce Canyon
Roger Longdin

Cold air is clear air

Cold Arctic (or Antarctic) air currents are unable to carry much humidity, dust and haze, and thus produce exceptionally clear air. Such conditions, easily anticipated from weather forecasts, can be wonderful for photographing distant mountainscapes. JC

Light in the glen
Roger Longdin

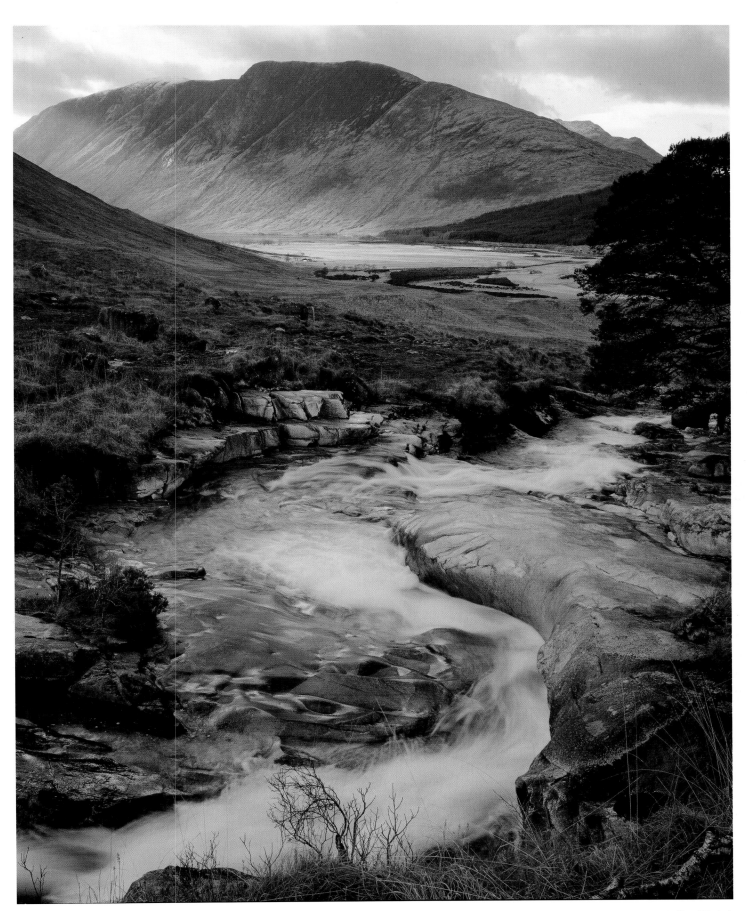

CRITIQUES
Wilderness landscape

 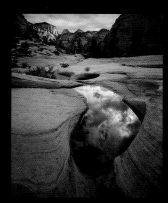 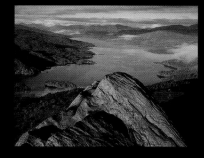

There can be no doubt that like Ansel Adams, one of the greatest talents of this man is to bring us right to his side whilst he makes his images. By some mysterious inexplicable transference, it is possible to truly feel and see all that he did; not necessarily at the moment that he depressed the shutter release but before, after which is a much more profound and grand exchange. The decision to offer us the oval pool along with it's ovular repetition makes it clear that this was the anchor that would fix the foreground. Of course, his immense experience confirmed that this was where he should rest and we with him. The sky and all the relationships blend and just fit beautifully. CW

It was the 'rushing toward me' feel of the sky that was the first thing that arrested me about this image. The cold greyness of the rock and the ice-like water were the second. He has brought the water and sky up to meet one another with the rocks being left to float around their relationship. CW

The sky we cannot see is revealed to us in reflection almost as if we have been granted a privileged view of a secret denied to others. The unseen yet seen sky brings with it a sense of a threatening storm and alarm. I would be intrigued to know whether it was Joe's intention to create such a response. Maybe not, but I hope that he may be happy with it nevertheless. CW

I am unfamiliar with photographing from heights and would normally I would only be able to identify with mountains seen from below which gives them, in my view, extra gravitas. Somehow I am not made dizzy with this image; it does not separate me from known references leaving me unable to cope. It might be the comforting vivid blue that makes me feel no sense of threat. CW

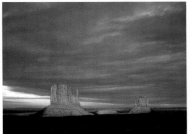

The Mittens
Simon Miles
Page 19

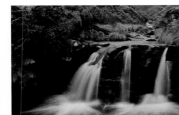

Three waterfalls
Jonathan Horrocks
Page 20

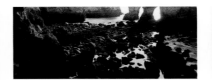

Ponte de Piedade
Peter Karry
Page 21

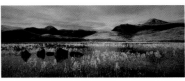

Winter in Glencoe
Richard Santoso
Page 22

A sense of sculpture

CW: *I like this image and, as with all images, when you revisit it there are elements that appear even better than before – and those that don't work quite as well. My only slight criticism is that the light is slamming into the middle of the picture, so there isn't quite as much sense of sculpture or modeling as there could be.* DW: *Yes, in an ideal world side-lighting is usually best.* EE: *Clearly that wasn't available. Instead, I feel contrast has been achieved by the strong red set against the cold blue. Then there is that band of clear sky, sweeping away from the lower left, that gives a lovely flowing sense of depth to the picture.*

Location: Monument Valley, USA.
Camerawork: Ebony 5x4 with 150mm Apo-Sironar, Fuji Velvia 50, 2 seconds, f32, without filtration.
Technique: This was one of those moments when everything fell into place. After a day dominated by thick cloud, there seemed little hope of a decent sunset. At the last moment, however, a gap appeared just over the horizon. I exposed four sheeets of film and a few seconds later, the moment was gone.
Post capture: Basic levels adjustment in Photoshop to achieve correct density for the print.
Inspiration: I was fortunate to be in the right place at the right time to record this image as the wonderful light, perhaps the most theatrical I have ever witnessed, lasted only a few seconds.
Style: I work primarily with medium and large format transparency film to capture images of Southwest England and wild places around the world.
Aspiration: I continually strive to improve my understanding and appreciation of light and the basic elements of composition, such as line, shape colour and tone, which underpin the landscape photographer's art.

Avoiding burnt out highlights

CW: *I'm fascinated by moving water, preoccupied with it. With all the turbulence in this image, technically you have to be careful; there's so much activity here that you could end up with burnt out highlights. The photographer has handled the subject well, getting his metering spot on.*

Jonathan asks: *What tips have you got for taking pictures in the burning midday summer sun?*

EE: *I would follow David's approach and look for inner landscape-type subjects that have a more limited brightness range as they don't take in the extremes of sky and shade.*

Location: Fairbrook, Peak District, England.
Camerawork: Canon EOS 300D 18–125mm Sigma lens, ISO 100, 2 seconds, f22, with a polarizing filter.
Technique: I used a polarizer to try and increase colour saturation though the light wasn't great.
Post capture: Converted from RAW using Capture One LE Velvia Vision in Photoshop.
Inspiration: I wanted to re-visit the location when the heather was in bloom, having enjoyed it on a Light & Land trip. The light was not as good as I hoped but I am pleased with the result and without the light there was I would have got no picture at all.
Style: I'm a scientist and mathematician by trade, so I love this aspect of photography and I'm particularly drawn to strong geometric compostions.
Aspirations: I'm keen to improve my technical understanding to the point it becomes second nature, so all my time can be devoted to getting the composition right.

Dealing with contre-jour lighting

JC: *It's very striking backlight, although I find the juxtaposition of bright highlights and black shadows a little unsettling. In an ideal world, you'd have a gigantic reflector overhead in the form of a big white cloud, that would help reduced contrast.* DW: *He has handled the scene well. Yes, it is burnt out through the arch, but I don't think it is an issue.* CW: *It could be in a large print. Your eye might go to it and this would detract from the more interesting areas.* DW: *Maybe not, because it is the origin of strong diagonal lines. It is part of the design and structure, so it doesn't worry me. Am I the only one to think this?*

Location: Lagos, Algarve, Spain.
Camerawork: Hasselblad XPan, 45mm with centre spot filter, Kodak Elite Xtra Colour 100, 0.7 seconds at f22.
Technique: I drove here to await the sunrise. Then I positioned myself to photograph into the light.
Post capture: None.
Inspiration: This is a spot I visit anytime I go to the Algarve because of the imposing rock structures. On this occasion I used the subtler light of sunrise to bring out the textures of the smaller rocks littering the shore.
Style: Anything that reflects the beauty in the world.
Aspiration: More impact in spatial landscapes.

A question of flare

Richard asks the question: *What is the best way to minimize flare (which is evident in some of my pictures)? I have used some cardboard to block the sun from falling on the lens as much as possible, without it showing in the picture, but couldn't always eliminate the flare completely.*

JC: *90% of the time the best solution is to step as far away from the camera as possible and simply use your head, hand or hat, to cast a shadow just over the lens. Lens shades are generally a waste of time, that is the ones that come with the lens. In this image flare is not an issue.* EE: *I don't have an issue with flare. I see it as a hallmark of photography, like the way a wide-angle lens can distort a scene.*

Location: Glencoe, Scotland.
Camerawork: Hasselblad XPan 2, 45mm lens, Velvia and an ND grad.
Technique: Although the sun stays low throughout the day here in winter, all the shots I took here were either early in the morning or late in the afternoon. When the sun was out, there was usually a very moody sky which sometimes contrasted well with the sunlit foregrounds.
Post capture: none
Inspiration: I love the Scottish Highlands, you can go to the same places and take totally different pictures. On this occasion, the light was low enough to highlight the reeds in the foreground and hills in the background.
Style: Scenery or moody, watery landscapes.
Aspiration: To be able to see a potential image more quickly or, rather, differently. Sometimes I look too much for the stereotypical landscape shots.

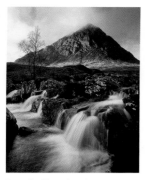

Buachaille Etive Mor
Richards Childs
Page 25

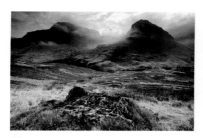

Glencoe
Paul Marsch
Page 26

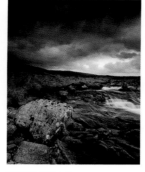

Allt Chailleach
Neil Brayshaw
Page 27

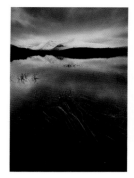

Came the cold
Graham Robinson
Page 28

Interpret the brightness range

Richard says: *For me the most demanding thing is accurately metering light levels and applying the relevant filtration. So, I guess the question here has to be, did I get it right?*

JC: *Here, yes. The key is in interpreting the brightness range one is trying to control. Typically, misinterpreting it is where people go wrong most often. A spot meter is the most reliable way of measuring the range – camera meters are usually not up to the job.* EE: *This image is taken from a portfolio that Richard submitted. I would add that whilst the intention of a portfolio is to unify a set of pictures, it will also highlight any inconsistencies in the photographer's work.*

In-camera or post capture?

Paul asks: *Is it better to use in-camera or post-capture techniques to balance the light?*

JC: *When we ask a question like this we often already know the answer which best suits our style of work! The truth is, it depends on how you work and what your skills are in each different area, if you know how to use blending in Photoshop, there are times when it is great option. But to say that one approach is better than another…well, it's a question of workflow. I'm used to getting it right in-camera.*

A question of viewpoint

DW: *All the elements are there: stunning light in the sky, stormy clouds, the boulder on the left and flowing water to the right. It would have been worth changing camera position, to include more of the water, but I suspect Neil didn't have long to shoot the picture. As an alternative viewpoint, he could have waded into the shallows and concentrated on the relationship between the water and the sky.*

Balance affects mood

Graham asks: *Could the balance of the picture be changed in any way to enhance the mood?*

DW: *I think the composition is great. It all supports the mood which is cold and powerful. The only problem for me are the little tufts on the extreme left, where they kiss the left hand edge. The contact is a little distracting.* JC: *Yes, my suggestion is to crop a small part of the left edge.* CW: *It cleanses the picture.* EE: *What is the effect of cropping that left hand edge?* JC: *The picture becomes contained and in its own world. Without it the eye can't circulate around the frame.* CW: *It is interesting how the smallest of interruptions affect one's pleasure in a picture.*

Location: Glencoe, Scotland.
Camerawork: Ebony 45SU, 90mm lens, Fuji Velvia 50 rated at ISO 40, f16, Lee 0.6 ND grad and 81a filter.
Inspiration: Having moved to Scotland in 2004 I have found myself blessed to live in one of the world's wettest places. With nearly a trillion gallons of rain each year, and living in close proximity to the sea, it is inevitable that much of my work would be informed by this element. Although I now make my living from my photographs I am still relatively new to the art and enjoy the many challenges that large format photography has imposed.
Style: Photography came about as an extension of my interest in wild places and plants. These remain my favourite subjects to photograph but landscapes in changeable conditions have to be number one.
Aspiration: The area I would most like to improve is in metering correctly and not making calculation errors that ultimately leave me applying the wrong neutral density filter. I spend much time agonizing over this and, although I am improving, there is nothing worse than the disappointment of seeing a transparency returned when I've got it wrong.

Location: Glencoe, Scotland.
Camerawork: DSLR EOS 350D with 10–22mm lens, 1/60 second, f16, with a 3 stop ND grad.
Technique: This was a difficult picture, the sun between the Two Sisters was very bright and the grad filter has darkened the mountain tops.
Post capture: Mild curves and saturation in Photoshop. Foreground detail was lifted via a blend of two exposures.
Inspiration: Strong light behind the peaks and similarity between foreground rock and second sister.
Style: Landscape, big vista.
Aspiration: To improve my compostion.

Location: Rannoch Moor, Scotland.
Camerawork: Ebony RSW 5x4, Schneider 90mm lens and Velvia 50, rated at ISO 40, 2 seconds, f22, with a 0.6 ND hard grad.
Technique: The sky was darkened using a 2 stop ND grad, to balance it with the darker foreground rock, but mainly to reveal the dark and brooding nature of Rannoch Moor on a bleak and wet November day.
Post capture: None.
Inspiration: I was drawn to the bleakness of Rannoch Moor and the passing dark clouds enhanced this mood, but also contrasted well with the beautiful muted clouds of the foreground. The light needed to be dramatic and dark, as bright sunny conditions would not have conveyed the sense of isolation.
Style: I am drawn to wild places that are not overly influenced by man. I seek to show the beauty of those places, generally viewed in warm light to enhance colour contrast.
Aspiration: To work on composition and selecting viewpoints.

Location: Rannoch Moor, Scotland.
Camerawork: Kodak DCS760 6MPX DSLR, 12–24mm zoom at 15mm and ISO 80, 1.6 seconds, f22 and greyish grad.
Technique: Going for dawn light in winter.
Post capture: Photoshop for image cleaning and contrast/density correction, both local and general.
Inspiration: I wanted to place the background against an interesting foreground with flat water between.
Style: My work is very varied, but I particularly enjoy natural history.
Aspiration: To develop my ability to see and portray emotion.

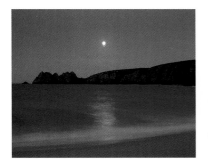

Moonscape
Keith Folly
Page 29

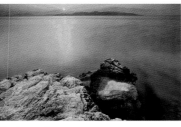

Kouloura 1
Patrick Medd
Page 30

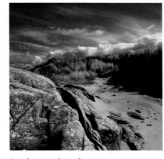

Rock, sand and grass
Julian Barkway
Page 31

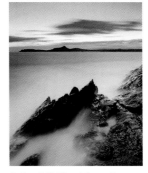

St David's Head from Ramsay island
Rupert Heath
Page 32

Simple lighting, maximum effect

JC: *This is a real statement: Rhapsody in Blue.* CW: *I would like to have seen the moon on a third.* DW: *I don't know. The positioning of the moon makes it for me. I think it needs to be right bang in the middle.* EE: *And the double image of the moon?* JC: *I think it is graduate filter flare. It's not objectionable. I go along with David and think the moon is right where it is.* CW: *What is really nice is the reflection of the moon in the water. It has a lovely, soft quality.*

Keith asks the question: *What time does reciprocity failure kick in with Velvia 100?*

CW: *The manufacturer's data sheets give the best answer. And of course, test, test, test.*

Location: Porthcurno Beach, Cornwall, England.
Camerawork: Mamiya RZ 2, 110mm lens and Veliva 50, 20 seconds, f16, without any filtration.
Technique: I waited for the tide to come in and for the moon to be high enough to reflect off the water.
Post capture: No post camerawork.
Inspiration: I wanted a photograph that would look silky.
Style: My preferred style is landscapes involving water, coastal or inland, but preferably coastal.
Aspiration: To be able to know right away where to take accumulative meter readings from with a spot meter and to transfer these to the camera.

Positioning graduate filters

Patrick says: *The balance of exposure is critical here particular in determining the position of the grey grad. Any tips?*

CW: *It can be hard to see the division between the graduated and ungraduated area. He should use the depth of field preview on his 35mm camera and close the lens down to the working aperture. Then he can evaluate the filter's effect.* JC: *It's not only a question of being able to see it, but when you stop down the position of the graduate changes anyway.* CW: *Yes, the shooting aperture reveals where to put it and what you'll get.*

Location: Corfu, Greece.
Camerawork: 35mm Fujichrome Velvia and a long exposure. ND graduate, 81c and Lee polarizer.
Technique: An ND graduate was used to balance the sea and sky, and the polarizer to cut down reflections nearer the camera, to reveal the undersea formations.
Post capture: The image was scanned into Photoshop, levels adjusted, with local burning and dodging to achieve contrast control.
Inspiration: I am drawn to thee quality of the light at dawn and dusk, and the colours of the Mediterranean sea set against the amazing rock structures of the coast of northern Corfu. The light was critical (as in all landscape photography) to providing atmosphere and generating the best and richest colours in the scene.
Style: I am most inspired by the coastal landscapes of the Mediterranean, although I enjoy all travel landscape photography. When working in colour I like to indulge in beautiful colours of sea and sky. In monochrome I prefer higher contrast, more abstract images.
Aspiration: To improve my anticipation skills. Too many of my photographs are still taken in response to the light rather than in anticipation of it.

Contrasting elements

CW: *Here there are two different types of sky, which always helps to create interest and I love the way the colour of the grass and the texture of the foreground rocks contrasts with the sky.* JC: *Yes, it's very striking. I like the storm weather front, with its dark shadows, it helps the grass to come forward. There's a classic thing in art that warm colours come forward and cooler colours recede, e.g. blue mountains recede with haze.*

Location: Anagarry Strand, Co. Donegal, Ireland.
Camerawork: Mamiya 645 Pro, 35mm lens, Velvia 50, 2 stop ND soft grad and a coral grad.
Technique: This image was made in the often unpromising light of mid-afternoon, but I wanted to do justice to the interesting sky, whilst including characteristic elements of the Donegal coast (rock, sand, grassy dunes). I found a location where I could bring all the elements together in a satisfactory composition. I metered for each part of the scene and, with a graduated filter in place, set an average exposure in order to retain shadow detail. A coral filter was used to compensate for the slightly bluish quality of the mid-afternoon light. Rather than an example of how to best exploit perfect conditions, this image represents an attempt to produce a strong photograph despite harsh and unpromising light.
Post capture: Standard colour-correction adjustments in Photoshop, further lightening of the large shadow area on the right and cropping of an area of bland sky to leave a square composition, which I feel works well.
Inspiration: Here, the interesting cloud-patterns and the texture of the rock.

Post processing work

Rupert says: *You emphasise the importance of getting things right at the time you release the shutter, but how much post processing do you actually do, and how much do you consider acceptable in terms of adjusting contrast and colour if it helps to achieve a result closer to the lighting and mood you experienced, versus what you wanted or were able to capture?*

EE: *This issue has been covered in the Gallery Workshop pages. However, as the main use for photogaphy is in books and magazines, in my experience almost every image needs some treatment in Photoshop to ensure that it best suits the requirements of the printed publication. I've checked every image in this book and had to tweek almost all of them.*

Location: Ramsay island, Pembrokeshire, Wales.
Camerawork: Ebony 45S, 90mm lens, Velvia 50, 2 minutes, f22, 0.9 and 0.3 ND grads.
Technique: A very particular combination of tide, wind weather, sea state and timing was required here, both for the quality of light and for the consequent exposure time that I sought.
Inspiration: I love being out in wild places well before dawn, especially in the hot summer months when the coolness of the early hour is blissful, particularly down on rocks by the sea.
Style: Plants are my great passion, from fungi and dead wood to wild flowers and native trees. I also find myself inexorably drawn to the Atlantic west coast.
Aspiration: Focus and perspective control an large format.

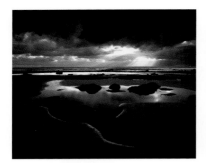

Robin Hood's Bay
Peter Rand
Page 33

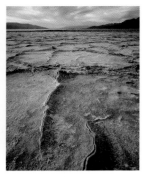

Cracks in salt pan
Despina Kyriacou
Page 34

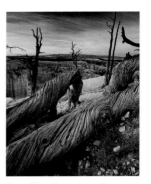

'Fossilized' tree trunks
Despina Kyriacou
Page 35

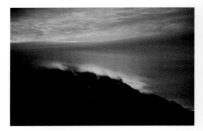

Dents du Midi
Graham Whitwham
Page 36

What is the right amount of filtration?

DW: *What makes this picture is the wonderful splash of sunlight coming through the distant clouds. And the reflection on the sand.* JC: *Yes, it's a beautifully judged composition.* DW: *One could argue that the filtration is a bit heavy on the clouds, yet it still works.* JC: *Yes, but he needed to retain the brightness of the sun rays. I think it's about right.* EE: *If we read Peter's Post capture notes, we'll see that he very cleverly 'cheated' the filtration!*

How contrasty the light?

Despina asks: *Do you think there is enough contrast in the light to lift the image?*

EE: *Despina's inspiration for the picture was to accentuate two of the salt pan cracks (see her Inspiration notes, below). I think the result speaks for itself; the light succeeds in accentuating them. Any more contrast and it wouldn't be the subtle cracks that we would see, rather a couple of overly dark, dominant shadows.*

Surreal of artificial?

Despina asks of Charlie: *There is an eerie quality to the light, do you think the foreground looks slightly surreal? Or does it look slightly artificial?*

CW: *Post execution of an image it is so easy to be slightly contradictory. I would say the light looks ever so slightly artificial, but maybe that is exactly how it was, in which case I take it all back. I do love the relationship between the two upright trees and the foreground double diagonals.* DW: *I know Despina waited for a long time for the sun to go down. The success of this image is absolutely dependent on waiting for the soft light; the afterglow is what makes this picture really work for me.*

How do we judge success?

EE: *The success of a picture can, at least in part, be judged by comparing it to the original intention the photographer had for the image. Here, Graham says the lighting was crucial. He waited for the sun to shine horizontally onto the cloud that was draping the summit. He had a plan and acted on it, but was this enough? Does the picture stir our emotions? Is it the first one we see on this page? Does it need to be printed big or small? These are just a few of the many questions we need to ask ourselves as we are about to press the shutter release. For me, this quiet picture works, but best in isolation, away from the competing attention of adjacent images.*

Location: Robin Hood's bay, Yorkshire.
Camerawork: Toyo 5x4, 90mm lens and Fuji Velvia 50 (rated at ISO40). No filtration.
Techinque: An early start before dawn. When the sun rose it was dull with a heavy, overcast sky. I was on the beach looking for good subjects when I found the rock pools and the sun started to break through and I was fortunate to get this picture.
Post capture: This is a bit of a 'cheat'. I took two exposures, one with the sky perfect but the beach underexposed, the second with the beach perfect but the sky washed out. Both images were scanned and sky/foreground combined. No other post processing was required.
Style: I really want to do landscape but I don't seem to have huge success! I also do portrait and sport with slightly more success.
Aspiration: Some aspects of technique could be improved, but mostly 'seeing' successful pictures is the most important area.

Location: Badwater, Death Valley, USA.
Camerawork: Large format view camera, 90mm lens, Fuji Velvia 100, f22 at 1/4 second, 1.5 stop ND grad filter.
Technique: There was good cloud cover in this late evening shot to give diffused light, but with enough contrast to give the image some depth.
Post capture: Image scanned to make a digital file.
Inspiration: I was interested in the surface textures of the cracks, made by the changing weather on the salt pan. I wanted to accentuate two of these salt pan cracks to attempt to draw the viewer into the landscape. There was enough directional light to highlight these salt pan cracks – enough, I think, to lift the image.
Style: I look at the quality of the light, the way if affects potential subject matter, and compose the image around that, be it a wider view or close-up.

Location: Bryce Point, Utah, USA.
Camerawork: Large format view camera, 90mm lens and Fuji Velvia 100, f22, 1 second exposure, with a 3-stop ND grad filter.
Technique: I waited for the sun to set behind the mountains and hoped to get the light ten to fifteen minutes later. Cloud cover was good and the afterglow lit the cloud and foreground tree trunks.
Post capture: Image scanned to make a digital file.
Inspiration: I was drawn to the 'fossilized' tree trunks, carefully composed the image and waited. I took a risk as I did not know how the afterglow would affect the subject matter within my image. It seemed to distribute itself along the sky area and lightly along the tree trunks. To this extent the light worked well for the image.
Style: I like to interpret the landscape, finding existing properties within it and discovering their beauty.
Aspiration: Always to improve on technique, where possible, in difficult lighting situations.

Location: Dents du Midi, French-Swiss Border, above The Rhone Valley.
Camerawork: Leica RE 35mm, 180mm lens, Fuji Velvia 100, aperture priority mode and no filtration.
Technique: I waited for the setting sun to shine horizontally onto the small cloud which was draping the summit of the mountain.
Post capture: None.
Inspiration: An unusual cloud wreathed over the summit crags struck by fleeting rays of the setting sun breaking through a small gap in an overcast sky. The lighting was crucial.

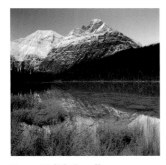

Mount Edith Cavell
Gert ten Dolle
Page 37

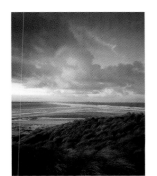

Budle Bay
Richard Holroyd
Page 39

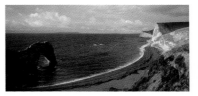

Sunrise in Dorset
Adam Pierzchala
Page 40

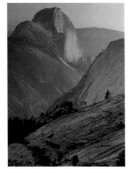

Yosemite
Chris Andrews
Page 41

Dealing with reflections

DW: *Gert has captured a fleeting moment of warm light just grazing the mountain. We get a real sense of size and majesty and he has organized a simple foreground that works well.* JC: *All the elements are correct. Everything is nicely balanced.* CW: *The side lighting has conveyed the serrated nature of the mountain quite beautifully.*

Gert asks: *How bad is it if the reflection of a mountain is brighter than the mountain itself?*

EE: *I can think of at least two Ansel Adams mountain/lake pictures in which the reflection is considerably brighter. We don't notice this because there are other more powerful elements within both those images.*

Defying intellectualisation

CW: *There are lovely flecks of pink distributed throughout the grass, giving a feeling of cats fur that is so fantastic. I love the relationship between the sky and foreground grass. This picture is so enjoyable to look at that it almost defies efforts to intellectualize it. It's wholly satisfying. It has a lovely painterly quality. It is not dramatic and yet it is hugely so. The water takes us off to the horizon and the lovely wash of natural pink. It looks as if there hasn't been much filtration, a tiny bit of grad perhaps. I don't want to say anymore other than lovely – and can I have a copy?!*

Natural or enhanced colours?

JC: *Adam says he used a warm up filter. If the colour of the scene is already naturally warm, I would always ask the question 'why?' In this case the filter has also killed off the blue of the sky.* EE: *Yes, this raises the question, does colour photography always have to try to look natural? Isn't colour filtration a personal choice, just as it is in B&W photography? The premise of filtration is that we use it create an image that is in harmony with our idea of how we want the picture to look – which may be warm or cool – rather than how others wish it to be.*

A musical quality

JC: *If Ansel Adams had been a colour photographer he would have shot this. It has a soaring, almost Wagnerian quality. There's not much more to add.* CW: *The very bottom left is out of focus, but who cares. One could argue that it's a bit tight on the top; some more sky might have helped – perhaps not. I like that you don't see the source of the light. It is a marvellous picture.* DW: *Yes, I particularly like the compressed perspective as well.*

Location: Jasper National Park, Mount Edith Cavell and Cavell Lake, USA
Camerawork: Rollei 6008 I2, 80mm lens and Fuji Velvia, f22, the shutter speed was not recorded, and a 0.6 ND grad.
Technique: It was a beautiful morning and it had frozen that night. The sky was very clear and to balance the brightness of the snow with the surroundings I used an 0.6 ND grad.
Post camera: None.
Inspiration: The day before we had been to this location and although it was cloudy at the time it looked wonderful. We returned the next morning for sunrise. The warm sunlight on the snowy mountain, together with the frosty grass created wonderful contrast.
Style: I like the great views of mountains and landscapes in general, but also like to look for smaller details and do macro work.
Aspiration: Seeing the possibility of a (great) picture and knowing what to do, when I do. At present I'm struggling, sometimes because I don't see it. Creativity is not my strongest point. Furthermore I want to improve my compositions, especially now that I have moved up to the square 6x6 format.

Location: Budle Bay, Northumberland., England.
Camerawork: Ebony SU, 90mm, Fuji Velvia 50, f22,1 second, 0.6 ND grad and 81B filter.
Technique: I waited for one hour for the sun to begin to emerge from the clouds.
Post capture: I scanned the image and adjusted it in levels.
Inspiration: The richness of the texture of the marram grass and the movement of it against the rest of the scene.

Location: Man of War, near Durdle Dor, Dorset, England.
Camerawork: 35mm Elitechrome EBX, 28–105mm lens, Coral 3 or 81B grad filter and ND 0.6 grad.
Technique: Balancing the sky with the foreground, and using filtration to boost the colour.
Post capture: Minor curves and histogram adjustments in Photoshop, to correct the scan.
Inspiration: Fantastic dawn and sunrise colours progressing from fiery red to golden yellow.
Style: Nature (close-ups), insects and flowers, landscapes and travel
Aspiration: Adding more emotion and passion into my images.

Location: Ormstead Point, Yosemite National Park looking across to Half Dome, USA.
Camerawork: Pentax MZ–5 35mm film camera, Sigma 70–300mm f4-5.6 lens set to 300mm, Fuji Velvia 50 film rated at ISO 40, f16, exposure taken from general reading, shutter speed not recorded and no filtration.
Technique: I waited until the sun picked out the side of Half Dome, leaving the foreground in shadow. The granite in the valley picked up the surrounding reflected colours.
Post capture: Scanned with a Canon 8400F scanner and adjusted with levels in Photoshop Elements to match the original.
Inspiration: Half Dome is an iconic mountain. The view from Ormstead Point and the scale of the landscape is awe-inspiring. The single tree on the middle slope helps to balance the picture.
Style: I find that the discipline of looking and appreciating how a particular landscape makes me feel helps transform me from a tourist to a traveller.
Aspiration: My biggest concern is falling into the trap of photographic clichés. The challenge is to create images that mean something to me rather than making images for photography's sake.

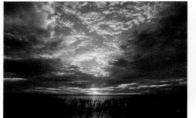

Moanachira river
Benjamin F Bailar
Page 42

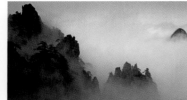

Haungshan
Paul Ng
Page 43

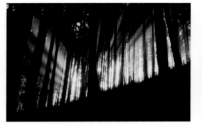

Small mountain, Hatakeda
Hiroyuki Mori
Page 44

Looking to sea
Eli Pascall-Willis
Page 45

The right time to use a polarizer

Benjamin asks: *Would a polarizer (not in my bag at the time) have helped or hurt this picture?*

CW: *It wouldn't have done anything to the sky, because we are looking straight at the sun. But it might have reduced reflections on the water.* DW: *But the reflections are a key part of the picture.* EE: *He also says that he had a go at photographing the scene with a shorter focal length lens, but it reduced the elements of the image to such a small size that the ripples in the foreground were lost.* CW: *Conversely, if he had used a longer and therefore slower lens, he might not have had sharpness in the reeds.*

A question of cloud cover

Paul asks: *How can I capture detail in a scene which is partly obscured by a layer of cloud?*

EE: *Good question! I would say that Paul has alluded to the answer, below, when he says 'The right moment lasted only a few seconds….'. In other words, he is saying that much of landscape photography is a waiting game, being patient, anticipating those fleeting moments of sunlight or being poised for when the clouds momentarily part. Had Paul taken his picture any earlier or later, it would not have worked.*

Using positive and negative spaces

EE: *This kind of bold subject is perfect for black and white photographers like me. The picture is made up of opposing diagonals (the line of the hill versus the rays of sunlight) and strong verticals. As I look at the image, I ask myself, am I looking at the black forms of the trees and the hill, or the bright rays of sunlight? It's like a lesson in drawing, learning to see and work with positive and negative spaces – a lesson we can apply to our photography. My eye keeps switching between the dark and light spaces, holding my attention – a hallmark of success.*

Creating a visual narrative

EE: *Too often we focus our attention on the moment, rather than working out a visual structure in which the event can sit. Here a composition has been beautifully created, in which the line of the branch has been used to point us to that moment when the clouds parted, to reveal the last of the daylight. For this picture to work, it must be printed so the bright focal point retains detail, otherwise the photographer would be inviting us to look at a blank space (not what she experienced) and there our interest in the subject would abruptly end. To add interest, and to balance the bright focal point, there is a nice highlight running along the tree – imagine the picture without it.*

Location: Moanachira River, Botswana.
Camerawork: Canon IDS, 24mm lens, RAW, 1/320th second at f9.
Technique: The stillness of the river, combined with the dramatic clouds, created the mood I wanted in this picture. The reeds nicely break up the reflection of the sun.
Post capture: Photoshop CS2.
Inspiration: The use of a wide-angled lens included the upper, blue and white tones of the sky, avoiding the solid red of many sunset photographs. I also photographed this scene with an even shorter focal length lens, but that reduced the elements of the image to such a small size that the sense of the ripples in the centre foreground and the highlights behind the reeds on the right were lost.
Style: Landscapes with minimal manipulation.
Aspiration: To improve my ability to visualize and compose photographs – nothing technical.

Location: Huangshan, Anhui Province, People's Republic of China.
Camerawork: D70s, 35–70mm at 35mm (52mm in digital), f22, 1/320th second, with no filtration.
Technique: Using the ambient light.
Post capture: Photoshop 3 (auto/smart fix) and tighter cropping.
Inspiration: The clouds were in a constant state of flux. The little peak on the right balances the shot and the relatively oblique, mid-morning light did not burn out the cloud detail (which was crucial). The right moment lasted only a few seconds before the clouds dispersed.
Style: Landscape, cityscape and underwater photography.
Aspiration: To meter accurately in manual mode.

Location: A small mountain in Hatakeda, Bizen-shi, Okayama-ken, Japan.
Camerawork: Asahi Pentax Spotmatic, Asahi Pentax–Takumar 50mm f1.8 lens, with Kodak Tri–X 400 film.
Technique: I came to this location in the morning, when I knew the sun would be in the right place to catch the rays of light passing through the evergreens. It took a while to find a position that would give me the least flare. I did this by having a high horizon line and a strategically placed tree, which blocked a lot of that direct light.
Post capture: I made the image darker, and increased the contrast slightly.
Inspiration: I was told about this view by my mother and brother, who had come across it while out on a walk. In this image the subject is the light itself, made to look dramatic by the forest of evergreens. (One can also say that the subject is the forest, and that it appears dramatic due to the light!)

Location: Formby Beach, near Liverpool, England.
Camerawork: Practica BX20, 35mm, 30–70 mm lens, Ilford FP4 rated at ISO 50, f16 at 8 seconds.
Technique: As the light faded I scanned the beach for some foreground interest and set up when I found this branch. A small pocket of light opened up which the branch seemed to point to. My heart raced as I released the cable.
Post capture: Coventional processing and printing, although I processedd the film in D–76 for 7$\frac{1}{2}$ minutes instead of the usual 13 to pull process – this produced very nicely controlled grain.
Inspiration: For nearly two hours I hid in a wood from hail and then a snow storm. I was about to head back to the train, when I turned and saw the clouds parting. I rushed down to the beach with my heart pumping as the clouds parted beautifully. The reflections play a crucial part in creating a sense of depth.
Aspiration: To work in colour, being able to capture exactly what's there.

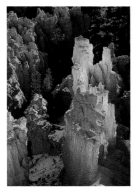

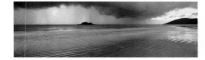

Cape Tribulation
Michael James Brown
Page 47

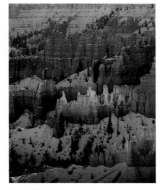

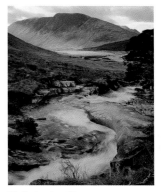

Bryce Canyon at sunrise
David Jackman
Page 46

Backlit Spires
Roger Longdin
Page 48

Light in the Glen
Roger Longdin
Page 49

Matching focal length to the subject

CW: *There is a wonderful apparent inner glow emerging from this canyon and the central spire has been cleverly pronounced by setting it against the blue/black darkish background. I feel a very slight sense of deprivation as to what lies outside the frame and wonder if the focal length could have bee fractionally wider which would have allowed a less mean clipping of the rocks at the back.* JC: *This composition successfully manages the high contrast of the subject. The sunlit spires emerge dramatically from the shadows of the canyon floor, and the snow in the shadows helps increase the sense of depth.* DW: *One has to recognise that the real world doesn't always handily conform to the lenses we have available – nor allow us to alter the distance from our subject to achieve perfection!*

Location: Bryce Canyon, from Inspiration Point, Utah, USA
Camerawork: Contax 167MT, Contax 85mm f1.4 lens, Fuji Velvia 50, f16 with an unrecorded exposure.
Technique: The light was such that I let the camera decide – there were no appreciable contrast problems
Post capture: Very litttle work.
Inspiration: Superb light in a wonderfully natural setting.
Style: I like recording the light and landscape that is available to me.
Aspiration: To be selective – particularly when there is such scope, as in this situation.

Capturing natural phenomena

JC: *This is a fantastic, wonderful phenomenon. How great to have witnessed it and Michael's picture conveys the event beautifully.* DW:*Yes, I particulalry like the manner in which the cloud rises like the headland and the way the wave leads our eye along to that point.* CW: *The cloud in the centre has a wonderful, descending feel. One doesn't often see rain so clearly and powerfully conveyed.* JC: *Holding the shadow detail has really helped to give the picture a lovely sense of place.*

Location: Thornton beach, Daintree National Park, North Queensland, Australia.
Camerawork: Fuji GX617, 90mm lens, Fuji Velvia 50, 1second at f22.
Technique: I used a 1 stop ND grad and tilted it to the right (difficult on my camera with the protection bars on the lens).
Post capture: Colour and exposure matched to transparency in Photoshop.
Inspiration: It had been raining and I decided to trek out onto the beach through the bush track; the adrenalin was pumping because this is a very active area for crocodiles. I was mesmerzied by the contours of the dark cloud almost mimicking the contour of the land below and loved the difference in light, from dark sand, to light sky and then to dark cloud.
Style: All of my work currently is in the panoramic 3:1 format, which requires a great deal of compositional thought. A poorly composed panoramic image becomes very boring if the right balance of foreground interest, leading lines, general subject content, and light aren't brought together correctly.
Aspiration: I would love to improve my ability to read low light and then couple this with a greater understanding of my chosen film's ability to record accurately what I have seen.

Mystery and magic

CW: *Bands of red serrated rock with subdued soft light assists in making the lit rock more effective. The blue of the snow is an excellent foil for the red and it was fortunate that there was only a scattering of snow on the rock as if there had been, the impact of the image might have been diminished.* JC: *Using a long lens, Roger has filled the canvas of his image with detail and subtle colours. Those unfamiliar with Bryce Canyon might initially find this image mysterious yet beautiful. I know the place, yet still feel the picture has a mystery and a magic to it. The dark red of the rock and the light blue of the snow covered slopes make a wonderful juxtaposition. And the soft sunlight on the pink formations in the middle is perfect.*

Location: Bryce Canyon, Utah.
Camerawork: Linhof Technicarden 5x4, Fuji Velvia 50, exposed at ISO40.
Technique: The majority of the scene was in shadow, with just the spires picking up the last of the light. I exposed the shot according to the spires.
Post capture: Printed on Cibachrome.
Inspiration: I love the way the spires seem to glow and the colour contrast of the pink and blue.

Simple designs, complex contents

JC: *What a wonderful image, it conveys the essentials of the Scottish landscape – rugged mountains, running water, fleeting light. The composition is simple to understand, well balanced, full of echoes and curving rhythm. Yet there is masses of complex detail. Pictures within the picture.* CW: *Many landscape images invite the viewer to wander through often gentle foregrounds and middle distances before finally delivering them to a strong hulk of mountain or hill beyond. This image offers a delightful series of curves and slopes all happily fitting snugly within one another.*

Location: Glen Etive, Scotland.
Camerawork: Linhof Technicarden 5x4, Fuji Velvia 50 at ISO 40.
Technique: Waited for the glen to be lit and the rock reflections in the foreground
Post capture: Printed on Cibachrome.
Inspiration: The lovely curve of the foreground rock helps to lead the eye through the entire image.
Style: Any type of landscape where morning or evening light enhances the essence of the image. Also detail shots in soft light.
Aspiration: Being proficient at Cibachrome printing.

INHABITED LANDSCAPES
Charlie Waite

The Jura, France – a revelation in working the light

After many hours of heavy rain during the night, I awoke with an awareness that I would be present at that thrilling moment where the weather system changes character. The dense, vapour-heavy atmosphere would be replaced by lighter air and clearing skies. As the early light of dawn gently increased, I took an unfamiliar minor road. One sharp corner later, I was offered this heavenly gift of an image. My valley was bathed in diffused, celestial amber sunlight, giving the impression that the light was radiating from somewhere deep within. For one memorable moment, my outlook was ablaze with golden warmth. It felt at the time as if it was a performance for me and me alone. CW

> *Digital methods offer us a plethora of techniques for manipulating images, but my preference, and I believe the preference of my esteemed colleagues, is to achieve the image in-camera.*

Charlie Waite

From Win Green, Dorset

I have been photographing here for over thirty years and still the much sought-after image eludes me; in this case because I arrived too late. The design is as I would have wished it but the ideal light had brushed this scoop of land some half hour earlier, while I was still on my way. While I was happy that the far distance had been dropped into shadow by compliant clouds, more than half of the foreground land is in shadow due to a rapidly sinking sun. I would have preferred to arrange for the serrated shadows that march across the landscape to have terminated nearer to the left of the frame. I should have heeded the quiet voice which had urged me to set off earlier.

FOR THE FIRST TWELVE YEARS of my professional life I worked as an actor, mostly on the stage but also a little television and film. I was always fascinated by stage lighting and felt that lighting designers were the unsung heroes of the theatre. I often had a good deal of 'resting' time between jobs and I used it to travel to the West Country with a 35mm camera that my father had given me the money to buy. In those early days, it was very much a case of simply driving around the lanes of Devon, Somerset and Dorset in my beat-up old VW Beatle and responding to valleys, hills and rivers in a very innocent way. I had no great ideas about composition or design and just made photographs that seemed to look 'OK'. I do remember that I often liked to photograph after the rain had passed, which is still the case today.

I HAVE BEEN WORKING with professional and amateur landscape photographers for very many years and derive continued pleasure from doing so. I once thought that there could not be very many people like me – people who were often prepared to devote much time to making an image. But since starting Light & Land with Sue Bishop, the distinguished flower photographer, I have come into contact with many hundreds of lovers of landscape photography and see them all as kindred spirits. Regrettably, many folk now feel themselves cut off from the natural world and I like to think that, through our landscape photography, both my eminent colleagues and those who I meet on Light & Land tours can serve as evangelists for an alternative and deeper way of appreciating the landscape. I am also passionate in my desire for people to 'revisit' the camera and see it as it should be seen – a hugely creative tool which allows everyone an opportunity to express themselves artistically and which provides a means of drawing us closer to the essence of the world around us.

I HAVE HIGH HOPES that this book will not only inspire the contributors to continue to make fine images but will also stimulate those who have not yet discovered that a lifetime's worth of wonderfully rewarding experiences awaits them within that relatively simple and humble tool, the camera.

The Somme, France

After five days of despondency the moment finally came when all the columns within the nave of this cathedral were lit as I had hoped. On each of those days, light had visited me at this scene but not enough to provide sufficient coverage and too diffuse in quality. What I needed was a precise and surgically accurate delivery of light to prevent the back hill being lit, which would have dragged the eye onward and out through the back of the image. A light breeze was needed to co-ordinate with the light. To have made the picture with any of the other lighting scenarios would have involved making a compromise; a word I do not care for yet often have to accept when making images.

It will always be Ansel Adams, the meticulous and consummate art technician, who impresses me most. Clearing Winter Storm and Mount McKinley never fail to take my breath away.

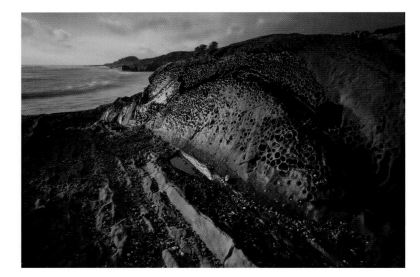

Big Sur, California

Despite having had to cope with numerous difficulties while making this image, I still enjoy it; yet the pleasure is tempered by the knowledge of what could have been. I would have wished for a wider lens which would have allowed me to get higher and so revealed more of the distant hill, this error has resulted in the sense of depth becoming diminished. The last light was almost ebbing away as the shutter was depressed and I regret the deep, dense shadow on the far right. If there was to be a shadow lacking in detail then it should have been created by intention and not misfortune. As it turned out, the 81C filter exaggerated the warmth excessively. I should have been confident enough to assume that the last three minutes of sunlight would provide ample warmth. The burnished glow toward the end of the honeycombed rock gives pleasure, nevertheless.

I AM ALWAYS DRAWN BY SCENERY that has resulted from human interaction with the land. I take great pleasure in observing and photographing the precise and immaculate patterns created by the ploughman's unintentional artistry or the undulating rhythm of a dry stone wall climbing and dipping over the contours of a Lakeland fell.

I have worked a great deal in France, Italy and Spain and have become very fond of the rural way of life in these countries where there are still smallholdings that provide enough for a family's needs with a little left over to take to market. This is a way of life that has virtually vanished from Britain. I am certainly captivated by the idea of working with the land and by the magical process of growing food. I am aware that this is a romantic attraction that might well not survive too much practical experience of the hard labour involved, but in the meantime I still find myself exclaiming in wonder at the sight of a big, fat, multi-layered leek with its white root tentacles still intact.

I remember the first time I saw a crofter's cottage in Sutherland at the northern tip of Scotland and thought how it seemed to have emerged organically from its surroundings and pondered on the harsh lives that folk endured in days not so long ago. I enjoy some architectural settings, the use of local stone and an English country park where time and artifice have combined to mould the scene. My photography often flourishes in a pastoral setting where previous generations have introduced order and laid out a landscape for me.

MY MOTHER WOULD ALWAYS ENCOURAGE me to visit art galleries to see how painters worked with light. I became particularly fond of the impressionists, marveling at the ingenuity and skill which enabled them to flood their pictures with light. There was a time when I would just look 'at' a painting without examining the more subtle nuances within the work. I remember going to see an exhibition of paintings by Claude Lorraine, the French landscape artist. He was much more

at home with landscape than with figures and would often employ others to paint in the people in his figures in his semi-mythological works. I was struck by way in which he used his mastery of light to convey depth.

Years ago, I read a beautifully poignant book called *The Initials in the Heart* which introduced me to the work of the glass engraver, Laurence Whistler. Here was a man who could craft beaded light onto a glass with his fine engraving technique. Another, perhaps the most important, image that made a lasting impression on me was *Grand Central Station in 1934* by a photographer called Hal Morey – curiously not a landscape; also, the first very theatrical images of steam trains by Winston Link.

IS THERE A PARTICULAR IMAGE I've made that marked a seminal moment in my understanding of light? I am sure that it was the vision of *St Claude Valfin* with its golden cloak of light which I saw one Sunday morning many years ago. I know that I experienced this overwhelmingly beautiful moment because I have the image: but if I had not then I might well believe it to have been a dream.

That moment is as alive for me today as it was all those years ago and at the time, strangely, it had little to do with photography. Certainly, I made the image, but I could barely drag myself away from this towering emotional experience. It is hard to intellectualize about this photograph as it seems to me to be beyond explanation. All I know is that this was landscape photography at its very, very best. Would that I could be transported to the place and time once more. I know, too, that I am not guilty of embellishing the awe and joy that this scene gave me. It is all too easy to become romantic and obsessional about certain memories, but this memory is embedded into my very being and each time I look at the image I am propelled back to that truly heavenly moment.

Lake Titicaca, Bolivia

In a sense this image could be thought of as being diabolically unlikely. The juxtaposition of sapphire-coloured water and sky and the sail of the small boat, all perfectly matching in hue, might have seemed too much to hope for. Again, a day's worth of rain had preceded the moment when I stood on an old school desk to make this image. The clarity beyond the lake had revealed the mountain peaks and the relatively directional nature of the light gave a sliver of shadow to the sail and some much needed relief to the thatched boathouse.

THERE ARE TIMES when the light is so subdued that it appears to play no part in the making of an image although, of course, this is an absurd notion. Some time ago, I made a photograph of an old mill near Besancon in south-western France. There was a mist that seemed impenetrable. Gradually, over time, it became less dense and light seemed to grow from the centre of the image, like a revelation. I recall regarding this soft and gloomy light as 'bad' and of no use to me, little imagining that I would enjoy the image of the old mill for many years.

There are other times when light and its direction and quality dominates an image forcefully. These moments are often planned and wished for, though many times one's hopes are dashed by a rogue cloud that obstinately sits in front of a setting sun and only draws to one side when it is too late. I, like my contemporaries, am emotionally drawn to warmth. Most landscape photographers are long for a warm, amber light which, of course, usually materializes either early or late in the day.

LANDSCAPE PAINTERS HAVE CONTROL of the light within the confines of their canvas and can direct it as their hugely acute imaginations dictate. A specular highlight that glints from a surface can be managed and its course traced through the painting as it bounces from surface to surface, perhaps finally coming to rest on a face or the hull of a boat. This freedom is denied the landscape photographer as, up to a point, we have to receive what is on offer and can only partially manipulate the light according to further our purposes.

And, of course, it must be acknowledged that it is not always light alone that dictates the success or failure of an image. Form, balance and the juxtaposition of shapes may often lead the way with light playing, in a sense, a subordinate role.

WHEN WORKING WITH STUDENTS of landscape photography, I have found that the best way to proceed is to discuss the most subtle aspects of the prevailing light, looking at a variety of surfaces and observing the way in which they reflect or absorb it. I always find it helpful to talk about this 'borrowed' light and to point out the way in which shadows can be conveniently filled in by the reflected light from, say, an opposing pale-coloured wall. I am always keen that we should all be familiar with the way in which light can be delivered to a particular point within the scene; a compliant cloud will often do that job for us.

I urge students of photography to visit as many galleries as possible, to look at as many paintings as possible and to expand their understanding of light and its behaviour.

When we look at a landscape, it may well be that we do not fully 'see' it and take it in. I often emphasize this point by suggesting that we turn our backs to the landscape that is to be photographed and, without giving my students a chance of sneaking a quick look round, ask them to describe what they have been looking at. Photographic 'seeing' must be an in-depth process and the more understanding we have of the ways in which light can behave, the more we will learn.

Monte San Savino, Tuscany, Italy

In terms of design and story, I felt that this image had what it takes to work. It has failed chiefly because of light. It seems to me that the bottom half effectively provides modeling and thus conveys depth, but, in contrast, the remainder is lifeless and flat. I had returned three times in pursuit of a livelier sky and more shadow areas directly beneath the house. I would have preferred it if the distant hill had not been lit and if the dwelling and its accompanying cypress tress had been set off against this darker background; I would also have been delighted if both trees and house could have fitted in neatly beneath the horizon. Sadly, the sky remained a darkish grey. Some high cirrus lit by a pink setting sun would have related well to the shadows. Another time perhaps.

Sluga Pass, Italy

On our human timescale, rocks speak to us of permanence. But they are, of course, anything but permanent on the grand scale of geological time in which continents collide in what we perceive to be infinitely slow motion and igneous rocks are thrust upwards by cataclysmic heat and pressure bursting through the sedimentary rocks above. I had wanted some strong directional lighting to set off the fractured foreground rock and to illuminate the twin summits in the distance. A much needed shadow was cast onto the lower slopes, providing the contrast between front and middle distance of the image. It seems to me the hard shadows on the splinters of the foreground rock play an important role.

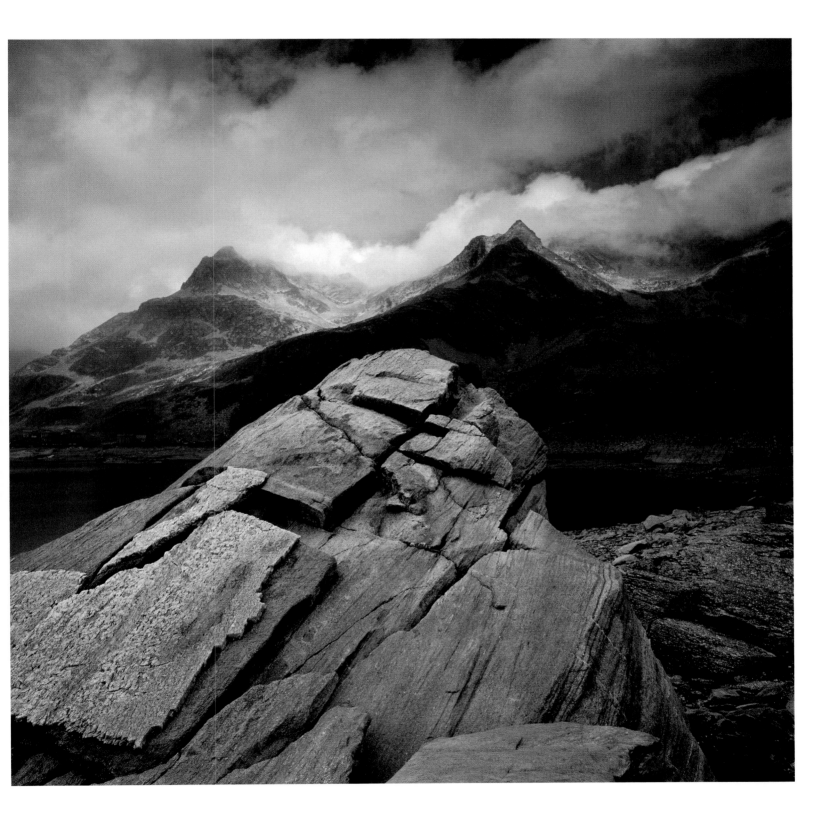

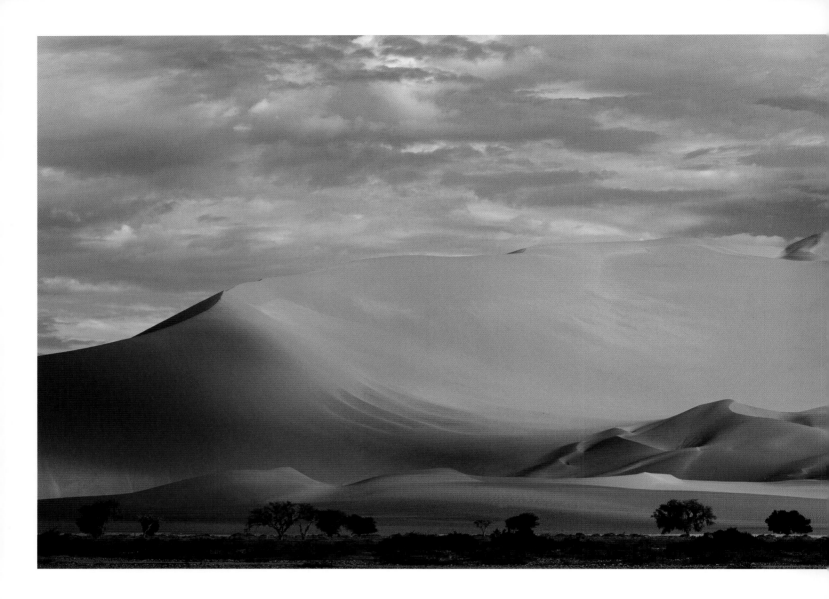

Sossusvlei, Namibia

It would be easy to distrust the redness in this image, but not when you consider the effect of the first rays of sunlight, inherently red in quality, slamming onto the red, iron-oxide sand dunes – essentially red light falling onto a red surface. As is often the case, the capricious nature of light keeps the landscape photographer alert to new and possibly favourable situations, and also to the possibility that lighting conditions that were expected and hoped for will fail to materialise. Thankfully, there was just sufficient modeling on the dune to provide a sense of shape and depth. Also, the line of trees at the base of the image received little or no direct sunlight, further helping to give a sense of depth.

Steptoe Bute, Washington State, USA

I continue to enjoy this image for its rhythm and tossing, sea-like feel. An early rise ensured that the first ten minutes of hard sunlight did its job in leaving puddles of shadow scattered throughout this bucolic scene. The intention, though, was to maintain the continuity of smooth lumpiness throughout. There are small patches of rough ground which conflict with the overall velvety feel and ideally these areas should have been left unlit thereby making them less conspicuous. Clear skies on that morning played a crucial part in making the pattern cohesive and understandable. There is another issue unrelated to light or the lack of it. The sudden veering off to the right of the dividing line that is evident down through the centre of the image; it should not have done that.

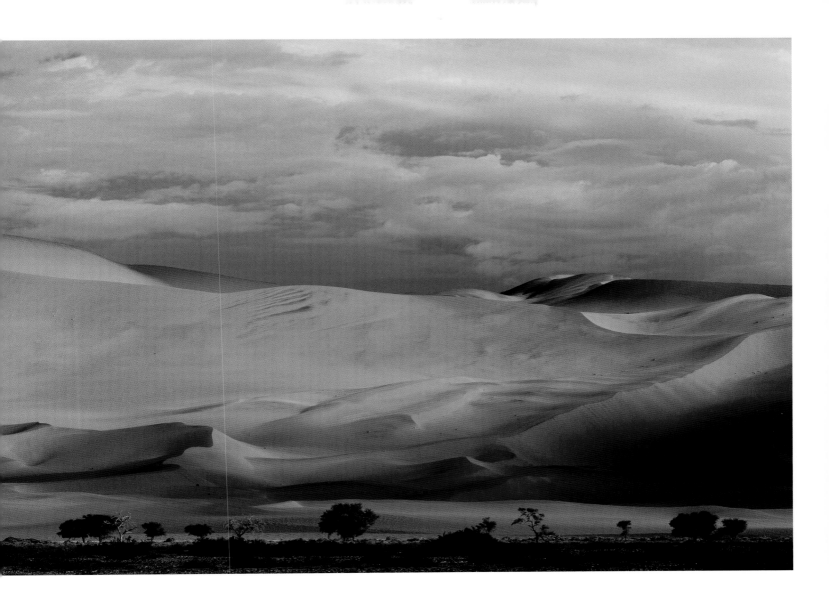

My top five tips for working the light

1. Without a camera, look at the way in which light interacts with different surfaces. Perhaps set up a simple table-top still life where it is possible to move the light source from one position to another.

2. Become obsessive about light and take every opportunity to observe its behaviour in conjunction with every conceivable surface.

3. Set aside a special time for your photography and make images of a landscape setting in different lighting situations. Study and analyse your results. Define as best you can why the lighting does not seem to have been successful.

4. Make repeated visits to a favoured location and work tenaciously to produce an image that matches your previsualized ideal.

5. Tolerate as few compromises as possible and, when they are unavoidable, be aware of what they were, why they were allowed and where they have sullied the image.

GALLERY WORKSHOP
Inhabited Landscapes

Understanding light

It takes considerable practice to understand how light falls upon a subject and how that light is reflected and absorbed by surfaces. Mastering light does not mean that we can expect to control it, rather that we learn to work with it and utilize it to our best advantage. Light and its distribution throughout the scene is to be fully evaluated. Keep vigilant always. CW

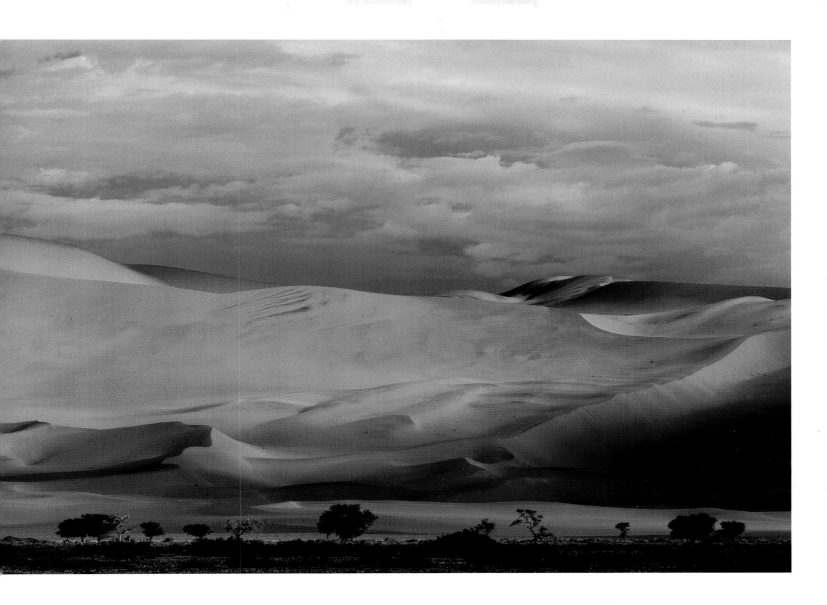

My top five tips for working the light

1. Without a camera, look at the way in which light interacts with different surfaces. Perhaps set up a simple table-top still life where it is possible to move the light source from one position to another.

2. Become obsessive about light and take every opportunity to observe its behaviour in conjunction with every conceivable surface.

3. Set aside a special time for your photography and make images of a landscape setting in different lighting situations. Study and analyse your results. Define as best you can why the lighting does not seem to have been successful.

4. Make repeated visits to a favoured location and work tenaciously to produce an image that matches your previsualized ideal.

5. Tolerate as few compromises as possible and, when they are unavoidable, be aware of what they were, why they were allowed and where they have sullied the image.

GALLERY WORKSHOP
Inhabited Landscapes

Understanding light

It takes considerable practice to understand how light falls upon a subject and how that light is reflected and absorbed by surfaces. Mastering light does not mean that we can expect to control it, rather that we learn to work with it and utilize it to our best advantage. Light and its distribution throughout the scene is to be fully evaluated. Keep vigilant always. CW

Swithland wood
Keith Urry

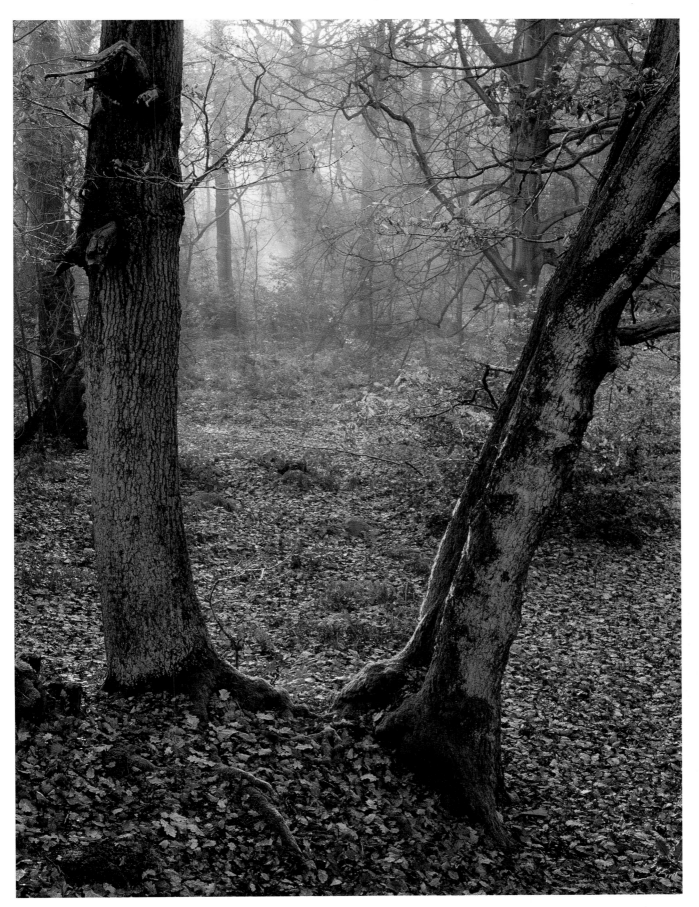

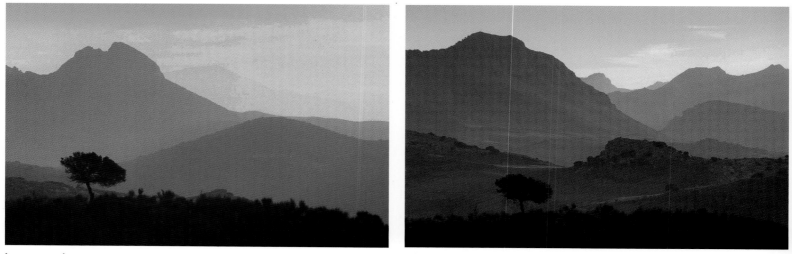

Lonesome pine
Keith Schubert

A planned approach

*I advocate careful planning and adopt an almost military approach to
landscape photography. Plan the capture of an image with the same attention
to detail as a general might plan the capture of a strongpoint. Favourable light,
when it is on offer, will be short-lived and is seldom just 'come across'. On some
days it can be too much, too overwhelmingly bright, delivering an impossible
subject brightness range. But then, on one miraculous day, it will be perfect
and you are jubilant with the knowledge that you are making your image just
at the right time, in the right place and in the right light. It is at these moments
that one experiences a kind of ecstasy as everything seems to combine in the
way that one wishes, with light binding it all together. CW*

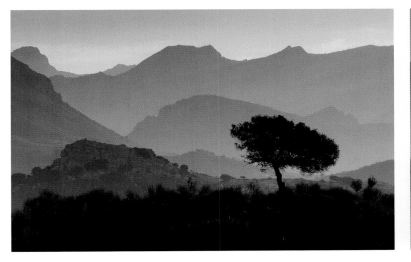

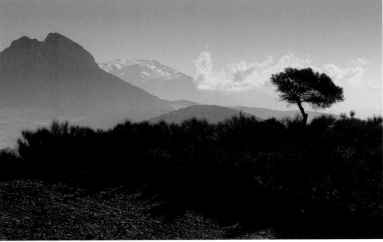

Re-visit and review

Every time we review an image there will be some elements that don't appear to work and others that appear even better than before. Neither the locations we photograph nor the images we make of them are static; even after they are committed to film there are new lessons to be learnt. The key is to study the image and try to recollect what is was that attracted us to the subject in the first instance, before we made the photograph. This will not always be evident, but the hope is that we will be able to recapture the feeling that inspired us to make the image when we see it again, out of the context in which it was made. CW

Optimum lighting conditions

The ideal is for artists to time their photography to take advantage of the optimum lighting conditions and reduce any dependency on post-production salvaging of the image which introduces 'dishonest' lighting. Filtration of one kind or another is often crucial to good landscape photography, for it is only with some optical manipulation we can create an image that matches either what we actually see or the idealized version of it that we see in our mind's eye at the moment of capture. CW

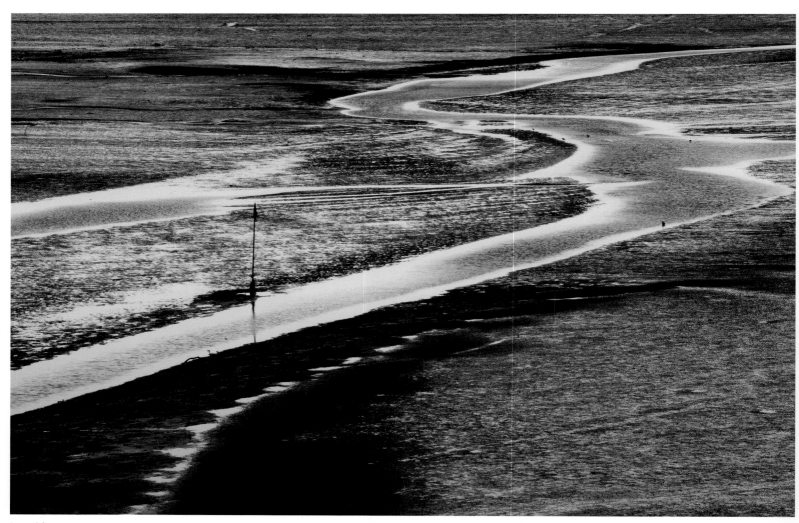

Low tide
David Rowland

Experience and interpretation

We make photographs based on the way in which we experience and interpret a scene. But our photographs will be seen by people who have never been to the same locations and will judge them by a different set of criteria. The business of making images is an entirely personal and subjective creative endeavour. We can never be sure where the impulse to make a particular image comes from. But it may be that the catalyst comes from a reservoir of previously seen images (most not consciously recalled) that have accumulated and become embedded in the artist's mind. In other words, it could be that the stimulus to create the image is no more than recognition or recall. CW

In-camera

Creating a picture in-camera is hugely gratifying. The process of composition and construction is about wrestling with the component parts, to make them interlock and inter-relate and, for me, that's where the pleasure is to be found in landscape photography – not in post-production work. Striving to achieve the image in-camera will, in my view, always be an ultimately more enriching experience. CW

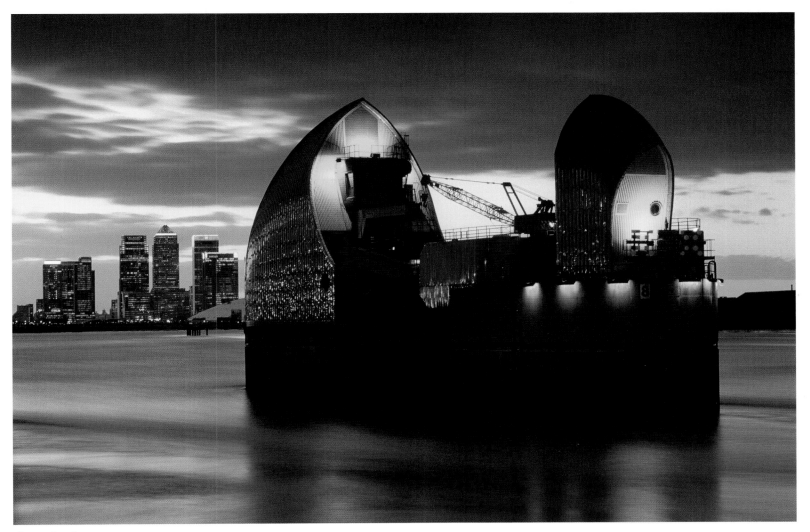

Thames barrier
David Rowland

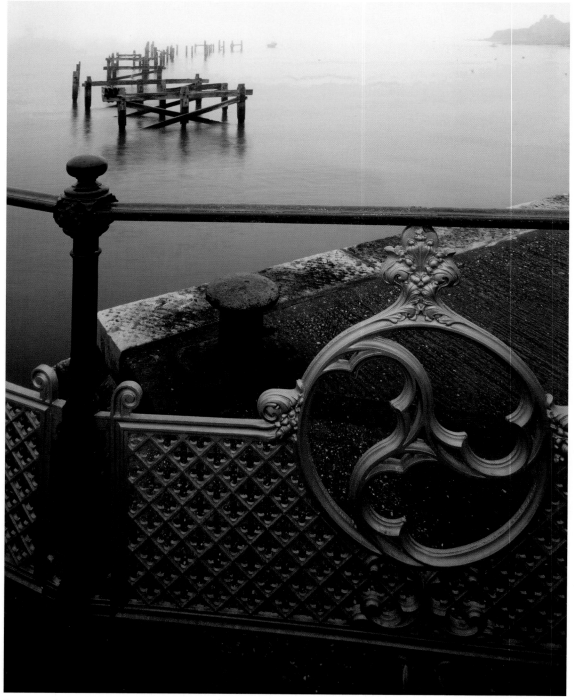

An unpredictable process

All photography is bound to involve a degree of unpredictability and it is here that the tension and pleasure is to be found. The perfect image is and will be always be out of reach, and so it should be. But the challenge is to try and predict the outcome as accurately as possible. This means planning what can be planned for; a photographer who just 'hopes for the best' is no better than a chef who starts preparing his 'signature' dish without being sure that he has the necessary ingredients. CW

Swanage pier
Bruce Cairns

Battersea park
Iksung Nah

The Dordogne
Edward Rumble

Rules of composition.

It must be the case that many of us have an innate sense of design and aesthetics. After all, we make decisions about our own domestic environment – where to place a table, a mirror or a picture – and these involve the basic rules of composition – basically what looks 'right' or what 'works'. But do we need to consult a rulebook to work this out? We find out what works through experience and the day-to-day process of inhabiting a space. CW

Get to know your location

In Britain, we know how side-lighting accentuates the shape and form of the White Cliffs of Dover, while, in America, experience has shown that the serrated forms of Bryce Canyon can be brought to life through back-lighting. What light is 'best' for other locations and how do we arrive at such a conclusion? One of the many functions of light is to help mitigate the two-dimensional nature of the photograph. Depth is to be sought when possible. CW

Vineyard
Graham Whitwham

A very personal affair

Creative photography is about integrity – being true to ourselves – and the most important factor is the joy and pleasure we can get from making a photograph. It is best that the objective be defined, as a trial and error approach is haphazard and unscientific. The image that we make should be a two-dimensional manifestation of the whole experience of engaging with our surroundings. All artists should invest into the making of an image as much of themselves as possible. CW

Open gate
Richard Santoso

Which filter?

Every landscape photographer would love to custom-build a neutral density graduate filter for each photograph. The eye, in conjunction with the brain, can embrace an extensive subject brightness range; the film or chip cannot. A set of graduated neutral density filters will assist by compressing the subject brightness range. They allow all values (that matter) to be embraced by the media used and are absolutely mandatory for effective landscape photography. A polarizer is an extremely important filter when used judiciously but it is secondary to neutral density graduated filters. CW

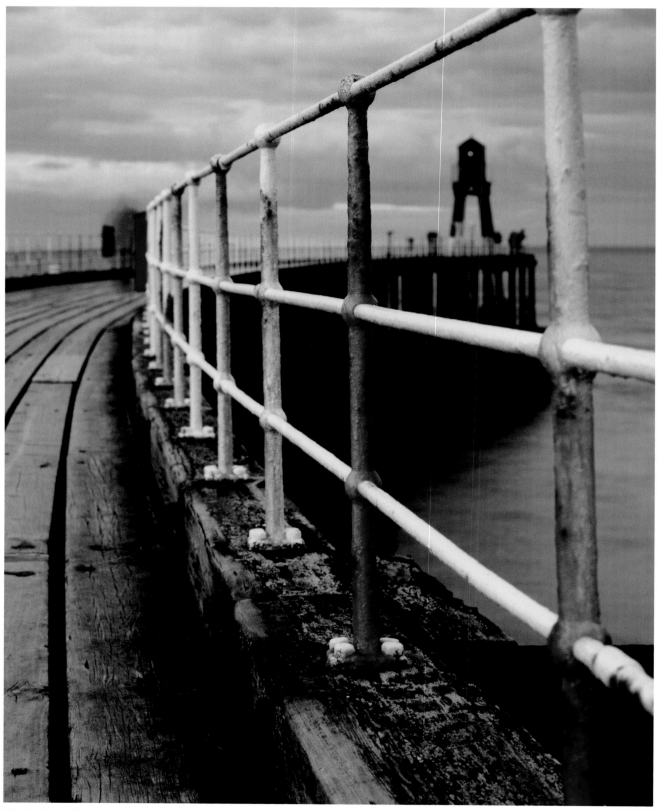

Whitby pier railings
Melanie Foster

Skill and invention

A question I am often asked is whether the artist is possessed with a gift that is only available to the few. I believe that through practice and great familiarity with the entire process of image making and all its ramifications, one can improve; but improve in what respect? After a while, there emerges a 'signature' of sorts, a 'way' of proceeding. This can be based on a series of shapes within the landscape that continue to attract us. Each time we recognize these shapes and forms, we decide to make another image. Many will regard such an approach as a formulaic one which leads to a repetitive style. This may be so, but it does not diminish the pleasure that the artist receives. I believe that continuing along familiar lines in some way reaffirms things for the artist and that it is a significant and important process for those who create images, or indeed for anyone who work in any field of artistic endeavor. Perhaps the voice you have is the only voice you need? CW

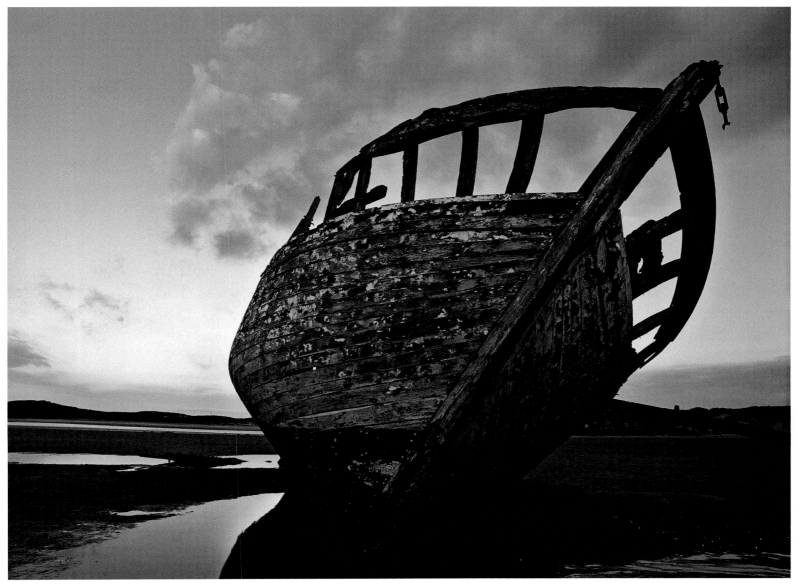

Beached wreck
Julian Barkway

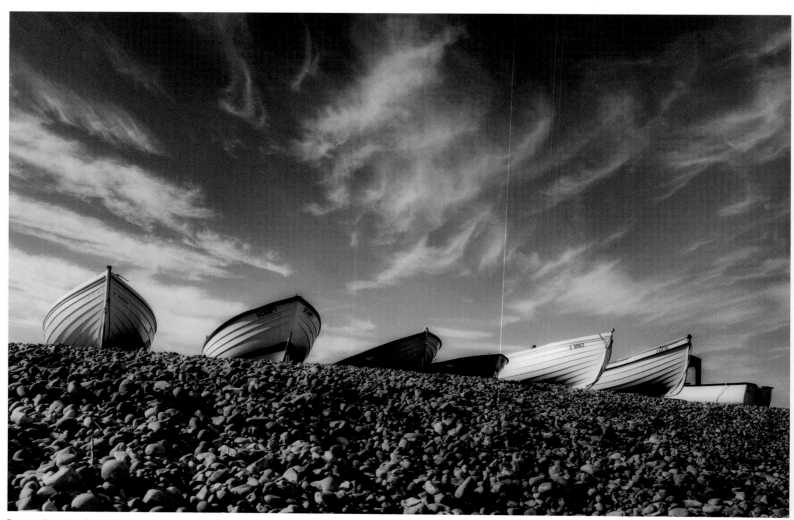

Boats – Pett Level
Lesley Aggar

Metering the scene

Should we believe the camera's meter? A full understanding of metering goes hand in hand with the appreciation of light. The camera meter is very sophisticated these days, and with the digital histogram the curve can be investigated and changes made. But it is also good to have a hand-held spot meter as this will help mature one's grasp of light and its behaviour. CW

Does the light unify the picture?

Light must be studied though its behaviour can never be predicted with total precision. For example, the beautiful warm evening light that bathes the landscape in a mantle of amber is usually thought of as characteristically Mediterranean; but the same light can be found in northern Europe. Despite many claims to the contrary, every region in the world will have its share of ravishing light. CW

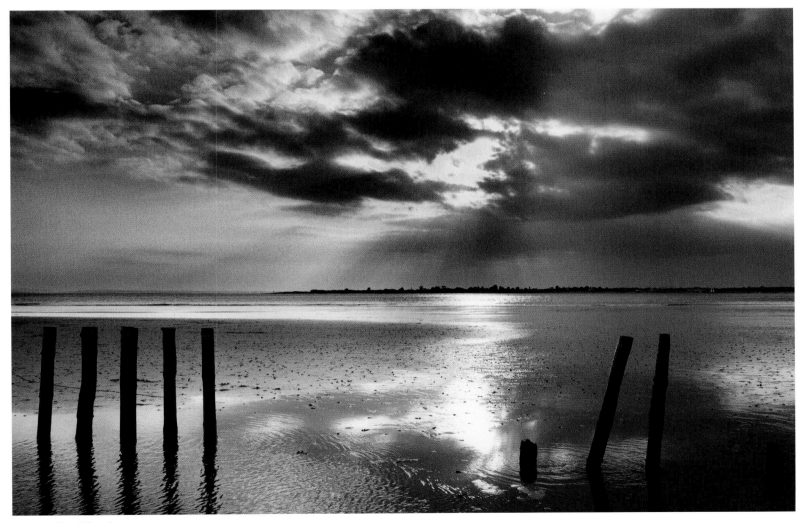

Sunset – West Wittering
Lesley Aggar

A waiting game

People can often be heard to say 'You were lucky to get that light!' But luck should have nothing to do with it. Getting the best light is a waiting game and the waiting, with the sense of happy anticipation that precedes the making of the image, is where much of the pleasure resides. There is much contemplation involved and all of this contributes to the pleasure. Luck is an opportunity seized, so they say. CW

Belvedere dawn
Tony Shaw

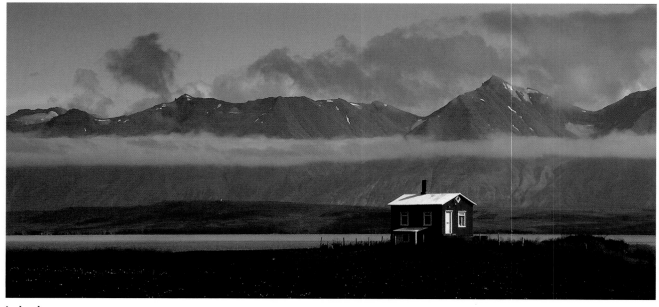

Iceland
Chris Andrews

Which format says what?

Square is unorthodox and works well for design-orientated photographs. Human vision is perhaps more oval in nature and square would conflict with this as would panoramic. Think about the format, remembering that the 35mm format of 36mm x 24mm has been shown to very successful over very many years. Many people enjoy the panoramic camera with its huge angle of view and there are outstanding practioners of this form of photography, but I urge you to try a panoramic camera before committing to buying one. Do not fall into the trap of assuming that changing to a larger format will improve your photography. It may well in time help you to perfect the decision-making process simply because it allows you to see more, but much of photography is about perception. CW

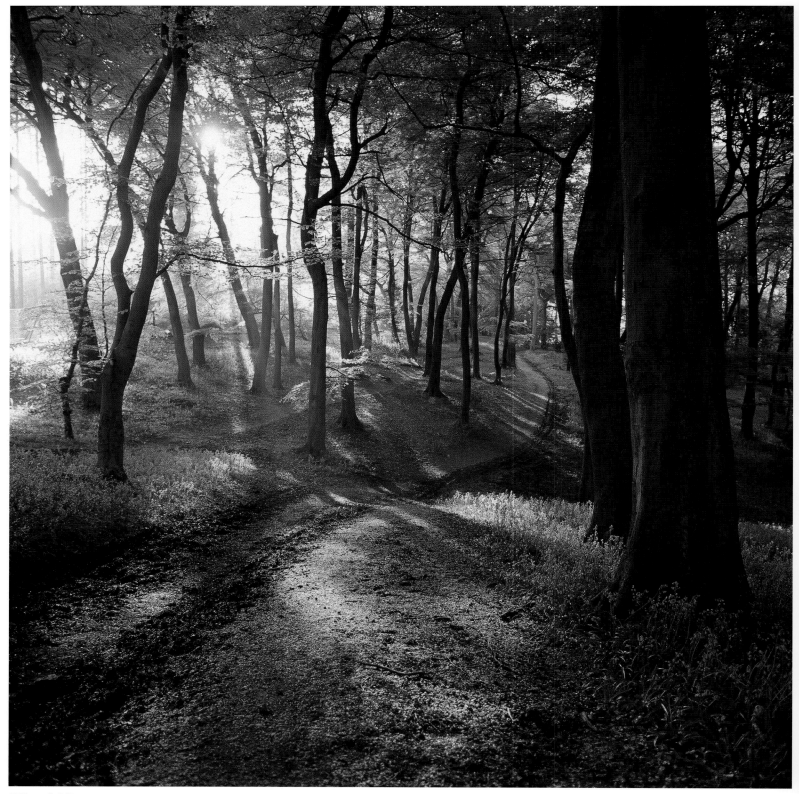

Chiltern bridleway
Richard Holroyd

Whitby pier
Richard Holroyd

The rhythm of a picture

Try not to deny the beholder of the image anything that matters. The whole business of landscape photography seems to me to be about revealing rather than concealing. The beauty of the way that a tree trunk emerges cleanly from the ground or the way in which its very tip brushes the sky is worth preserving. The rhythm of the image can be destroyed by a conflicting element. If you have established a series of arcs then try not to introduce anything that will undermine and destabilize the sensre of grace that you are hoping to convey. Sitting down to a meal made up of a collection of delicious vegetables, no one would think of porridge. CW

Insight and revelation

The question could be posed: 'Why photograph'? This gives rise to a huge debate but, essentially, the impulse that leads one to make a landscape image perhaps amounts to no more than a simple wish to please oneself. For there can be no doubt that the image-making process draws us into the essence of things. There are those that feel that the camera comes between the photographer and a clear understanding and appreciation of the scene and that when the camera is raised to the eye, the artist is immediately separated from the true experience. This could not be further from the truth. The camera acts as a channel for us to engage 'wholeheartedly' with the human experience of responding to our surroundings and, I would argue, should be thought of as a means of facilitating an elevated form of appreciation. CW

Washington from Jefferson
Paul Sharratt

Infrared empire
Paul Sharratt

Vitaleta
Adam Pierzchala

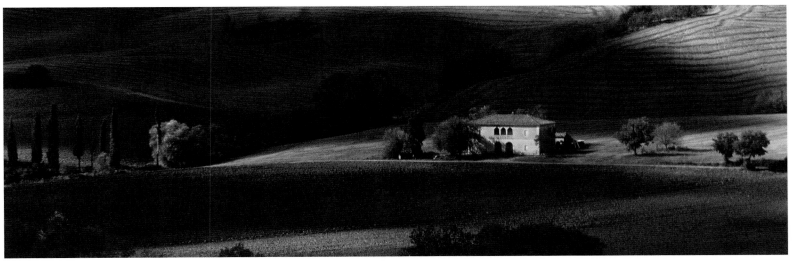

The pink villa
Dylan Reisenberger

Size and scale

Many images that are shown to me are, in my view, printed too small. It should not follow that if the subject is a small detail then then a small print should be made of it. On the contrary, the reverse might be the case. In the US, there is a current trend to make very large images, perhaps up to five feet in length. They can be very effective, but beware of the image that has been made large in the hope of concealing the fact that the image is in fact mediocre and lacking in content. A finely executed image will 'work' at any size. CW

Black and white or colour?

It is an entirely personal choice as to whether the image is made in colour or black and white. In some ways it is academic as the black and white image will involve and require the same rigour as a colour one. Do not allow yourself to be persuaded that colour photography is more 'artistic' than black and white; this is a spurious and an absurd contention. However, it could be said that with black and white the absence of colour distills the essential qualities of the image. CW

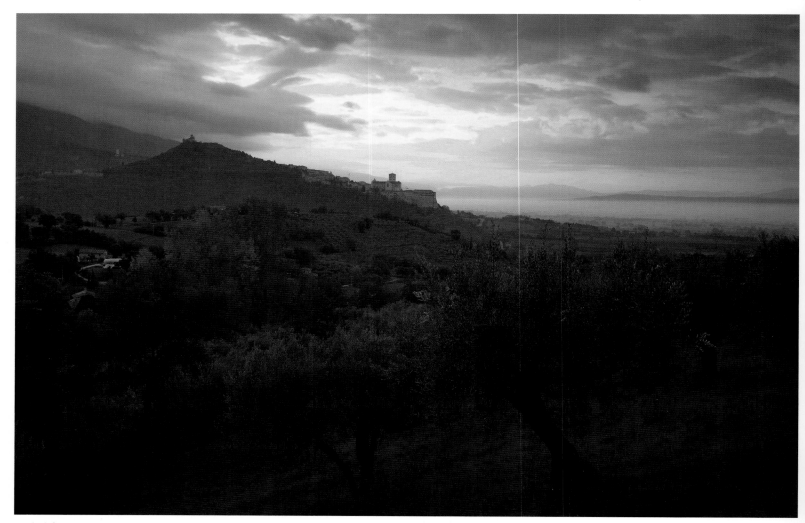

Assissi dawn
Chris Howe

Minimalism or magnificence?

Many people have suggested that large vistas are cumbersome and unwieldy, hard to compress into a rectangle whist still embracing all the mood, the meaning and story that to be told. Some, I know, are daunted by large expanses of landscape and seek refuge in the close up or the long lens dragging a segment of the image out of its sense of place, out of its context. This is no crime, but an attempt should be made with vastness and not shied away from. Once we have become intimately acquainted with all the component parts of a scene, then the mechanics of construction can begin, with light being the catalyst that will elevate the image to possible magnificence. CW

The different qualities of water

If the weather is poor, it is often an idea to head for water where one can enjoy twice the light. Water can provide that most wonderful phenomenon where land and water are fused by reflection. Many artists are drawn to water and interpret it in different ways. Often long shutter speeds are employed in an attempt to depart from the literal. A raging sea can be calmed by a two-minute shutter speed, which transforms a wave-washed boulder into a sculptured rock cloaked in a shroud of apparent mist. Water, like sky, provides us with a mobile element with much can be done. CW

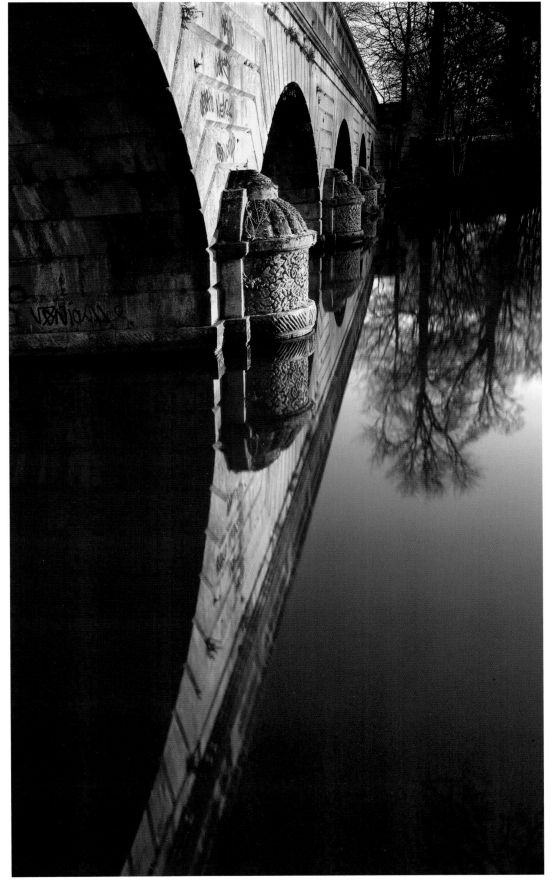

Bridge
Adrian Hollister

Different types of sky

The impact that the sky has on a photograph cannot be underestimated. The sky affects the mood, structure and meaning of a picture. We need to consider what type of sky would be best for a landscape, and compare it with what is actually there? If the two don't match up, then it is best either to look for a subject that can be married to the nature of the sky or to await a sky that suits the shapes that exist on the land. CW

Copse in shaft of light
Colin Turner

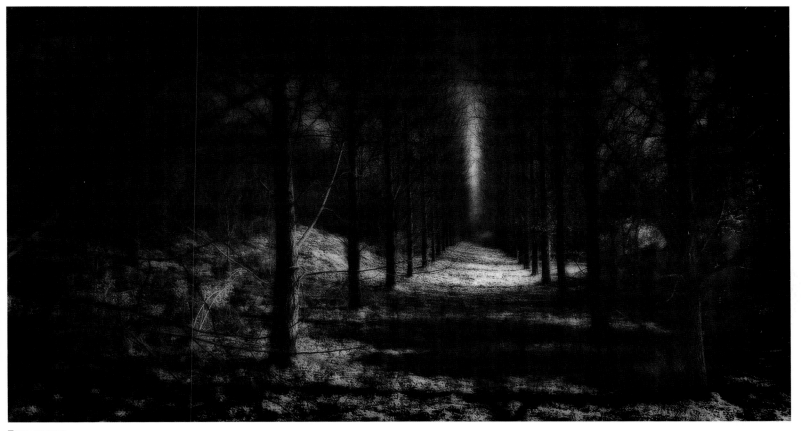

Tree avenue
Colin Turner

Retain a sense of intrigue

When I look at a photograph, I don't want to be provided with a fait-accompli. I want my imagination to play a role. This is especially true when looking at abstract photography, where the imagination is taken into another and perhaps unfamiliar dimension. It may be that this style of photography will not awaken anything within you but it may also offer a new way of appreciating an image; it may require some intellectual spade-work, even if only to discover that there was nothing to be uncovered after all. CW

At first sight

Where does the eye first settle when it looks at a picture? Is it the place we intended the eye to go, or does it go there because the photograph contains an unplanned distraction? The eye and brain will establish in a millisecond of time whether they find the image satisfying or not. If any of the component parts conflict with the main body and thrust of the image then the eye will be led astray in its passage through the image and the image will be rejected. It is probable that the beholder of the image will not at first sight comprehend why the image is not enjoyed. However, a negative reaction cannot be converted to a positive one. CW

Camera position

I would suggest that you do not automatically make the image from the height at which you stand. It is all too easy to adopt a position that seems most comfortable, with your legs slightly apart and your backside sticking out – what might be called the quintessential photographer's stance. Perhaps it is a good idea to leave the camera in the box until you know from where the image will be made and at what height. CW

Industrial remains
Alan Simpson

Derelict shack
David Jackman

Evaluating the effect

Using the depth of field preview facility helps us to identify the point at which we wish to apply neutral density to a local area of the image – usually the sky. This method will ensure that the effect of the filter will be at its optimum at the aperture to be used. Using neutral density graduated filters with rangefinder cameras can only be partially accurate as it is obviously not possible to see the true effect. Some medium format rangefinder cameras provide a ground glass screen which fits to the rear of the camera. This solves the problem. It may be possible to acquire a small piece of frosted glass that can be temporarily attached to the back of the camera if one is not provided. Any filtration should be conducted with care. If the use of a filter is conspicuous, the image will fail. CW

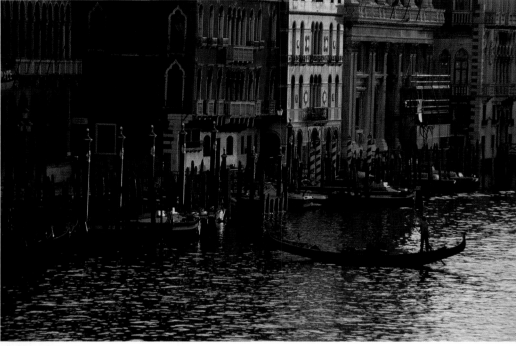

Gondola reflection
Lynn Tait

The Grand Canal
Lynn Tait

Cropping

Cropping is perhaps the most tantalizing aspect of photography. The fiercely aggressive and abrupt vertical and horizontal edges of any format will slice through a piece of landscape and ideally the crop should be made where it is as uninvasive as possible. If there is a wall or river in the image, or any sinuous element that has enjoyed free passage through the frame, there will come a point where it must depart. Its exit, or its entrance for that matter, must be thought about carefully. Likewise the side of a hill, is it better to crop as it ascends or descends? Personally I prefer the latter. CW

Tuscan sun
Micheal James Brown

Morning or evening light?

I am often asked whether I prefer morning or evening light. My answer is often, 'I do not know.' The subject and the way I want to tackle it will dictate the quality of light I need. However, morning light does sometimes seem to combine well with one's sense of freshness and new beginnings. My state of mind is often more attuned to the rhythms of the landscape in the early morning. CW

Avoid intellectualization

Try not to fall into the trap of feeling that there must be an intellectual explanation for every aspect of photography. The photograph is a purely visual experience. It will more often than not be informative and can rely on the beholders imagination to contribute to its meaning. A photograph can, of course, carry within it huge and sometimes subtle meaning especially in documentary photography. CW

CRITIQUES
Inhabited landscapes

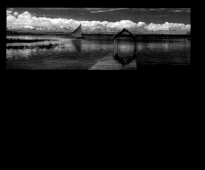
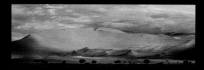
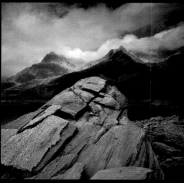

I'm sure that Charlie wasn't the first photographer to see this subject but his image is so strong and deceptively simple that it eclipses all others. The moment is paramount here: it is absolutely crucial that the light strikes the trees just so, giving them solidity, and that the avenue leads into darkness. The image has an inherent tension between the organic forms and the formal and restrained composition. DW

Why is this image so much more than a mere postcard? All the ingredients seem to be there for a shallow and obvious image: blue sky, white cloud, strong light. Yet the photograph transcends the elements. The composition succeeds because it is both elegantly simple and very finely balanced – think how the composition would have been wrecked had the boat moved a metre or two forward. The limited colour palette is also fundamental to its success, a splash of greensward or a red sail would have engendered a very different mood. DW

The mood of this image is almost overpoweringly ancient. The light conveys the feeling of the weight of eons pressing down, transporting the viewer to a mythical land. The sky is oppressive, almost operatic. But despite the lowering clouds it's not a gloomy image, it's more heroic than tragic: this is landscape as theatre! DW

The colours are very strong yet the light is so delicate that it seems to caress the sand. It's another elegant composition but, I feel, slightly unresolved. It's wonderful that there is no focal point, no placing of an object on a third, but Charlie's usual powerful sense of design seems to be absent. The colour contrast between the amber sand and the blue-grey sky is simply beautiful and the moment must have been wonderful to witness but sadly the image doesn't really make my heart sing. DW

Swithland Wood
Keith Urry
Page 69

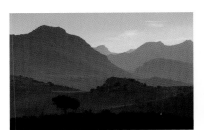

Lonesome pine
Keith Schubert
Page 70-71

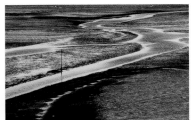

Low tide
David Rowland
Page 73

Thames barrier
David Rowland
Page 74

Positioning the light

CW: *This image is bursting with atmosphere. The emerald green of the trees against the speckled ground is lovely and the two knife-edge highlights running down the right hand tree tells us precisely where the light has come from and the effect it has had. A few sunbeams slicing through the diffusing steam beyond gives the image yet more mood and depth. Looking at this image, it seems almost possible to gauge the temperature. DW: This is an exemplary distillation of form from a very chaotic subject. A rare occasion where strong light works when photographing in woodland! The back lighting separates the main subject from the background granting depth where soft light would not have.*

More saturated colours

JC: *This portfolio might seem to be suffering a little from under-exposure – half a stop or so. CW: He might have believed his camera meter, which is something we all forget. JC: When we all start out shooting colour, we tend to think that under-exposed pictures look better, i.e., more saturated, whereas over-exposed images look washed out. But, I'm a great believer in pictures that have a luminous quality and this can only be achieved through optimum exposure – making sure all the elements in the scene fall within the film's exposure range. If they do not, then either exclude them or use ND graduate filtration to pull them into line.*

Anchor points

DW: *The thing that anchors this picture as an illustration is the navigation marker. Take it out and the image becomes an abstract, and all about light playing on wet surfaces. The photograph works with or without it. CW: It simply depends on whether the photographer wants to include a reference point, or not. Take it out, and we could be critiquing this picture in the Inner landscapes section.*

Cross-over light

DW: *This is a good illustration of the use of cross-over light. JC: Yes. The idea of cross-over light is that the ambient and artificial light are equal, and that they mix without creating excessive contrast. If you haven't got a spot meter, then squint at the subject, or stop down with the depth of field preview facility, and if you can still hold detail in both the artificial and naturally lit areas then it should work. CW: If it doesn't work, and artificial light is too dominant, then the resultant black skies can be quite abhorrent. David has done well here.*

Location: Swithland Wood, Leicestershire, England.
Camerawork: Mamya 645E, 80mm lens, Velvia 50, f22, 1 second exposure, 81A warm filter.
Technique: I waited for the sunlight to breakthrough the trees in the background and lift the mist, also to highlight the foreground trees.
Inspiration: I had found this location a week earlier and liked the shape of the foreground trees. Without the backlighting the scene was lifeless so I returned knowing where the sun would rise. With the mist and light the scene was transformed and brought to life.
Style: Fine Art, Landscape.
Aspirations: I am constantly trying to improve all aspects, but correct filtration and exposure always need working on.

Location: Andalucia, near Antequera, Spain. From a portfolio of six images taken early on the same day.
Camerawork: Pentax Z1, various lenses (short, medium and telephoto), Fuji Velvia 50, various apetures/shutter speeds, ND v/ou 85C and 81 series filters.
Technique: Before sunrise the tree is best silhouetted against the sky. Later, in the early sunlight and working from different viewpoints, it can be positioned against the various planes of recession within the mountain backdrop. However, care had to be taken to avoid flare as a this is an 'open' location.
Inspiration: 'Lonesome pine' – the title I gave this tree on my first visit, has stuck – but it is a wild olive! This, to me, is a special location, providing solitude even though this is a relatively populated area, close to a road. An early visit is essential; within an hour of sunrise the tree becomes a nondescript part of the overall scene, rather than a pivotal part of an atmospheric image.
Style: General landscapes and nature photography, particularly plants and flowers, are my favourite fields.
Aspirations: To improve in all areas.

Location: Low tide at Ngatoringa Bay, Auckland, New Zealand.
Camerawork: Canon 1Ds Mk 2, 70–200mm lens at 200mm, ISO 200, 0.5 seconds at f22.
Technique: The picture was taken as the sun was setting (above the top of the picture), highlighting the texture in the sand and the ripples in the water, as well as adding a pleasing colour.
Post capture: RAW conversion, levels adjusted and hue added in Photoshop.
Inspiration: A low light was sought to bring out the definition in the sand and water, with the evening light taking the harshness out of the picture. The stream flows nicely across the frame.
Style: Landscapes, cityscapes and nature.
Aspiration: Improving my composition, lighting technique and understanding of digital technologies. Getting the exposure right first time.

Location: Thames Barrier, London Docklands, England.
Camerawork: Canon T90, 70–210mm lens, Fuji Velvia 50, 30 seconds at f16.
Technique: The evening sunset reflected on the gates gave a complementary colour to the sky and the water.
Post capture: Scanned and adjusted with levels in Photoshop.
Inspiration: The reflections from the gates and background skyscrapers are brought to life by the sunset.
Style: See previous photograph.
Aspiration: See previous photograph.

Swanage pier
Bruce Cairns
Page 74

Battersea Park
Iksung Nah
Page 75

The Dordogne
Edward Rumble
Page 76-77

Vineyard
Graham Whitwham
Page 78

Composition is in the detail

JC: *I have a slight issue with the corner of the concrete, immediately behind the balustrade. There is no separation between the two, but apart form that the composition is very close to being brilliant.* DW: *If we're being particular, there is very slight distortion of the right-hand circle, but as the camera is looking down on the scene it would be difficult to do anything about it, even though it is shot on a 5x4 camera with movements.* EE: *Use the transform function in Photoshop, perhaps…?*

Location: Swanage, Dorset, England.
Camerawork: Linhof Technikardan 5x4, 90mm lens, Fuji Velvia 50, I second at f32 and no filtration.
Technique: The light was very flat and diffuse, diffused further by soft mist. I was looking for subjects that would suit this type of light.
Post capture: Scanned.
Inspiration: I was attracted to the shapes, the monochrome colours especially the soft purple and blue, and the old pier in the mist. The image needed soft, misty conditions and diffuse light.

Working in unknown locations

Iksung asks the question: *How can you increase the likelihood of capturing good light when you plan a journey to an unknown and unfamiliar location?*

CW: *Don't go there expecting to get it right on day one without having the seen the place before and not being able to define your objective.* DW: *Yes, but you can do some pre-planning with maps, to see where the light will be coming from at different times of year. But success then boils down to those little things like foreground details, the organization of elements within the frame, and you won't know those until you are there. Also, you can look at other people's photos but that might unduly influence your treatment of a scene.*

Location: Battersea Park, London, England.
Camerawork: Bronica SQA medium format (6x6), 150mm lens, Fuji Velvia 100F, 15 seconds at f16 with 81A filter.
Technique: I waited until the street lights came on and the ambient light was low enough for the lamps to be able to illuminate the leaves on the ground.
Post capture: The transparency was scanned and cleaned up in Photoshop, using cloning tools. I adjusted the curves slightly to match the original transparency.
Inspiration: Earlier in the day I was photographing a line of trees and spotted the scene, so I waited until the light levels were right. The low ambient light level enables the image to convey the exact atmosphere at the time.
Style: Landscapes, cityscapes and low light photography.
Aspiration: Develop my composition ability and more efficient use of hand held light meter.

Placing pictures together

EE: *How much are we drawn to photographs by the way they are used on the printed page? What happens, say, when a lovely picture of some triangular-fronted French barns is placed next to another depicting the elegant, horizontal form of a boat, or when the two are joined by the vertical forms of a group of walnut trees? The experience of flat planning and designing books tells me that the simple pairing or complex grouping of images plays a crucial role in how they are perceived as individual or collective statements. How much can – or should – this effect the way we make our pictures?* DW: *Photographs are always interpreted in their context whether it be a book magazine, gallery or living room wall.*

Location: Dordogne, France.
Camerawork: Hasselblad 501cm, Fuji GX617 and Fuji Velvia.
Technique: Lots of blue skies lacking interest prompted me to exclude open horizons and look for more 'intimate' images. I felt that this approach also suited the tranquil and enchanting nature of the landscape.
Post capture: Transparencies were drum scanned, with minor contrast and saturation adjustments in Photoshop CS to closely match the original.
Inspiration: No skies, but the direction of the light was important, giving the buildings a three-dimensional quality and providing highlights on the boat, in particular. Verdant spring greens were sometimes emphasized with a polarizer. I looked for simple compositions that emphasized shape and order.
Style: Landscape: waiting for the light in beautiful locations!
Aspiration: Seeing more ordered images in difficult, chaotic scenes. Accurate spot metering subject mid tones and brightness range to select the correct ND grad filter.

Harsh and stark landscapes

JC: *This is a very correct composition of an almost shockingly stark landscape. I already know I don't want to go there! The serried ranks of little enclosures, and the two palm trees perched and poised in this landscape of volcanic ash are intriguing and surreal. The landscape doesn't appeal to me on a personal level, but it is a fine photograph.* CW: *How many people would accept that these almost monotone colours are real? They are, of course, and the semi-aerial perspective (while maintaining the palms as vertical) is very striking. Good light on the palms sets them off well against the darkness and the patterns made by the winegrower's brilliant stone windbreaks make for wonderful repetition and intrigue.*

Location: Lanzarote vineyard, Spain.
Camerawork: Leica RE 35mm, 180mm lens, Fujichrome 100, aperture priority mode and no filtration.
Technique: I sought out strong, low, directional light to highlight the two trees and reveal patterns created by the lines of the vine shelters.
Post capture: None.
Inspiration: A simple, unusual and striking scene of horizontal and vertical lines, which was almost monochromatic. Yes the light was crucial.
Style: Landscape work in interesting light, excluding people but not their influence(s).
Aspiration: The ability to visualize a more artistic interpretation of a subject, and also to produce images with more impact.

Open gate
Richard Santoso
Page 79

Whitby pier railings
Melanie Foster
Page 80

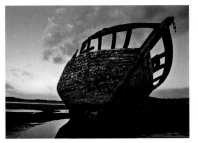

Beached wreck
Julian Barkway
Page 81

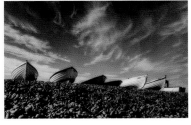

Boats – Pett Level
Lesley Aggar
Page 82

The decisive moment

CW: *Talk about the decisive moment! However, there is a little problem in the very bottom left, something is out of focus, most probably it couldn't be seen as the camera is a rangefinder. It might have been nice to photograph just the gate, as well – perhaps Richard did.* DW: *Watch out for the bailer twine on the gate!* CW: *There is some raggle-taggle stuff on the left, but from the gate onwards, the light is lovely.* DW: *Yes, this image beckons.* JC: *There is a strong sense of place. It's a quality of light picture.*

Deliberate movements

JC: *I think this is the first use of deliberate swing movement on a view camera that we've seen.* CW: *Would you prefer to see it sharper all over?* JC: *That would have been impossible on 5x4.* DW: *In terms of the composition, I think it's great – the way that the green light is framed by the hole in the railing. There is an axtraodinary contrast between Melanie's picture, here, and Richard's on page 87. Wonderful.*

Designing a picture

JC: *This is certainly a striking image. But, there's a flaw in the design. There is a timber support on the right, which gets confused with the dunes beyond. This might have been solved by moving the camera lower and making it into a feature…* CW: *…or setting it against the sand?* DW: *I'm intrigued as to how the picture would look if there was more reflection of the boat. It looks as if it is available. I'm not saying a reflection of the whole boat. In this type of situation, one could walk backwards; legs are the best zoom lens, so they say.* JC: *But that might have changed the shape of the hull.* CW: *Yes, the bulk of it is effective.*

Never miss an opportunity

CW: *This image has been made in the full knowledge that the high cirrus sky could not possibly be wasted. The hull of a boat is always the most appealing part of its construction and this arrangement is both unfamiliar and dramatic. I am slightly disturbed by the last boat on the right which seems to be obstinately facing the other way, but little could have been done about that. The gritty foreground suits the image perfectly. It is strong image, well executed and entirely fitting for black and white.* DW: *Only three elements here: sky, beach and boats. The direction of the light is perfect for modelling the boats. A beautifully simple image.*

Location: Near Tarn Hows, Lake District, England.
Camerawork: Hasselblad Xpan 2, 45mm lens, Fuji Velvia and ND grad.
Technique: I wanted the sun to appear shining just over the tree-line to highlight the mist in the field.
Inspiration: I took a picture earlier in the week when the sun was too high, and thought I would try again. The light is crucial as the sun is a point of interest and lights up the mist just enough, I think.

Location: Whitby, North Yorkshire, England.
Camerawork: Lotus 5x4 camera, 300mm lens, Fuji Velvia 50, shot at f8.
Technique: I used a shallow depth of field. The plane of focus was placed on the rusty railing in the foreground.
Inspiration: I liked the way the railings framed the lighthouse.
Style: Landscape photography.
Aspiration: Pre-visualization of the end product and competent use of a large format camera!

Location: Bunbeg, Co. Donegal, Ireland.
Camerawork: Mamiya 645 Pro, 35mm lens, Fuji Provia 100 without filtration.
Technique: I wanted to use the soft light of dawn, before the sun had fully risen. This would bring out the delicate colours and textures of the peeling paintwork in a way that would not be possible in more contrasty, direct sunlight. I also thought that a subtly coloured sky would best complement the rust-reds and browns of the rotting hulk.
Post capture: Post-scanning, I darkened the picture slightly to optimise the colours and performed the usual colour-corrections.
Inspiration: I happened on Bunbeg quite by chance, unaware of the shipwreck. I saw the boat first when the tide was high at sunset the previous day and took some rather unsuccessful pictures. After consulting local tide-tables, I returned at dawn and was able to get close enough to use my widest lens. I tried various angles but this was the only one that really worked. The soft dawn light is critical in bringing out the textures of the decaying timber and paint, whilst the pastel sky complements and enhances the colours of the ship.

Location: Pett Level, Hastings, Sussex, England.
Camera work: Pentax 6x7, 55mm lens, Ilford FP4 at ISO 200, 1/125th second at f22.
Technique: Afternoon light in spring.
Post capture: Monochrome hand print with slight diffusion, plus burning and dodging, scanned into photoshop and duo-toned.
Inspiration: I was shooting a different image, then I looked behind me to see the boats almost surfing across the shingle with a paint brush sky.
Style: My work is very varied, but I am drawn to the ever changing moods of the sea, which I capture often, as I live on the coast.
Aspiration: To develop the way I see and portray emotion.

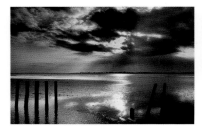

Sunset – West Wittering
Lesley Aggar
Page 83

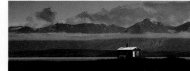

Iceland
Chris Andrews
Page 84

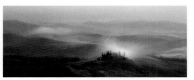

Belvedere dawn
Tony Shaw
Page 85

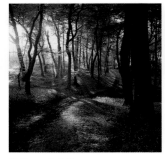

Chiltern bridleway
Richard Holroyd
Page 86

Images within images

CW: *The five sticks to the left and the two to the right, as well as a stunning sky (beautifully balanced), make this a striking image. My only niggle is the reflections of the sticks, but I appreciate that to have included them would have meant cropping the sky, perhaps, or a wider lens may have done the trick. An entire reflection is often more pleasing than a decapitated one. The exposure is spot on with the sky not looking over emphasized. DW: This feels a little like two images because of the two sets of posts. I wonder if it would not have been better to exclude the group on the left.*

Location: West Wittering, Sussex, England.
Camera work: Nikon F90X, 28–70mm lens, Ilford FP4 at ISO 200 at f11.
Technique: Afternoon light in autumn.
Post capture: Monochrome hand print with slight diffusion, plus burning and dodging, scanned into Photoshop and duo-toned.
Inspiration: I like the groynes in the foreground as they give perspective and add interest to the dramatic sky.
Style: See the previous page.
Aspiration: See the previous page.

Include nothing that is superfluous

JC: *The cold light sets off the dark brown painted building.* CW: *And the relationship between the band of sky and the band of water, taking up the same amount of space, is extremely effective.* JC: *Yes, it's a good design.* CW: *Chris has thought about the composition, to create a lonely, northern hemisphere-style image of solitude.* DW: *Nothing is superflous in this image.*

Location: The Red House, just outside Darvik, Northern Iceland.
Camerawork: Pentax MZ-5 35mm, Sigma 70–300mm f4-5.6 lens at around 150mm, Fuji Velvia 50 at ISO 40, f16, shutter speed not recorded, and polarizer. Taken using panoramic mask built into the camera.
Technique: By mid-morning the sun had burnt off the high-level cloud. The low line of cloud, that is characteristic of Icelandic fjords, was back-lit by the sun. The photo was taken when all the elements came together, with the sun picking out the house in the foreground.
Post capture: Scanned with a Canon 8400F flatbed scanner and printed on Canon Pixma i8500 colour printer. Adjustment with levels in Photoshop Elements to match the original slide.
Inspiration: This is a location that requires the right light to lift it out of the ordinary.
Style: Photography gets me to explore the world. I enjoy travelling to new places and appreciating how a particular landscape makes me feel: it helps transform me from a tourist to a traveller.
Aspiration: My biggest concern is falling into the trap of photographic clichés. The challenge is to create images that mean something to me rather than just images for the sake of taking photographs.

The right place at the right time

JC: *This is one of those magical moments. You almost can't believe it happened. The building seems to be lit within itself and really draws the eye there, yet the whole landscape is vital to the composition.* DW: *A truly magical moment. We've all been there quite a few times and I've never seen a photograph like this, which is surprising considering it is an almost overworked icon of Tuscany and considering how many thousands of photographs have been made of it.* EE: *So, what has the photographer done that makes this picture so special?* JC: *Being in the right place at the right time – and having a good idea of when that might be – is 90% of the art of landscape photography.*

Location: Val d'Orcia, Tuscany, Italy.
Camerawork: Toyo 45G, 90mm Super Angulon lens, Fuji Velvia 50, 2 seconds at f22.
Technique: This picture was taken at 6a.m. and there was no sun, but the colours in the hills and sky make the shot.
Post capture: Scanned with an Imacon Flexlight, cropped at the top and bottom.
Inspiration: This was the first sunrise I ever managed to get up for. It had rained heavily the previous evening and Charlie said we might get mist. We certainly did and it moved all the time, so I waited for it to drift behind the house. Although not an obvious sunrise, I think the layers of colours compensate for the lack of the sun.

A sense of rhythm

JC: *I wonder if there was any other way of handling the two beech trees on the right? But the pathway beyond is so perfectly placed; going left or right might have altered the image unacceptably.* CW: *I think the big trees on the right inform us of the nature of the others.* DW: *My only slight niggle is on the left of the frame. It is ever so slightly too bright. A tiny bit of grad would have helped to knock it back, by half a stop perhaps.* JC: *At the same time it doesn't matter that much.* CW: *Yes. I think what he's done very skilfully is to create a rhythm in the picture.* JC: *Woodland is so difficult to photograph because of the huge amount of information. My criticisms are mere niggles when you consider the difficulty of photographing into the light.*

Location: Parkwood, Buckinghamshire, England.
Camerawork: Bronica SQi, 50mm lens, Fuji Velvia 50, f16, I second exposure and 3 stop ND grad.
Technique: Early morning gave the quality and direction of light needed for the critical elements of the image.
Post capture: Scanned and adjusted with levels in Photoshop.
Inspiration: I love bluebells. Sad or what? The light is the picture.

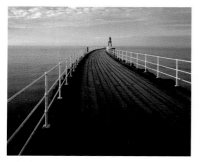

Whitby pier
Richard Holroyd
Page 87

Washington from Jefferson
Paul Sharratt
Page 88

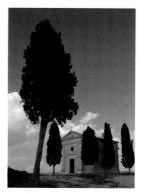

Vitaleta
Adam Pierzchala
Page 90

Infrared empire
Paul Sharratt
Page 89

Subtlety and quietness

JC: *An extremely elegant and sparse picture, with a precisely drawn sense of line. It's very asymetrical and yet there is something perfect about it.* DW: *It is important the sky is subtle and quiet.* CW: *Yes, Richard has really thought it through. Imagine he had changed his camera position just a little and how the image wouldn't have worked.* DW: *Perfection comes from balance, from the exclusion of the unwanted or distracting elements. There is nothing in this image that feels out of place.*

Understatement and elegance

DW: *This is a great example of lovely soft, cross-over light – a mix of artificial, fluorescent or sodium vapour light and the last light of the day. And, of course, it is a wonderfully understated, elegant composition in which I can't see anything wrong.* CW: *I think the texture on the pillars is wonderful. I bet Paul hugely enjoyed making it.* JC: *Are we almost ready to say perfection?*

Echoes and repetition

JC: *It's quite an abstract image but with some literal elements. When you look at it closer, there are some intriguing shapes and contrasting textures.* CW: *The two strong vertical elements are very good.* DW: *It has a 1930s feel – an almost fascistic monumental quality to it. It also reminds me strongly of the graphics work in some of the cartoon novellas – you could imagine a superhero like Batman stalking across this scene.*

Perfect positioning

JC: *When you make a picture like this, you have to position the camera extremely carefully. You have to get it perfect and it doesn't quite work here, but it could have been achieved.* DW: *One feels there ought to be space between the foreground tree and the one behind, on the left.* CW: *My problem is that the nature of a cyprus tree is one of being absolutely perpendicular, stately and sentinel-like in shape and style. Here they converge and lean in.* DW: *Adam has used a fairly wide-angle lens which will have increased the distortion.*

Location: Whitby, North Yorkshire, England.
Camerawork: Ebony SW, 90mm lens, Fuji Velvia 50, f22, 1 second exposure, ND grad and 81B filter.
Technique: I waited for the setting sun to appear below the cloud. (Solar eclipse viewing glasses essential!)
Post capture: The scan was adjusted with levels.
Inspiration: Well, it has been done before, but I still love the graphic simplicity, and the contrast of orange rust with dark boarding, and the green light on the end of the pier. The light was magical and drew the eye towards the horizon. Bliss!

Location: Washington DC, USA.
Camerawork: 35mm Nikon, 28mm lens, Fuji Velvia 50 and FDL filter.
Technique: I waited for the colours of twilight to appear.
Post capture: Photoshop adjustment with levels and foreground dodged.
Inspiration: To create a different angle of the classic Washington monuments. I was also attracted to the strength of the columns when viewed close up with a wide-angle lens.

Location: New York City, USA.
Camerawork: 35mm Nikon, 35mm lens and colour infrared film.
Technique: I made the image in the late afternoon sun.
Post capture: Photoshop adjustment with levels.
Inspiration: I was inspired by the composition.

Location: Vitaleta Chapel, Tuscany, Italy.
Camerawork: Kodak 35mm, 28–105 lens at 28mm, with an orange filter.
Technique: I used an orange filter to darken the sky and waited for the sun to go behind the clouds, to soften the light on the chapel, and to get more detail and tone out of the stonework.
Post capture: Minor curves and histogram on the scanned negative.
Inspiration: I spotted a composition: towering cypress 'protecting' the chapel. It was crucial to have fluffy clouds and soft light.
Style: Nature close ups – flowers and insects, landscapes and travel.
Aspiration: Adding emotion and passion to my images.

The pink villa
Dylan Reisenberger
Page 91

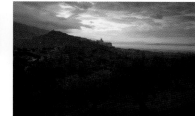

Assissi dawn
Chris Howe
Page 92

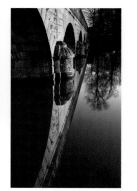

Bridge
Adrian Hollister
Page 93

Copse in shaft of light
Colin Turner
Page 94

An outdoor spotlight

CW: *A photograph that is reminiscent of a stage set. A brilliantly lit image where the photographer has capitalized on the prevailing clouds and made the shadows that they have cast comply with his lighting design. A theatre lighting director would be proud of him. JC: Clouds rarely seem to be in the place you hope they will be for long, which is why timing is sometimes as essential in landscape photography as it is in sports, wildlife and other genres. The clouds have shaded the sun here, creating a spotlight on the villa and a few trees nearby, and the photographer has judged the moment to perfection. Excluding the sky and minimizing the context helps concentrate the mind on this startling piece of lighting theatre.*

Location: Near Buonconvento, Tuscany, Italy.
Camerawork: Nikon F4 (self-modified with masked screens for panoramic photography), Nikkor 35–70mm/f2.8D at 35mm, Fuji Velvia 50, f11, 125th second and no filtration.
Technique: The villa is hit by a slice of light between cloud shadow, while the streak of light behind the cypresses to the left draws attention to their formation.
Post capture: None (straightforward scan, crop and colour-balance to match the original transparency).
Style: Stock photographer, but I'm also happy to undertake commissions. Specialist in classic Mediterranean destinations of Southern Europe such as Tuscany, Andalucia, Provence and The Dordogne.
Aspiration: Better compositions.

Extreme brightness range

DW: *I was there with Chris. It was an extremely challenging situation, with six or more stops difference between the sky and foreground, and it was very difficult to get the picture to look right. CW: He's made it look just like a renaissance painting and there is no conspicuous use of a graduate filter. DW: It's a nice composition, only let down by the corrugated barn. CW: One wonders whether it could have been hidden by changing position, so it disappeared behind some trees.*

Location: Assisi, Umbria, Italy.
Camerawork: Canon EOS-IDS II, Canon 24–70mm lens at 34mm, f10, 1/5th second exposure and ND grad.
Technique: I arrived pre-dawn, explored various parts of the olive grove, and then waited for some light and colour. I used an ND grad for the sky to balance the exposure and retain detail in the foreground.
Post capture: Capture 1 and Photoshop curves to enhance the pink of sky.
Inspiration: I had been past the olive grove five or six days running on a Light & Land course, it had to be the final shoot on the last morning. The Assissi church is the obvious focal point, but the olives are another obvious local feature. The question: how to combine the two in an interesting light? The light 'surrounds' the church.

Converging verticals

Adrian asks the question: How would you have avoided converging verticals and maintained the lighting?

DW: *This is a strong and dynamic composition. It seems to me that it is only slightly falling over. JC: Yes, what little convergence there is doesn't matter to me. JC: On closer inspection what is noticeable is some graffiti under the bridge (clearly there are artists who travel by boat!). But it is the blue juxtaposed with the gold that makes the picture. DW: Yes, the colour contrast works, although at first glance the dark shadow in the top right almost looked like someone's thumb over the top right of the image.*

Location: Virginia Water, Surrey.
Camerawork: Canon 5D, 24–105mm lens, 1.5 second exposure, f22 and Lee ND grad.
Technique: I had to use the ND grad inverted, to pull back the brightness of the water, in order to highlight the golden glow of the bridge as the sun rose.
Post capture: Photoshop CS2.
Inspiration: The colour, reflection and the purity of the bridge.
Style: Landscape.
Aspiration: Macro photography.

The magic of monochrome

JC: *I think more liberties can be taken with black and white than with colour, as I think this image illustrates. Never for a minute do we worry about whether it is realistic or credible, because it is so clearly a work of expression and emotion, even abstraction. Having said that I would have liked to see a fraction more detail in the cloudscape. But the way it is printed is powerful and really works. CW: For me, the deep black areas are a little too dominating despite understanding the purpose of the exposure being set up for a hugely dramatic contrast. Nevertheless, the image is very powerful due to the contrast. But, I am left wondering whether the slender content merits such a dramatic rendition.*

Location: North Essex, England.
Camerawork: Sinar Norma Super Angulon Kodak 5x4 HSIR film, f22, 1/15 second and Kodak 87 filter.
Technique: As a photographer with many years experience both in studio and on location, and therefore being used to either total or partial lighting control, it is a delight to discover an inner patience for chosen landscape situations and to work within certain parameters. One must be adaptable to the ever-changing moment and understand how light can constantly alter the intention of the image. As with all of my images I sat, watched and learnt.
Post capture: Printed onto Agfa Classic gloss and split-toned.
Inspiration: I keep a book of locations (ever expanding), which I have either experienceed personally or have been referred to, and this is the basis for me and my location vehicle (hippie truck!) to share great photographic experiences.
Style: To achieve a result which portrays my intention so that it can be felt by the viewer.
Aspiration: I aspire to improve all of my photography as there is always something new to learn.

Industrial remains
Alan Simpson
Page 96

Derelict shack
David Jackman
Page 97

The Grand Canal
Lynn Tait
Page 98

Tuscan sun
Micheal James Brown
Page 99

Elements of geometry

DW: *Design-wise, this is well thought out, the way the machinery sits inside the wheel and how the building nestles just on top. Soft, directional light prevents any confusion.* CW: *There is good construction here with minimum concealment of elements and the story – one of bygone times – is told with clarity. The chunky cog has been bravely dropped into the foreground to force us to confront it and get the message in one strong hit. It succeeds.* JC: *I must confess to being an absolute sucker for abandoned industrial landscapes, because I love the poignancy, the history and the sight of nature remorselessly retrieving what was once hers. The use of the soft light allows the rusty colours of the great toothed wheel and the cooler tones of the reflection and the landscape to harmonize.*

Location: Industrial remains in Cwm Orthin, Snowdonia, Wales.
Camerawork: Canon EOS D30 camera, Canon 17–40mm f/4 L USM lens, RAW file, f22 and 1/6th second shutter speed.
Technique: Shooting in flat lighting to reduce the contrast in the image.
Post capture: Levels and curves adjustments, sharpening and printing with Photoshop.
Inspiration: Cwm Orthin is one of my favourite places to photograph. It's a sombre valley full of the remains of old slate workings; you don't usually want sunshine there as it can spoil the atmosphere. In this photograph I wanted to connect the ruined building across the lake with the rusty old cog wheel in the foreground. The blank white sky added nothing, so I excluded it.
Style: Landscape photography in 'interesting' light.
Aspiration: The ability to meter accurately in difficult lighting.

Light of the American West

CW: *I'm always partial to sheds, so I am bound to find this one appealing. A relationship, albeit a tenuous one, is established between the tree, the pale green stems and the sky. The low angle perspective was a shrewd move as it affords greater stature to what is otherwise a dilapidated shed.* JC: *What works about this is the instant association with the place. Where else could it be but the American West? An abandoned pioneer's dwelling in Utah, Nevada or California presumably (please tell me I'm right!) The light has that hard clarity of the high country, beautiful, yet unforgiving and difficult photographically. Fortunately the presence of snow on the ground helps to lift the landscape a bit, but the sky is still a touch too contrasty and over-exposed for my taste.*

Location: Southern Utah, USA.
Camerawork: Contax 167MT, 25mm f2.8 Contax lens, Fuji Velvia 50, f22, Lee polarizer and exposure not recorded.
Technique: I used the camera to evaluate the exposure, having established the contrast level with a hand-held spotmeter.
Post capture: Very litttle.
Inspiration: An interesting and different scene when there was nice mid-morning light (November).
Style: To record faithfully interesting subjects and landscapes when the light is favourable.
Aspiration: Better selection – I may be missing better images when my eye says 'let's go for this instead'.

Light of Venice

JC: *Venice is understandably like a treasure trove for photographers. Water is the main reason, for there are other cities with fabulous architecture. This picture of the Grand Canal is delightful. Not the most original picture, but the lighting, the tightly-cropped composition and the position of the gondola are perfect, wonderfully evocative, quintessentially Venetian.* CW: *The view from Rialto (apart from the floating Vietnamese markets) must be one of the all-time best examples of living theatre to be seen in the world. This would not have been an easy image to make with endless waiting and no doubt some desperation. The solitary gondola lies beautifully balanced on a third and tells a story of a journey's end.*

Location: Venice, Italy.
Camerawork: Canon EOS 50 and Fuji Velvia 50.
Technique: This was shot during a preparation meeting on a Light & Land course. I don't believe in luck! Although I loath getting up early, it is the most magical time for photography.
Post capture: None. I don't like changing anything. What I saw is what you get.
Inspiration: Early mornings give added value; the light changes so quickly that every minute gives different qualities of light and it is the best time to learn about light.
Style: I like to change the ordinary into the extraordinary. Extracting and interpreting a segment of the landscape and turning it into an abstract form.
Aspiration: Macro photography. I have a macro lens but I don't yet know how to use it.

Principles of panoramic

JC: *With the panoramic format it is easy to get seduced by the novelty of the frame, but this picture utilizes every square millimetre of the shape to perfection. The landscape could be monumentally dull, a vast expanse of ploughed earth, yet it is anything but.* DW: *What makes it work is the modelling on the rolling landscape and the way the clouds echo the effect. It is nice to see this well-known location in autumn, after it has been ploughed.* CW: *As one who has become very fond of these trees over 25 years, it is always refreshing to see a strong interpretation of them. A great sky, full of foreboding and the lumpy nature of the landscape is beautifully conveyed by pools of shadow. The wide angle lens, pushing the trees far away, makes the scene so much more expansive.*

Location: Near San Quirico D'Orcia, Tuscany, Italy.
Camerawork: Fuji GX617, 90mm lens, Fuji Velvia 50, f22, 1 second exposure and Lee 1 stop ND grad.
Technique: I metered off the brightest part of the tilled earth and opened up by 1-1.5 stops. I love the warmth and the texture of the earth, and the cold blues/mauves of the angry sky. A wide-angle lens captured as many of the undulations as possible and meant the cypress grove was evident, but not dominant.
Post capture: Colour and exposure were matched to the transparency in Photoshop.
Inspiration: I really don't like to put my tripod feet in the holes of others, but this is one shot I really wanted to get. Best of all, the undulations of the landscape were far more evident than when they are clothed with their crop of wheat. I sat there in the rain for hours, waiting for the sun to peek through the heavy cloud, and about five minutes before sunset, the clouds parted and bathed the scene in the most amazing bright light.
Style: See Wilderness Landscapes Critiques.
Aspiration: See Wilderness Landscapes Critiques.

INNER LANDSCAPES
David Ward

Figure in the rocks – a revelation in working the light

This image was made in Upper Antelope Canyon, Utah, on my first visit there in 2001. It's a given that all photographs are, in a sense, light made concrete. For me this image is the 'stuff of light' in a more profound sense than any other I have made. Although solid rock has reflected the light, the product of that interaction suggests something which exists only in the mind of the viewer. The shapes are created from the play of light and not from the solid geology. This lighting effect is transitory, a few minutes earlier or later and there is no figure to be found. The image taught me about the magic of light in a deeper way than a thousand sunsets ever could. DW

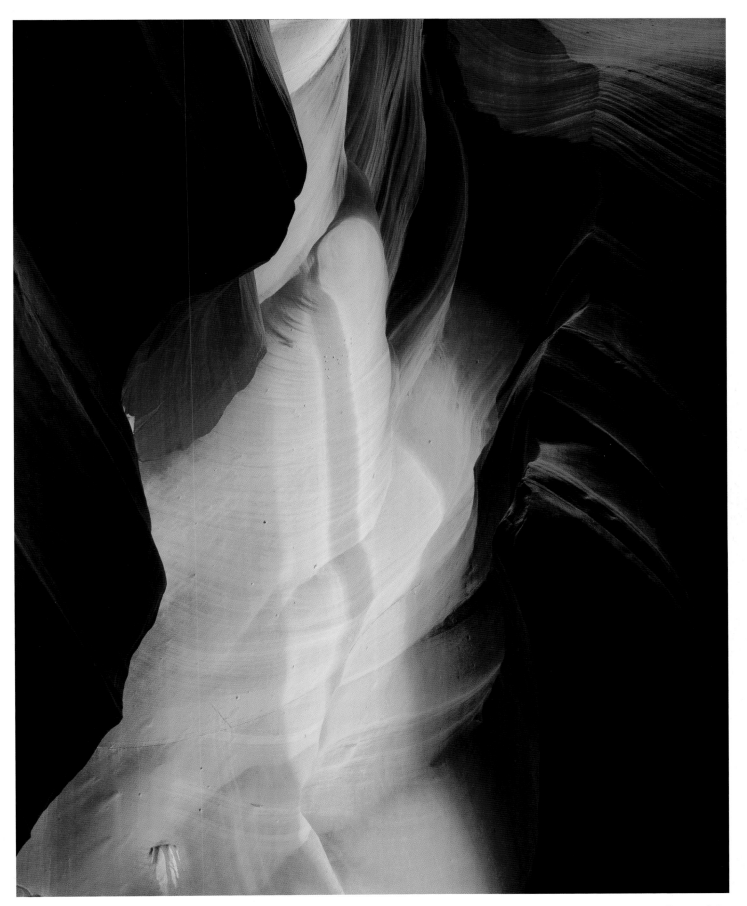

The trick with landscape photography is always to match the subject to the light and vice versa. Good light, therefore, can happen at any time and almost anywhere – it's a question of matching the light you have to the possible subjects. DW

David Ward

Islands in the grass
On the face of it this image might have been made just as successfully in overcast conditions but I think that the soft, warm light just before sunset is essential to its success. The orange light emphasizes the lovely warm colour of the grass stems and makes them stand out against the shadowed areas of the background. It also provides modelling of the rocks, without which the image would have appeared less dynamic. Accurate positioning of the camera was critical – an inch or two less height and the rocks began to overlap ruining the simplicity of the design.

WHEN I WAS A SMALL BOY, growing up in 1960's Britain, science seemed capable of solving all our problems; conquering famine, beating the Red Peril and creating endless labour-saving household appliances. So, I dreamt of becoming a scientist, joining the élite who were pointing the way forward into a bright, clean technological future. I was forced to rethink my life when I failed my Maths 'A' Level. I spent a year wandering from one temporary job to another before the notion of becoming a photographer sprung into my mind. It wasn't completely unbidden, I had always had a strong interest in art. Photography appealed to me as a 'natural' blend of art and science.

I took a degree in photography at the Polytechnic of Central London. My thesis was on the history of American landscape photography from the 1870s to the 1980s. I was then confronted with the real world and the necessity to earn a living. I worked as an assistant for various studio-based advertising and editorial photographers. I quickly realized that I didn't want to be cooped up in a studio for the rest of my career. I was desperate to photograph the natural world but knew that I couldn't make a living photographing landscapes. A decisive moment came when I spent a day with Paul Wakefield, the great landscape photographer. He persuaded me that I should try and live my dream and that working on large format would be the way forward. And twenty years on I've realized that I was right and that there's no money in landscape photography!

WHEN I STARTED LEADING WORKSHOPS for Light & Land I was labouring under the misapprehension that teaching was a one way street: I would simply impart to my students the (mostly technical) knowledge I had acquired over my career as a freelance photographer. I very quickly realized that teaching is as enriching for the tutor as the student and also that the technical aspects are the least important things in photography. Learning to teach has forced me to examine my own practice and in the process opened my eyes to not only how but why I make images. I believe that teaching creates a virtuous cycle in which the teacher learns more about about his or her self and is then capable of passing on more to their students. I'm not at all proprietary about any of the knowledge that I've acquired as a photographer and can't understand why other professionals might be. Technical information and the location of a photograph in the end count for very little in the making of great images; it's a photographer's vision that matters. I see *Working the Light* as an extension of my teaching practice in the field (no pun intended!).

Strangles
I often try to make compositions that convey a sense of ambiguity but because of the strong link between the photographic image and 'truth' it's often difficult to succeed. This image does have a sense of ambiguity; the space defined by the picture is hard to read – do the white lines fall on the same plane as the background or are they hovering above it and what exactly is being described in the image? I'll leave you to ponder…

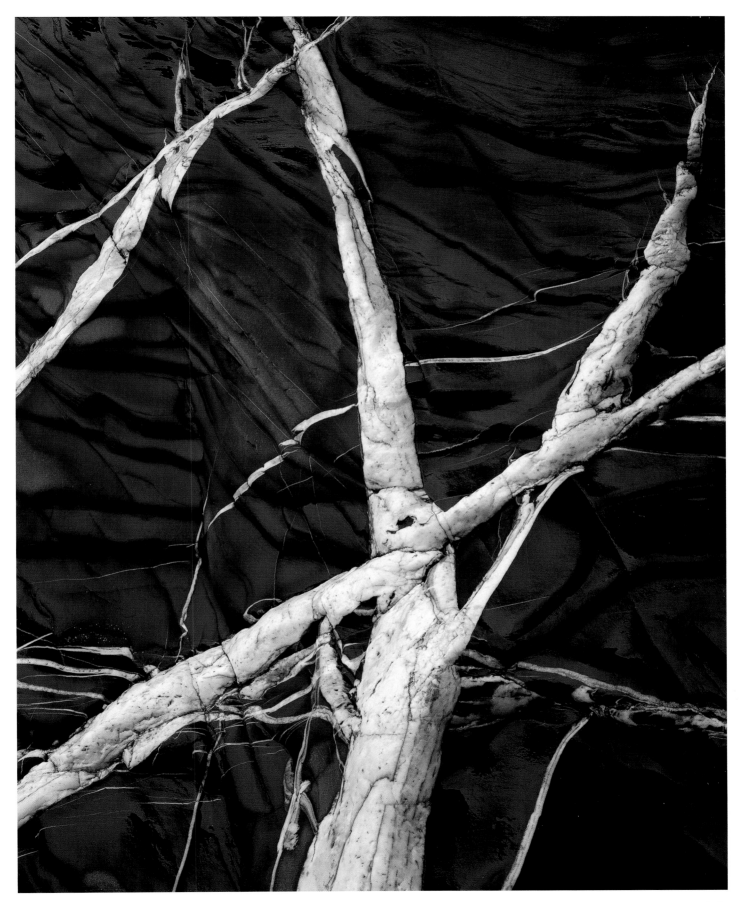

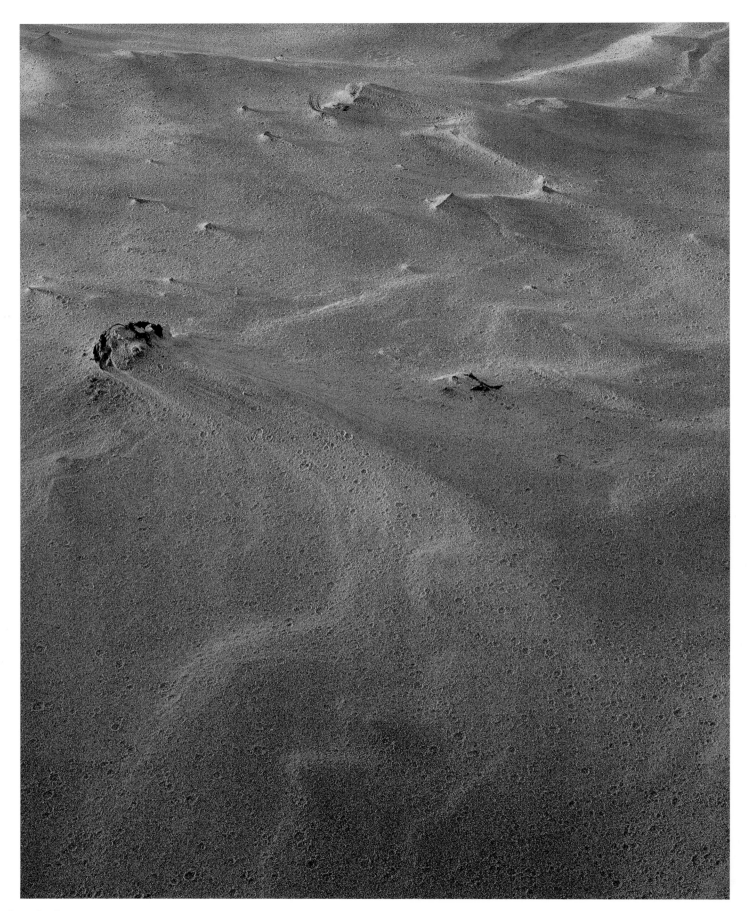

THE IMAGE THAT HAS MOST INSPIRED ME, the one which always springs to mind, is Michael Fatali's 'Evening's Edge'. I love the simplicity of both the composition and contrasting warm and cold colours. For their treatment of light I love many of the paintings from the Pre-Raphaelite movement, they seem to me to have been the first to 'see the colour of light outside the confines of a studio in the same way as photographers do.

Directional light is great for creating a sense of depth, by modelling the contours of the subject, but if I had to name a favourite it would be the extraordinary light that you sometimes get about fifteen to twenty minutes after sunset. You can get a quite intense roseate glow caused by sunlight reflected from clouds high in the atmosphere. It is often surprisingly bright, perhaps increasing the available light by a stop, and is both directional and soft.

AT A FUNDAMENTAL LEVEL, light is the unadulterated raw material of photography in a sense that it never can be in painting. When we look at a 'straight' photograph we can be certain that the object represented existed in a way that we can't be with a painting. However, despite this inherent veracity, we shouldn't be persuaded that photographs are the whole truth. Photographs lie: by omission, by collapsing all possible viewpoints into one, by the distortion of perspective and colour and in a thousand other ways. The difference with painting is that we expect it to be an artful lie from the outset. Indeed some people define art as the transformation of reality by the artist.

DESPITE PROUST'S ASSERTION that he hated sunsets I think that most photographers love the golden hour at the beginning and end of each day. The yellow/orange light at dawn or dusk awakens a deep-seated emotional response in humans and so makes for very appealing pictures. Dawn light in temperate regions of the world is often clearer than the light around sunset, but is often seems more difficult to work with because the transformation from night to day seems faster.

The problem for most photographers is recoginizing colour shifts that are more subtle than that at sunrise and sunset. This is because human vision is relative, not absolute. That is, we see our world in terms of how one colour relates to the other colours in a scene not the 'true' colours as they might be expressed as a wavelength of light. For instance when standing in the shadow on a day with an unbroken blue sky the light is infact extremely cold (the only source of illumination is the blue sky!). Yet human vision is very adept at correcting this cast and we often

An elegant design
The simple elegance of ferns has always been attractive to me. I've long been fascinated by natural design, and especially by the way that complex patterns emerge from simple rules. Ferns are a perfect example of this kind of structure. I isolated the frond shape from the chaotic background by using a very shallow depth of field. I tried a couple of different apertures but found that the larger one produced the best result. Soft, almost directionless light aided the distillation process and was critical to the success of the image, stronger illumination would have resulted in unnecessary complexity and confusion.

Budle Bay
The magic of light is that it can transform the mundane into a thing of extraordinary beauty. This patch of sand only became worthy of an image as the sun dropped near to the horizon. The low angle of the light gives exceptional modelling, picking out each tiny crater formed by a passing shower the previous evening and revealing the elegant, sweeping lines in the wind eroded sand. This miniature landscape is made almost perfect for me by the colour contrast between the pink sunlight and the blue skylight.

The difference between capturing light in a photograph and in a painting is that the photographer is constrained by the available light and the painter is free to invent his ideal light.

Lichen pictogram
Human perception is programmed to look for patterns, to create organization from incoherence. To put it another way, we look for meaning even where there is none. The growth pattern of the lichen on this rock speaks to us. We see a sign, from a primitive unknown language perhaps. It seems to speak of intelligence, whilst actually being the product of the lichen's blind expansion, searching for minerals embedded in the rock and controlled by the vagaries of the micro climate that surround it. This contradiction between reality and perception causes a kind of poetic image.

don't see it at all. Film or digital sensors, on the other hand, 'see' colours in a 'truer' way; shade light is rendered cold not neutral. Of course different emulsions or sensors render the world in slightly different, and often highly characteristic, ways. Once you learn to recognize the possibilities for exploiting the colour contrast between different light source numerous new subjects for photography become apparent.

THE BIGGEST PROBLEM for any kind of outdoor photography is controlling contrast, so for me there are no more important filters to carry than the neutral density graduates, Whilst I don't use them on every shot, they are invaluable when the contrast range exceeds my film's rendering ability. I will infrequently use warm up filters, such as the 81 series of orange filters. I used to use warm ups far more frequently but in recent years I have often sought out subjects that contrast cold and warm light sources, The last filter that I always carry with me is a polarizer. This filter differentially darkens blue skies and also darkens reflective surfaces by removing specular highlights and glare. Whilst digital manipulation can correct some errors in technique there is no substitute for the effect caused by using a polarizer. I always aim to get the image 'right' in camera and my primary objective when scanning my film originals is to get the scan to match.

AS I SAID earlier, the trick with landscape photography is always to match the subject to the light and vice versa. Photographs that lack this balance lack the essential ingredient that makes great images. Good light, therefore, can happen at any time and almost anywhere – it's a question of matching the light you have to the possible subjects.

Blue pebble
The art of photography is usually one of matching the available light to the available subjects. In this case I had a subject and composition that I was very happy with, but light that was far too harsh and from the wrong direction. I could have waited for approaching clouds to obscure the sun but cloud cover would have meant a more neutral colour temperature. I improvised a solution by using my camera rucksack to cast a shadow over the subject in order to get the cold colour cast I wanted from blue sky lighting the image.

My top five tips for working the light

1. Think about the colour of light – is it warm from early or late sun or cold shade light from a blue sky? Do you need to filter it or leave it as it is?

2. Think about the size of the light source – is it a point source (the sun for instance) producing strong directional light? Or is the whole sky the light source (cloudy, or a clear sky when the subject is in shade) giving soft almost directionless light?

3. Think about the height of the light source – how does it affect the shadows on the subject?

4. Think about the direction of the light – is it lighting the best side of your subject?

5. Think about how all these things together will affect the way your subject looks!

Smoking rock
Some images seem destined to take an age to make! In this case I struggled for over forty minutes with various problems: a retreating tide meant too much water at first, almost too little by the time I made the exposure; wet slippery rocks and an awkward camera position meant that I and my camera were in constant danger of falling into the water; and rapidly fading light meant that I was fighting reciprocity failure. I would have preferred some glancing golden light but needed to return at a different time of year to capture this. The final image is, I think, successful but my viewing of it is always informed by the travails involved in its creation.

Fractured green slate
This picture and 'Figure in the Rocks' (page 109). taught me very different things about light. This one taught me about using soft light, light with almost no direction to it – sometimes erroneously called "poor light". It is the first abstract photograph that I was reasonably happy with. The subject matter is very complex, both in terms of detail and topography and the image depends upon the softness of the light. Strong directional light would have increased the complexity even further and would also have overpowered the subtle shades of green and copper.

Gallery Workshop

Inner Landscapes

Unravelling the image

I learnt by looking at other photographers' work, seeing what excited me and by looking at transparencies I had taken, asking myself questions, such as 'why didn't that work?' Occasionally I would put a transparency on the light-box and go 'wow, that is just fabulous'. And I would look at that image again, again and again, over months and years, and ask myself 'why?' Gradually I would unravel the image. In the early stages we photograph things because we sense they work, but not understand why until later. DW

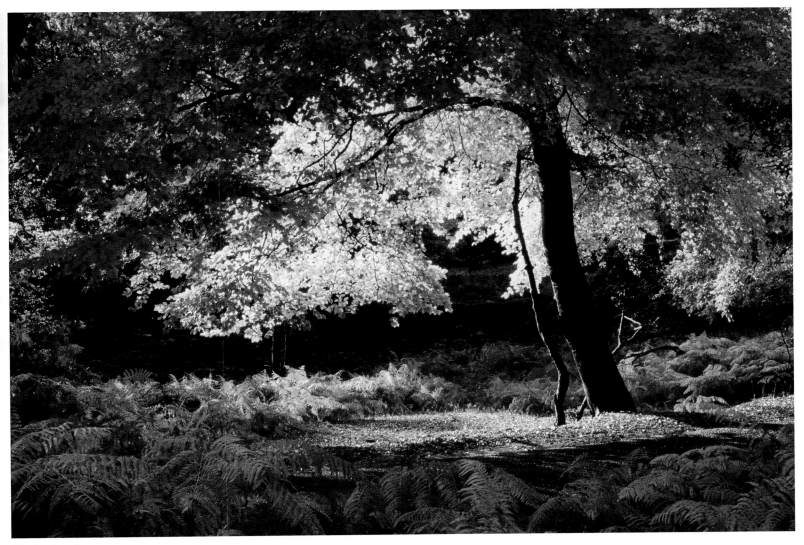

Glowing beech
Roger Creber

The need for constructive criticism

Self-criticism is an important part of the creative process, the photographers need to be able to recognize the jewels amid the detritus if they are ever to progress. The trick is to keep the critical approach within reasonable limits and not to stifle one's creative output by being overly critical. DW

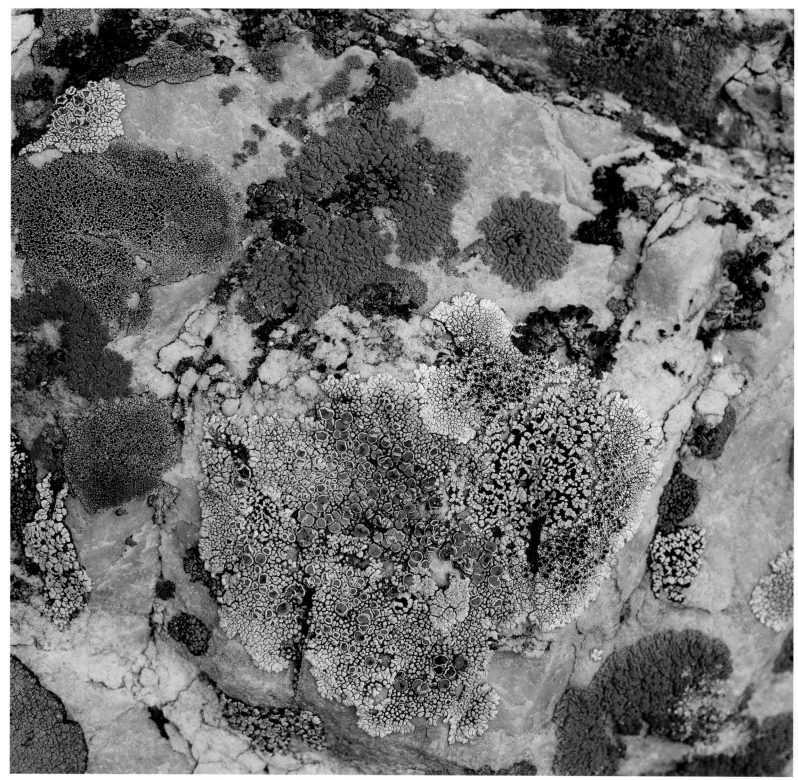

Rock detail
Gert ten Dolle

Light and time

Photographers work with two principal interconnected variables; light and time. The choice of time is often dictated by the light. The multitude of different combinations of quality of light - its colour, intensity and direction, mean that the same subject can be photographed many times with radically different results. DW

Wyoming brook detail
Jonathan Horrocks

Red brick
Richard Holroyd

Beauty in everything

Making inner-style landscapes is about opening our eyes to the possibilities that are all around us – whether man-made or natural forms. Beauty isn't the sole preserve of natural wonders and is often a function of decay. DW

Lose the horizon and widen our horizons

With the horizon in the picture we are standing in the world, by eliminating it we move into another world and have the potential to create one of our own making. DW

Beach cave
Richard Holroyd

Illustration or illumination?

it is healthy for us to not always know what a picture is, or where it is, or what is going on, not to see an image in its entirety, not to have any reference points. A lot of people would say "But I don't know what it is". DW

Swirl of flowing peat water
Peter C Roworth

Match the light to the subject

If the conditions are overcast look for details, if it's pouring with rain look for water, if it's windy look for motion - the possibilities are never-ending. Courage and imagination are usually what are in short supply. DW

Magenta rock
Bruce Cairns

Basalt rock
M. Bradbury

Inner landscapes can be found at any scale

Interesting details aren't just the domain of macro- or close-up photography. The search for pattern can be conducted at all scales – from a cliff face to a plant detail. DW

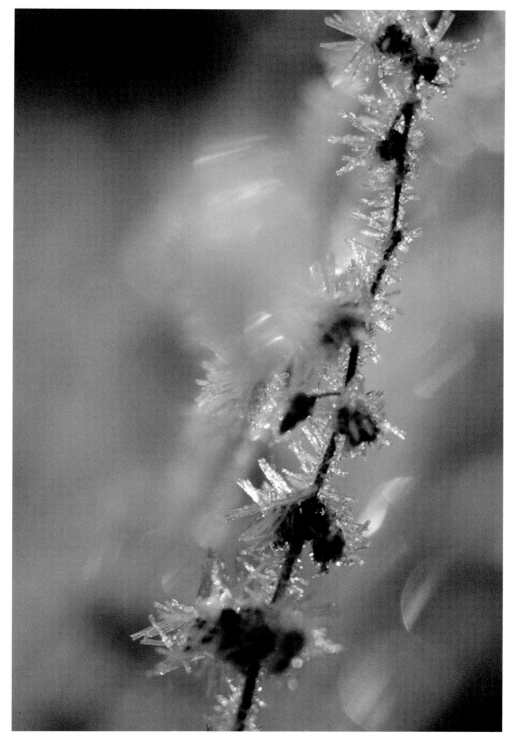

Understanding colour

Images are stronger if they are restricted to one portion of the colour pallette or if they use contrasting colours. Understanding the colour wheel is a basic foundation of colour photography – contrasting colours tend to be more dynamic, using complimentary colours produces a soothing result. DW

Frozen salmon river
Peter Karry

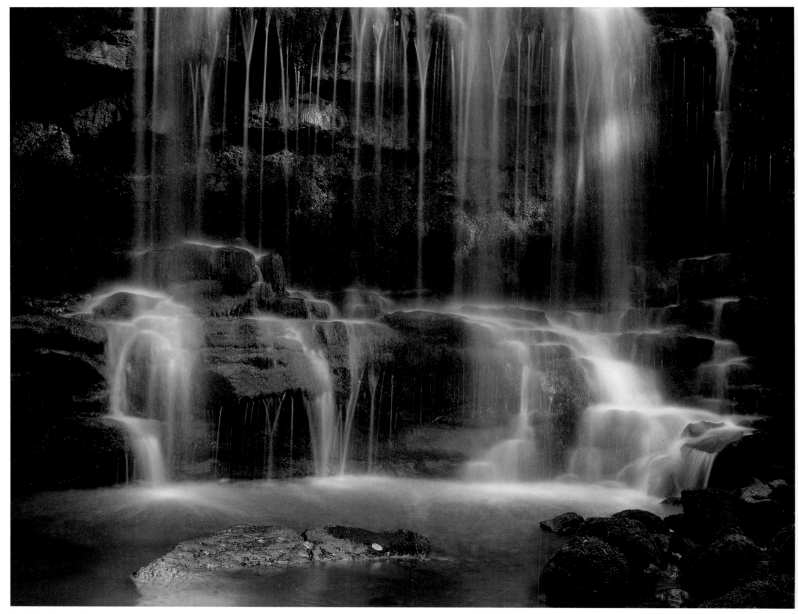

Scaleber force detail
Richard Childs

Don't be afraid of the dark

Mood is partly derived from the tonality of an image. If a picture is predominantly light then it has a 'light' feel. Dark images convey a more sombre mood. We can use photography to evoke a range of emotional responses. Landscape photography doesn't have to be relentlessly cheerful. Melancholic images can be beautiful too. DW

There is a world of difference between looking and seeing

Bill Brandt wrote that, 'The photographer must have, and keep in him, some of the receptiveness of the child who looks at the world for the first time, or of the traveller who enters a strange country.' This is the difference between looking and truly seeing. Looking is so often coloured by expectations but seeing is incisive and free of prejudice. DW

A fusion of elements

Every successful photograph is a balanced fusion of subject, composition and light. DW

Fluid motion
Richard Childs

Go beyond the obvious

It's difficult for a lot of people, when faced by such a majestic view, to pick just a small part of the whole scene, rather than photograph the bigger view. One feels one is missing out on something. DW

**Stream at Queen Elizabeth
Country park**
Keith Folly

Water, ice and granite
Julian Barkway

What time of year/day gives the best light?

I find myself working more and more in overcast or soft light. I don't think that there is a 'best' time of year for light, though the low angle and clarity of winter sunlight is always enticing. I have some experience of working in the Arctic but none of the Tropics so I can't really compare them. I like the clarity of light in cold climates and for this reason often prefer winter to summer – as an added bonus the days are also shorter! DW

Death Valley
Chris Andrews

The right light

There's no such thing as bad light, only light that isn't suited to the subject you had in mind. The trick is to be open to the possibilities of the light you have available to work with. DW

Know the rules and break them

Certain arrangements of elements within an image are pleasing and these have been codified into rules, such as the Rule of Thirds or the Golden Section. They are helpful as we learn our craft, but they should never be used by rote. The rules are not exclusive and the very best images break them. DW

Burn detail
Nick McLaren

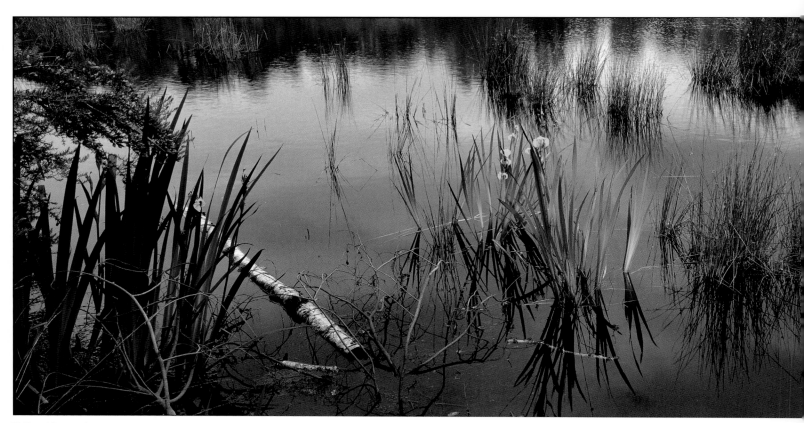

Yellow iris pond
Roger Creber

Develop an intimate knowledge of the location

*You can do some pre-planning with maps, to see where light is coming from
at different times of year, but actually success boils down to the little things
– foreground details and organization of elements within the frame. You
won't know those until you are there and have studied the location.* DW

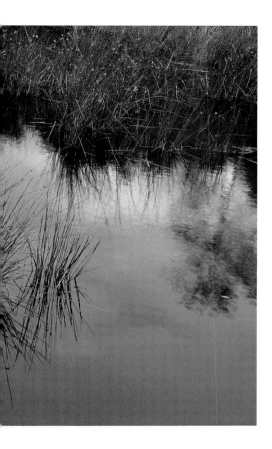

The right place at the right time

The window of opportunity for particular images may be particularly small , limited to weeks or even hours in the case of flora – or seconds in fleeting light. DW

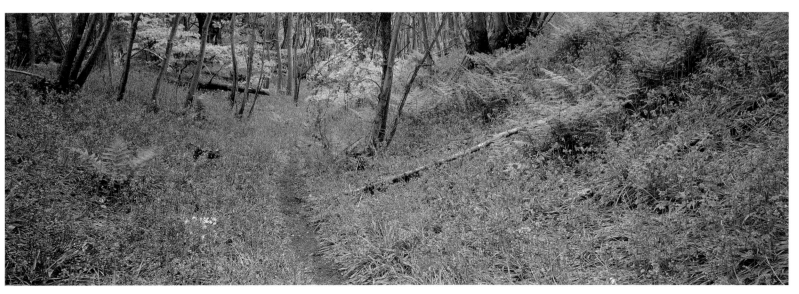

Bluebell path
Roger Creber

Bark
Adrian Hollister

Light sets the mood

Light defines the subject and transmits the information to the viewer. The light is everything! DW

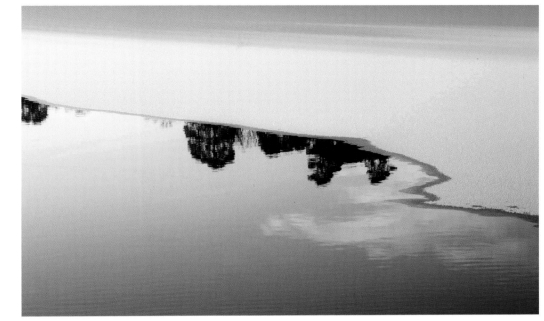

Sunshine over frozen lake
Adrian Hollister

The colour of light

Often we are not aware of how light changes – or even that light has a colour unless it is extreme, like sunrise or sunset. Eyesight is relative and not absolute. We don't see colours as a particular wavelength, rather we see them in relation to other colours within a scene. We may fail to notice that shadows are blue or that the light below a woodland canopy is green. Film, however, does see these different casts. We need to teach ourself how the film sees. The best way to do this is to shoot the same scene with and without filters and under a variety of different lighting conditions. DW

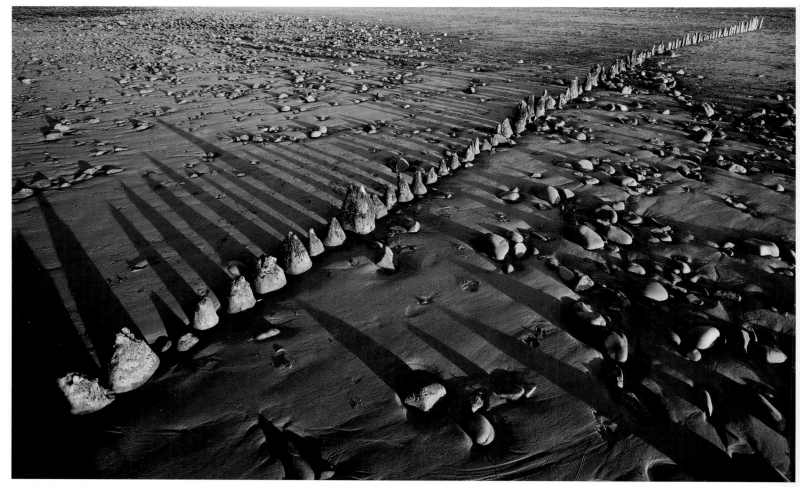

Beach of standing stones
Chris Howe

Look beyond the subject

I think that the most important lesson to learn about photography is that the light is as important as the subject. It's an old saw that we don't photograph the land but the light falling on it; but so many landscape photographers still make the mistake of photographing the subject without considering the way the light is falling on it. DW

A sense of mystery

Mystery makes you engage and look harder. There will always be a proportion of the audience who won't want to engage. But it's more rewarding as the result of being more demanding. If something is illustrative and we understand it immediately then it actually gives us very little back as well. When something has an element of ambiguity or an element of mystery it rewards us by holding our attention for longer than something more literal. DW

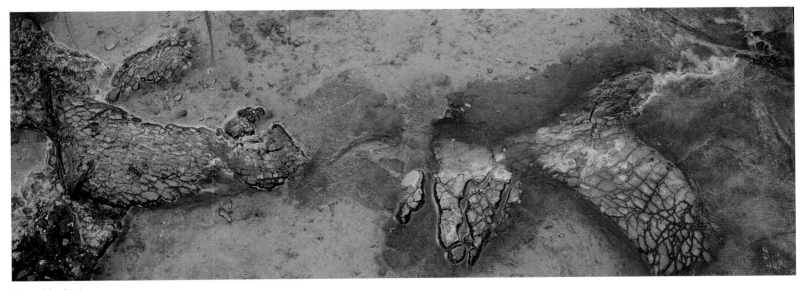

Crocodile skin?
Irma Mokkenstorm

Gwynedd Cwm Orthin
Alan Simpson

Simplicity

As Einstein wrote: 'Make things as simple as you can but no simpler.' Have the courage to come in tight on a subject. DW

The balance of detail and form

What makes an image work, at whatever the scale, is the balance between form and detail. You need enough detail for the eye to be fascinated, and you need a strong enough structure to support that detail. If the picture is lacking in either department you will start to lose that element of fascination. DW

Dancing trees
Alan Simpson

Learn from other artists

Of course we can learn from other landscape photographers. But we may pick up deeper insights from looking at the work of photographers working in different fields. Abstract colour photographers might benefit from looking at the work of painters such as Monet or Mondrian – even Pollock. DW

Reflection
Lynn Tait

Reeds Vermont
Lynn Tait

The point of focus

The tradition in landscape photography, as promoted by the f64 group, was to have everything in sharp focus – celebrating a clarity of vision. But the use of selective focus can help direct the viewer to a photographer's more individual view of the landscape – one which may be less concerned with ideals. DW

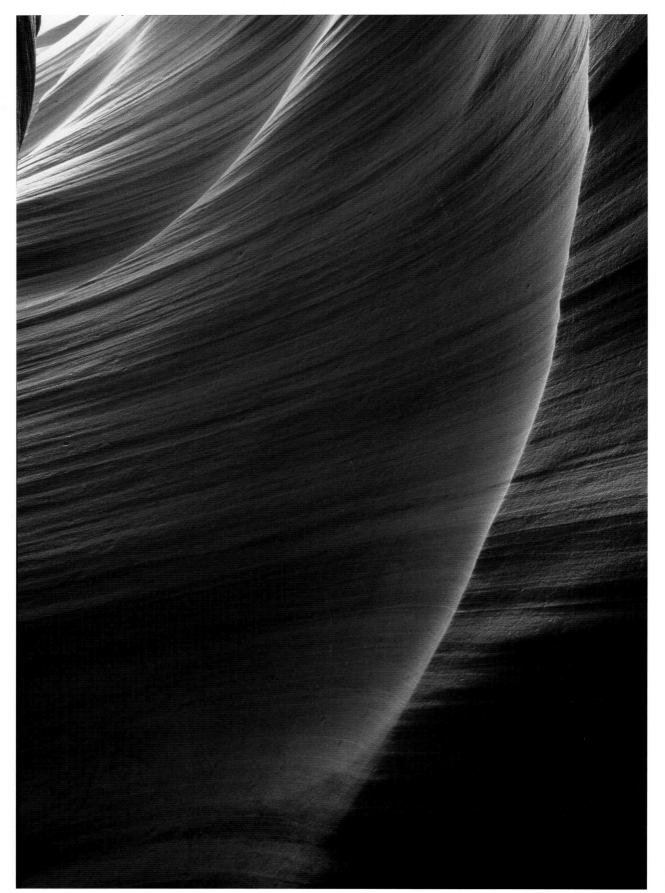

Sand Sculptures
Melanie Foster

Alternative truths

*Fuji Velvia has helped to make Antelope Canyon famous.
Photograph it on different emulsions or with digital capture and
the results will be strikingly different. When a colour film is affected
by reciprocity failure colour rendering may change, but this may
not always be detrimental. In the case of Antelope Canyon and
Velvia the warm colours are gloriously enhanced.* DW

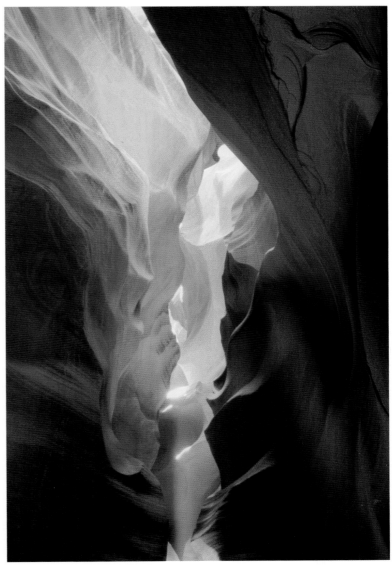

Shaft of Light
John J Egan

A single visit may not be enough

*Lighting effects can be transitory and seasonal. We may not get the best
light on our first visit to a location. Revisiting a place, and reviewing the
images we have made there, helps us put into effect what we have learnt
from previous experience. This will tell us what equipment we may need or
what time of day is likely to yield the right light.* DW

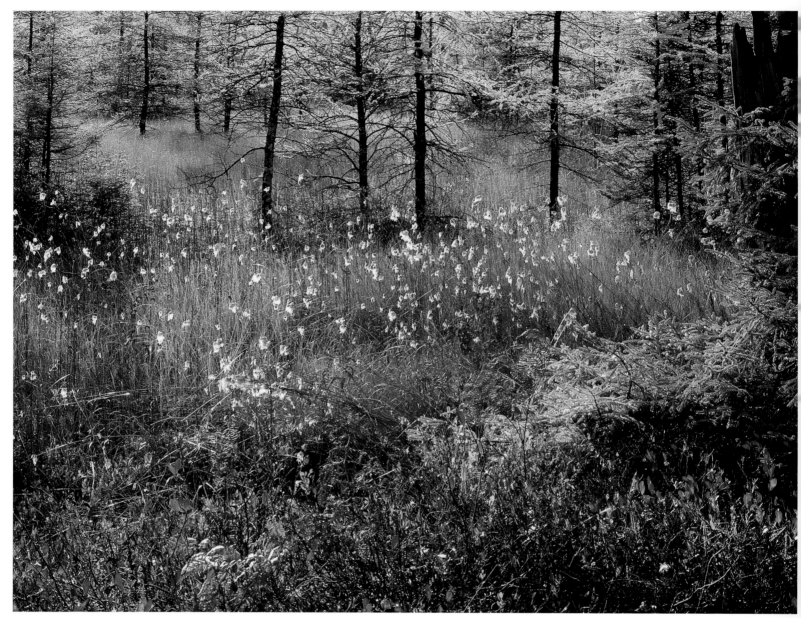

Glade after rain
Chris Elliot

Controlling the 3 C's

Contrast, chaos and complexity. These are the three factors that limit our ability to make photographs. This is because, firstly, the brightness range of a typical scene is greater than be captured either digitally or on film. Secondly, the world is essentially chaotic but as photographers we seek to organize it within a frame. And thirdly, the level of complexity of the natural world is greater than be directly translated into a single photograph. DW

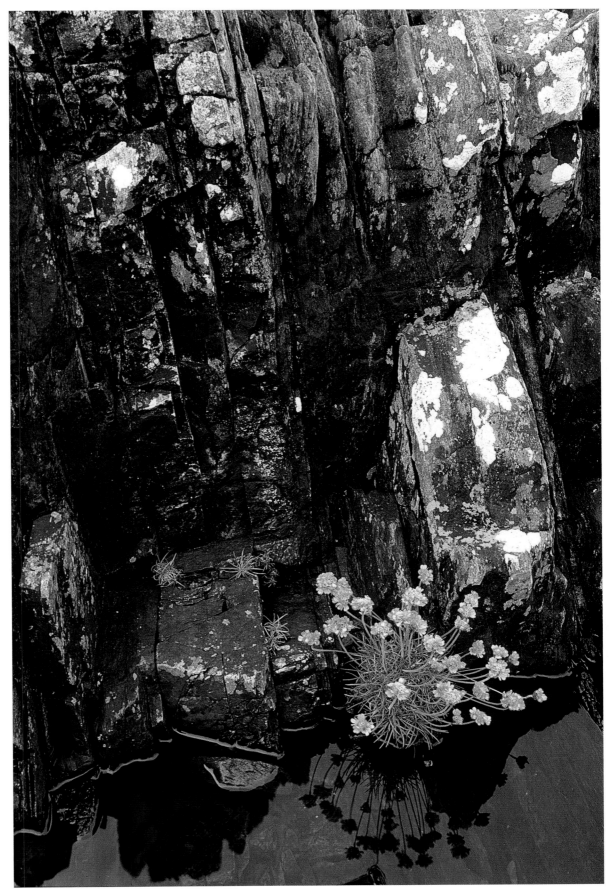

Controlling contrast

We need to know the contrast range of our chosen medium and how to reduce contrast within the frame if it exceeds this range. Typically the range for transparency film is 4 stops, perhaps 7 for digital RAW files and 10 for colour negative film. Digital cameras that only offer JPEG or TIFF mode, may limit the range to about 4 or 5 stops. DW

Rock and thrift at Doune
David Jackman

Controlling complexity

Perhaps the simplest means of reducing complexity is to use a shallow depth of field. Tight cropping keeps the number of elements to a minimum. Even lighting reduces contrast, which also reduces complexity. DW

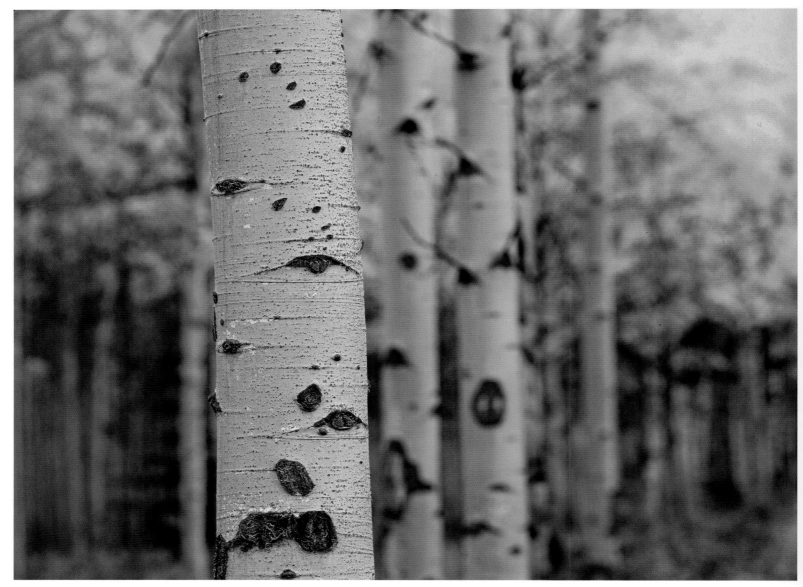

Aspens near Jasper
Roger Longdin

Controlling chaos

Finding or creating a structure and integrating it into the picture helps the viewer to interpret the photograph. Organization is partly dependent on scale: we may need to get closer to a subject or stand further back from it in order for organization to become apparent. Crop into any successful photograph and you will find chaotic elements even though the whole has structure. DW

Kicking Horse River reflections
Roger Longdin

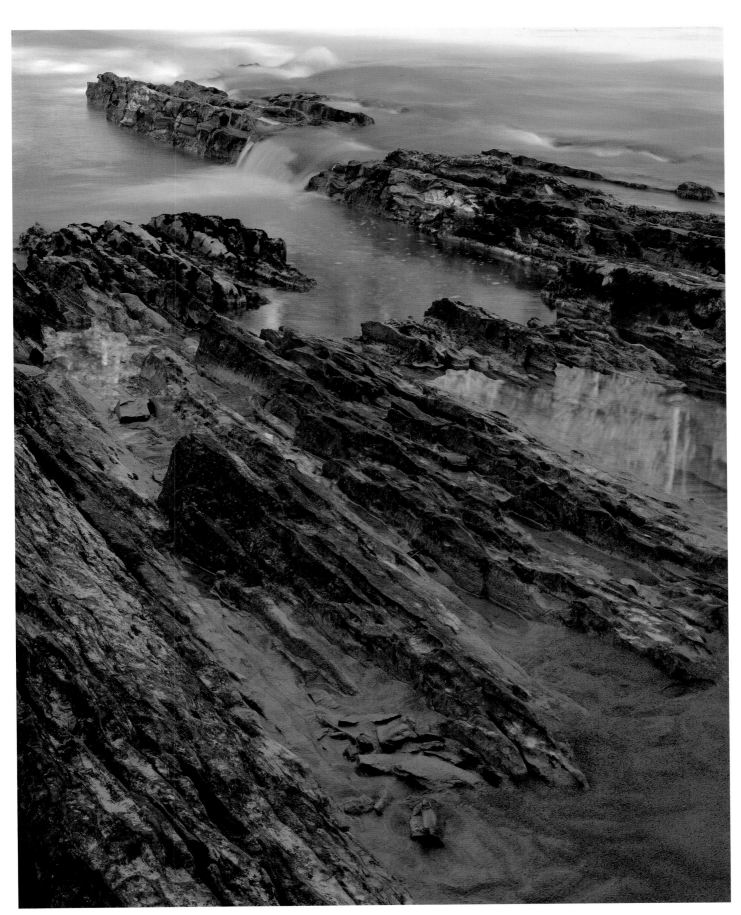

Achieve a sense of balance

Images need to have an internal balance and a feeling of harmony. Different tones and shapes shouldn't fight with each for the attention of the viewer. This doesn't mean that there can't be tension within the composition but that the image should be complete within the frame. Remember that what is excluded is just as important as what is included. This is perhaps the hardest lesson to be learned in photography. DW

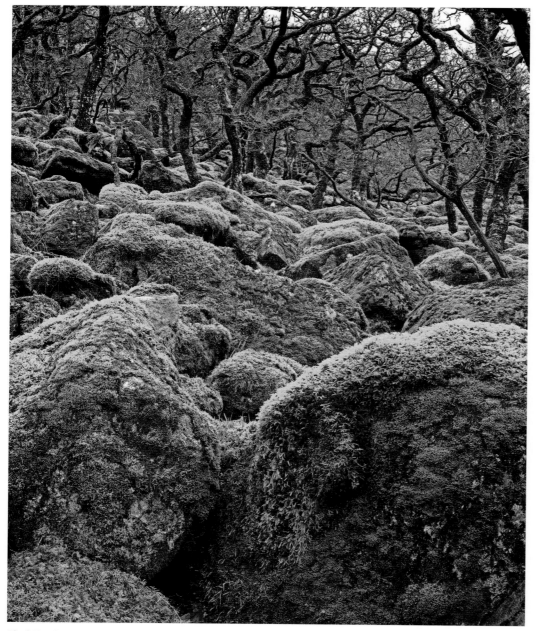

Black Tor Copse
Simon Miles

Black and white in colour

Don't be afraid of working in monochrome. The most powerful images may have a very limited colour palette. It is often said that b/w is about form and colour about surfaces. Limiting the colour information can allow the viewer to concentrate more on form. Another layer of meaning is overlayed on the form by the thoughtful use of one predominant colour. DW

Bristlecone Pine
Simon Miles

CRITIQUES
Inner landscapes

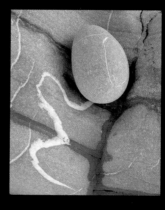

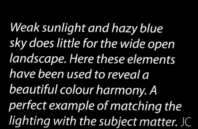

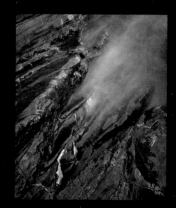

Shot on a gloomy day when few would have thought photography possible. I made a decent figurative of the same rock formation, but David has created a new world. JC

Weak sunlight and hazy blue sky does little for the wide open landscape. Here these elements have been used to reveal a beautiful colour harmony. A perfect example of matching the lighting with the subject matter. JC

Landscape as still life. Elegant soft lighting, but with some direction, exquisitely precise composition, colour cast (correctly) preserved. Simply beautiful. JC

This picture makes something out of almost nothing. It works as pure abstract colour and the blur of water creates a depth where there is none, but it does not fire my imagination as much as some of David's other images. JC

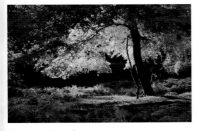

Glowing Beech
Roger Creber
Page 119

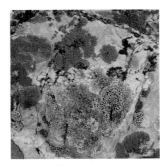

Rock detail
Gert ten Dolle
Page 120

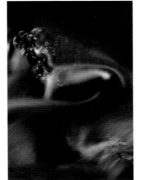

Wyming Brook detail
Jonathan Horrocks
Page 121

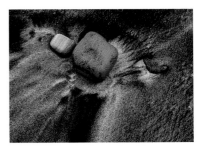

Red brick
Richard Holroyd
Page 122

Places of mystery

JC: *Woodland is a place of light and dark, and of immense visual complexity. Shooting into the light or in soft light is sometimes a solution, as is creating a composition with a strong central structure, as Roger's picture demonstrates.* CW: *In one instant, it is the sizzling sunlight setting the tree on fire that we respond to in this image. There are no deep areas of black nothingness (so undermining of some images) dominating any part of the image and all is bathed in golden vibrancy. I would like to have been there and this image succeeds in taking me.*

Location: The Bolderwood Ornamental Drive, Near Lyndhurst, the New Forset, Hampshire, England.
Camerawork: Nikon F100, Nikkor 28–105mm lens, Fuji Velvia 50 film, aperture priority mode, f22 to enhance depth of field and an warm-up 81 series filter.
Technique: Use of backlighting on a sunny day.
Post capture: None.
Inspiration: The golden foliage of this backlit beech in full autumn plumage was a glorious sight to behold. The glowing leaves in the centre, surrounded by the darker toned foliage and foreground bracken, show this tree to the best effect.
Style: Landscapes in pastoral and mountain locations. Creative woodland photography in spring and autumn.
Aspiration: To work with medium format and black and white photography. Improve my use of ND grad filters.

Nature's details

CW: *Mountains, ice, parched salt pans, archipelagos, lagoons and multicoloured forests, with herds of animals pouring from their cover, is what I see in this photograph. Taking the surface area as a whole, the photographer has skillfully orchestrated the patches of lichen so that there is no one dominating area to steal our eye from any other. Something of an achievement in this highly complex yet brilliantly balanced image that bounces us about from a macro to tropospheric perspective.* JC: *A facet of shooting nature's details is that, however abstract the content, the image needs its own internal logic. The space may be ambiguous, the surfaces elusive; but the balance and energy of the composition are critical.*

Location: Banff National Park, Canada.
Camerawork: Rollei 6008 I2, 80mm lens, 34mm extension tube, Fuji Velvia 50, f22, shutter speed not recorded and no filtration.
Technique: It was an overcast day, ideal for taking pictures of details.
Post capture: None.
Inspiration: I liked the different colours and the details of the rock and what is growing on it. (I'm sorry but I don't know what it is in English). It was an overcast day so the light was very soft and even.
Style: I like great views of mountains and landscapes in general, but also I like to look for smaller details and do macro work.
Aspiration: Seeing the possibility of a (great) picture and knowing what to do. Now I'm struggeling, trying to see it – creativity is not my strongest point. Furthermore, I want to improve my compositions, especially now that I have moved over to the square 6x6 format.

Light and time

DW: *There is a standing wave in the water which gives the picture its structure. What is quite extraordinary is the way that the submerged rock seems to glow from within. If I am to be really critical, then I'm conscious of a couple of little distracting elements: there is a highlight kissing the frame to the upper left and a green leaf touching the frame on the opposite corner, down on the right.* EE: *Once we notice even the smallest of distractions it's amazing how our eye keeps going back to them. It should be said, we photographers are probably hypersensitive to such details, the average viewer may not be.*

Location: Wyming Brook, Peak District, England.
Camerawork: Canon EOS 300D, Sigma 18–125 lens, ISO 100, f36, 3.2 seconds.
Technique: The muted hazy lighting was ideal for this kind of detail shot.
Post capture: Converted from RAW using Capture One LE Velvia Vision in Photoshop.
Inspiration: I love shots of slow moving water and using slow shutter speeds.
Style: I'm a scientist and mathematician by trade, so I love this detailed aspect of photography and I'm particularly drawn to strong geometric compositions.
Aspiration: I'm keen to improve my technical understanding to the point that technique becomes second nature, so all my time can be devoted to getting the composition right.

Beauty in everything

JC: *Weathering is an endless topic for the landscape photographer, and even a mass-produced object like this brick fragment makes a charming subject with its surfaces modelled by years of tidal tumbling. A detail in a photograph is analogous to a human portrait. We look, and look again, and examine the subject perhaps in a way we have not done before. We may get to know it better, to understand it differently. Every compositional decision the photographer makes, therefore, is especially critical. It is the way that we see it that makes the subject worth looking at.* DW: *I wonder how this picture would look as an upright, with more of the dark sand falling from the brick. It might not be an improvement, we don't know what was there.*

Location: Whitby, North Yorkshire, England.
Camerawork: Ebony SW, 150mm lens, f22,1 second exposure and 81B filter.
Technique: Flat lighting made the best of the texture and contrast.
Post capture: Scanned and then adjusted with levels. I cropped the picture, as the 150mm lens on the SW doesn't allow for close ups.
Inspiration: I loved the colour and texture of the old, eroded, building brick together with the eroded natural stone and patterned sand. Ashes to ashes…

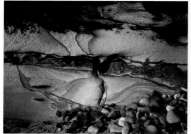

Beach cave
Richard Holroyd
Page 123

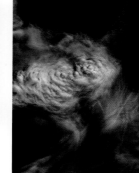

Swirl of flowing peat water
Peter C. Roworth
Page 124

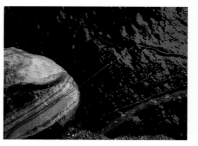

Magenta rock
Bruce Cairns
Page 125

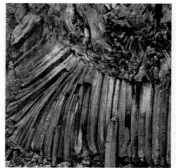

Basalt rock
Mike Bradbury
Page 126

Lose the horizon – widen our horizons

Richard asks the question: *What are your thoughts on the need to correct the colour shift caused by reciprocity failure?*

DW: *To me the grey pebbles look fairly neutral, so I'm not sure that anything needs to be done. There are wonderful things going on in the centre of this picture, so I would experiment, exploring different compositions. Do we need all the other elements – the top is quite dark? The sandstone itself is full of possibilities.* JC: *Yes, of all rock types, sandstone is the most adept at creating its own pictures.*

Illustration or illumination?

JC: *This vortex of bubbles perfectly shows the camera's ability to capture the most ephemeral union of water and light.* DW: *This is a really beautiful example of the play of light on moving water. It has an unworldly – other worldly – quality and the kind of photographic vision that leads you into a different kind of reality. Before the advent of long exposures we had no sense of what it looked like to see a number of seconds compacted into a single image – it's what we get in waterfall images, but this inner landscape image is much subtler.*

Match the light to the subject

DW: *The colours are quite startling. I have seen these kind of rocks in Cornwall, but the colours are quite rare. There is something going on in every quadrant of the image, and there is an overall balance in colour, form and line that I find most satisfying. The less subtle striations on the bottom left are all carefully worked in terms of composition. Soft light is essential, so is the very small area of sand at the bottom – it is important* CW: *It looks rather like posterization. The picture would look good as an enormous print, in an art studio somewhere.*

Inner landscapes at any scale

JC: *The sheer poetry of this basalt formation is no less wondrous now that geological science can explain its origin. Exquisite photographs encourage us to know more about the miracles of creation.* DW: *This pictures has such a limited palette, I wonder what it would look like in monochrome.*

Mike asks: *This was a once in a lifetime visit. How would you have worked the light?*

DW: *Go in tighter, perhaps. The top right is a little chaotic.* EE: *In answer to his question about the light, I don't see there is a problem with it. As David has said elsewhere, soft light helps to prevent the making of overly complex or chaotic images. What I particularly like about this image is nature's chaos and the way the pebbles add scale.*

Location: Whitby, north Yorkshire, England.
Camerawork: Ebony SW, 150mm lens with long extension for close-up, Fuji Velvia 50, f6 and 2 second exposure.
Technique: Positioning the camera to make the best use of the highlights. The cave offered subdued, even light at midday.
Post capture: Scanned and adjusted with levels to match the transparency.
Inspiration: The stunning colour of the flowing rock and the soft, subdued light were essential.

Location: Crowle Moor, Nr Crowle, North Lincolnshire, England
Camerawork: Nikon F2AS, Nikkor 55mm f2.8 lens, Fuji A Provia 100ASA 35mm, no filtration, shutter speed not recorded.
Technnique: I metered off the dark peat, recomposed the image, and used a slow shutter speed to emphasize the movement of the water and the bubbles.
Post camera: None.
Inspiration: The image area was only 12 square inches and I was intrigued by the relationship between the flow of water and the inner whirl of bubbles. The soft light of the day removed all harshness and contrast.
Style: I like making landscapes which convey mood to the scene and also (if possible) which show patterns. I also enjoy photographing wildflowers and the pictoral aspect of natural history.
Aspiration: Portraying wildflowers in the English landscape and balancing the light between the two.

Location: Cornwall, England.
Camerawork: Linhof Technikardan 5x4, 150mm lens, Fuji Velvia 50, f32, 3 second exposure and no filtration.
Technique: I chose rocks that were shaded by a cliff so that the light would stay diffused while I worked.
Post capture: None.
Inspiration: The contrasting magenta and cyan colours. The light had to be flat, soft and diffused to light the subject evenly and make the colours 'sing' on film.

Location: Aldevjar Foss, Iceland.
Camerawork: Hasselblad 500 cm, 150mm lens, Fuji Velvia 50, f11, 1/15th second and no filtration.
Technique: The light was very flat. I used an incident light meter to work out the exposure.
Post capture: I scanned the transparency into Photoshop 7. Adjustments were made using levels, contrast, saturation and unsharp masking.
Inspiration: The pattern of the basalt columns. I would have preferred to have had some directional light to enhance the shadows.
Style: Landscape and architecture.
Aspiration: The ability to see inner landscapes.

Hore frost on teasel
Peter Karry
Page 127

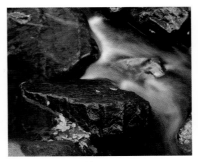

Scaleber Force detail
Richard Childs
Page 128

Stream at Queen Elizabeth Park
Keith Folly
Page 130

Water, ice and granite
Julian Barkway
Page 131

Close attention to detail pays off

DW: *The picture has a fairy-tale quality to it. The lighting is quite extraordinary. I'm not sure what scale we're looking at. Probably macro. It's effective. The out-of focus background with its rainbow colours adds to the effect. My only slight criticism is the way the stem reaches up and touches the top of the frame; otherwise I think it's very successful. JC: Working this close has obliged the photographer to pay close attention to the extremely out of focus elements which make up 80% of the image here. A job well done.*

Balancing direct and indirect light

DW: *Well balanced use of direct and soft light: Glancing direct sunlight has created very thin ribbons of water falling down. I like the little bit of sunlight in the water at the bottom. Something that could have been far too contrasty has been held together well. JC: Falling or flowing water is both a controversial yet favourite subject of landscape photographers. A long exposure creates something we acknowledge is not what we see, but rather a photographic fabrication built out of the fusion of time, and light on water in motion.*

A fusion of elements

DW: *I like the overall design, the way that the water flows down to the bottom right. There are a couple of technical issues. It's one of those subjects that needs to be pin-sharp. Also, there are some elements a little too close to the frame edge. A little more space might have helped, but it may also have revealed even more unwanted elements. CW: Where you have flowing water, aesthetically and emotionally it is nice to see a consistent rhythm flowing through the image. Here, are we given more rock than water?*

Radio or television?

DW: *Mystery makes you engage and look harder. There will always be a proportion of the audience who won't want to engage. But mystery is more rewarding as the result of being more demanding. CW: It is for a similar reason that I prefer the radio to television. DW: Specific to this image: I would like to see some separation between the reflection of the canyon wall and the ice. The way to get that is more elevation. I don't know whether it was possible, perhaps not. EE: How much separation could there be before the picture becomes too literal and its mystery would be lost?*

Location: Iceland.
Camerawork: Mintola 9Xi, 100–300mm lens, 35mm Kodak Elite Xtracolour 100, f16 and 0.7 second exposure.
Technique: I shot contre-jour, as the sun was rising, to obtain the combination of pink from the colour of the sunrise with the blue of the sky
Post capture: None.
Inspiration: I liked the textures and abstract shapes of the ice in the river, and the way the changing light affected the colours of the image.
Style: Anything that reflects the beauty in the world.
Aspiration: To attain more impact with spatial-type landscapes.

Location: Near Settle, Yorkshire Dales, England.
Camerawork: Pentax 67, 105mm lens, f22, 1 second and no filtration.
Technique: In all circumstances I rely on natural light levels to dictate the exposure time and apply ND filters to extend this, if necessary . Hopefully all of the images have a natural feel to them.
Post capture: None.
Inspiration: I recall a radio programme in which a woman described her emotions on visiting Niagara falls. Her sense of awe came not from the scale of the thing but from understanding the fact that it never stopped, that this had been happening over a timescale beyond our understanding. I feel the same whenever I am beside flowing streams and love to capture a moment in the water's eternal journey and how this has moulded the rock over which it flows.
Style: see Wilderness Landscapes Critiques.
Aspiration: see Wilderness Landscapes Critiques.

Location: The Trossachs, Scotland.
Camerawork: Mamiya RZII, 180mm lens, Velvia 50, 4 secs at f16.
Technique: It was overcast – perfect for this type of work. I looked for a location where diffused light was able to 'shine' on the rocks.
Post capture: None.
Inspiration: The contrast in colours from the rock to the leaves. This gave the picture an autuminal feel.
Style: Landscapes involving water – coastal preferably.
Aspiration: Metering so I would be able to get an exposure 'spot on' every time.

Location: Val Verzasca, Ticino, Switzerland.
Camerawork: Mamiya 645 Pro, 210mm lens, Velvia 50 and 81b filter.
Technique: The Val Verzasca is a steep-sided Alpine valley, the bottom of which rarely sees direct sunlight. The lack of contrast makes life much easier for the photographer intent on capturing the fascinating natural rock sculptures made by the fast-flowing river. In amongst the rocks, there are pools of water, which, due to their sheltered position, make fine natural mirrors. The sliver of 'gold' you see here is the golden light of early evening reflected once off the rock of the mountaintop and again off the water in the rockpool, to which a delicate layer of ice adds its own soft reflection. In the shaded part of the pool, the nearby rock can be seen reflected as well as a hint of what lies hidden below the surface.
Post capture: Scanning, then slight cropping of the bottom and the right to tighten the composition, followed by colour-correction to intensify the golden colour of the mountainside.
Inspiration: Seeing the sliver of reflected 'gold' in amongst the grey rock. Without the golden reflection this image would lose most of its interest and impact.

Death Valley
Chris Andrews
Page 132

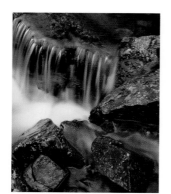

Burn detail
Nick McLaren
Page 133

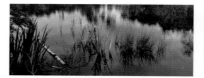

Yellow iris pond
Roger Creber
Page 134

Bluebell path
Roger Creber
Page 135

Composition is a feeling

DW: *We don't have immediate clues to scale. That's what I like about this picture. In fact, Titus canyon is huge. The image is well balanced and the area of warm light is a small but vital part of the composition.* JC: *Weston described composition as 'the strongest way of seeing' and he wasn't wrong. But I think the ideas of composition used by painters, which are of tension, flow, balance, line, proportion, symmetry and assymmetry, geometry, energy, mass, weight, light and dark, focus, space (including negative space) are exactly the same in photography.*

Applying movements

DW: *I know Nick is new to large format and he has done well here. However, the boulder on the right is sharp and everywhere else it is out. Either he has not applied movements or he has over-applied them.* EE: *What movements could he have applied?* DW: *Tilt. I think he may have applied swing. He's got a plane of focus top left to bottom right. What that has done is to throw out the bottom left corner and top right corner. He would have been better to use a tiny bit of tilt and stopped down a long way.*

An intimate knowledge of the location

JC: *Both this picture and Bluebell path have a casual charm about them, a quality of happy discovery, as if they were made while out on an afternoon stroll. This belies the fact that they are well composed, and may have been planned well in advance, with intimate acquaintance of the area, as the best landscape pictures often are.* EE: *Yes, Roger tells us that Yellow iris pond was indeed taken while out exploring the ponds and woods on the edge of Wimbledon Common. He says he took only one panoramic image. With the success of this image, and the knowledge gained from making it, a return visit at the same time of year could yield interesting results.*

It pays to plan ahead

EE: *As I set about designing this book, I began to look for some images that might work as double-page spreads. I experimented, running this and Yellow iris pond right across two pages. Neither worked, simply because their focal points were centrally placed, falling in the gutter. Since photography is so often used in books and magazines, it really can pay to think ahead when composing an image. Picture editors and designers love photographs with plenty of internal space that offer design flexibility. This is especially true of any picture that might be used as a front cover image, like Budle ay on Argentum's softback edition of this book. It's worth looking round your local bookstore to see what type of images adorn book covers.*

Location: Titus Canyon, Death Valley, USA.
Camerawork: Pentax MZ-5 35mm, 50mm f1.4 lens, Fuji Velvia 50 film at ISO 40, f22, general meter reading, shutter speed not recorded and no filtration.
Technique: The sunlight was streaming down the entrance to the canyon, illuminating the far wall (top left corner) with reflected light. The foreground was in shade, with the foreground rock picking up a strong blue cast as a result. Within five minutes of making this image the sun had moved, leaving everything in shadow.
Post capture: Scanned with a Canon 8400F flatbed scanner and adjusted with levels in Photoshop Elements.
Inspiration: A guidebook had a picture from around the same spot, taken from further back, showing the road winding through the canyon. I thought it would work better as a tighter image, concentrating on colour and geometry.
Style: See Wilderness Landscapes Critiques.
Aspiration: See Wilderness Landscapes Critiques.

Location: Yarrow Valley, Scottish Borders.
Camerawork: Ebony 45SN, wooden field camera, 150mm lens, Fuji Velvia, 4 second exposure, f32, 0.3 ND grad and polarizing filter.
Technique: The polarizing filter eliminated the reflections on the water and emphasized the colours and detail below.
Post capture: None.
Inspiration: It was the miniature cascade, with it's lichen-clad rocks that caught my eye and I was immediately committed to creating a composition around it. Overcast conditions helped to keep contrast to a minimum.
Style: Landscapes and more intimate compositions of abstract subjects.
Aspiration: Quicker exposure calculations with my spot meter. I quite often miss the best light because I'm still juggling figures in my head.

Location: Wimbledon Common, London.
Camerawork: Hasselblad Xpan, 45mm lens, Fuji Provia 100 film, aperture priority at f22 and Hasselblad centre spot neutral density filter.
Technique: I waited for a brief period of sunlight to lift the image.
Post capture: None.
Inspiration: This image was taken one morning whilst exploring the ponds and woods on the eastern edge of the Common. I only took one panoramic exposure as an afterthought after taking several 35mm shots of the same scene. This version, with its unusual composition, actually turned out to be the most successful. On this mainly overcast morning a very brief moment of sunlight has just caught the yellow iris flowers, leaves and grasses with their reflections to lift the whole picture. I feel that the blue sky reflected in the pond is vital, too. The green bank holds the image in at the top and the floating birch branch is an interesting component.
Style: Landscapes in pastoral and mountainous locations. Creative woodland photography in spring and autumn.
Aspiration: Medium format and black and white photography.

Location: Winkworth Arboretum, near Godalming, Surrey, England.
Camerawork: Hasselblad Xpan, 45mm lens, Fuji Provia 100 film, aperture priority at f16 and Hasselblad centre spot neutral density filter.
Technique: I waited for the sun to go in, to reduce contrast and for even tones, and to faithfully retain the colours of the bluebells and the fresh spring greens.
Post capture: None.
Inspiration: This image was taken on a visit one spring to capture the bluebells at this National Trust property. The panoramic format was perfect to capture this beautiful scene, with the path leading through the bluebell wood. I felt it was important to exclude any distracting sky.
Style: See previous photograph.
Aspiration: See previous photograph.

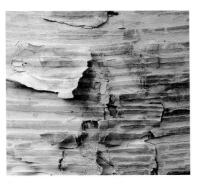

Bark
Adrian Hollister
Page 136

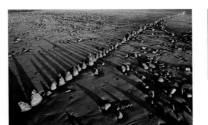

Sunrising over frozen lake
Adrian Hollister
Page 137

Crocodile skin?
Irma Mokkenstorm
Page 139

Beach of standing stones
Chris Howe
Page 138

Balancing colour and composition

DW: *Adrian's picture has a careful balance of detail and form. If there was too much detail the image would become chaotic; you must have form to hold the viewer's attention. I love the colour palette; it is simple and doesn't compete with the composition and vice versa. In the bottom corner there is a dark piece of bark and it's certainly the darkest part of the image and I find if I cover it, overall the balance of the image is improved.* JC: *The papery texture of this bark is well seen here in lovely soft light.*

Pictures within pictures

DW: *Lovely delicate colours and a reflection that is quite bold and strong. The sinuous line of the edge of the ice is beautiful and is echoed by the line of the reflected cloud above it. There are all kinds of scales here. You could go in quite tight in the central portion. There's a fabulous abstract image that could be made with a long lens in the bottom right, where the ice zig-zags. The tree on the extreme left I find a little distracting. I would have been tempted to go in a little tighter, to exclude the reflection of that tree.* JC: *There is a sense of fun expressed in this picture, with its cheeky reflection of trees. The overall colour harmonies are quite stunning.*

How much intrigue is enough?

JC: *The striking sidelighting on this row of weathered wooden stumps gives a tactile, figurative quality to the picture. Compositionally, the powerful diagonals pull one way then the other, creating a balanced state of tension. Yet the subject itself poses an unanswered question: it's a mystery, what is it? Sea defences? A shipwreck? Contemporary landscape art? It's a striking image.* EE: *It's fun to speculate on what would happen if we cropped left and right, so that we didn't know how much further this feature ran on? This could create an even greater sense of intrigue. As it stands, I love the image, but my eye does go to the bottom left and top right, to those empty spaces, and I ask myself, what if…?*

Playing with the imagination

EE: *What makes a macro image work?*
DW: *It's that balance between form and detail. We need enough detail for the eye to be fascinated, and we need a strong enough structure to support that detail. If the picture is lacking in either department it will lose that vital element of fascination.* JC: *The essence of an abstract nature photograph is that it stimulates the imagination, whether that is down to a perceived anthropomorphism ('that cloud looks like a giraffe'), or because it provokes a sense of rhythm, or movement or whatever,*

Location: Virginia Water, Surrey, England.
Camerawork: Canon EOS 5D, 70–300 lens, 0.3 seconds at f32.
Technique: After a beautiful sunrise the clouds came over giving a uniform colour, ideal for close-up/macro photography. This image would not have worked in bright sunlight due to the harsh shadows that would have resulted.
Post capture: Photoshop CS2.
Inspiration: I was interested in the effect of the horizontal lines and the cracking of the bark.
Style: Landscape.
Aspiration: To improve my skills with macro photography.

Location: Virginia Water, Surrey, England.
Camerawork: Canon EOS 5D, EF24–105 lens, f2, 1/8th second, LEE 0.6 on snow-covered ice.
Technique: I had to use an ND grad over the bright snow. I wanted to captured the sun rising over the snow-sprinkled, ice-covered lake, particularly trying to capture the colour of the sunrise.
Post capture: Photoshop CS2.
Inspiration: The red light and sparkling ice.
Style: Landscape photography.
Aspiration: Make macro images and to improve composition.

Location: Dunster Beach, Somerset, England.
Camerawork: Canon EOS IDS II, Canon 16–35mm at 17mm, f9 and no filtration.
Technique: I waited for the evening shadows to lengthen and cropped in on the line of stones.
Post capture: Capture1 Photoshop.
Inspiration: Beautiful warm evening light while I was walking along the beach with my family. The light makes the stones shine and fills the rest of the frame with shapes and shadows.
Style: Landscape, particularly (due to work and family commitments) my local Hertfordshire countryside and environment.

Location: The Paint Pots, Kootenay National Park, Canadian Rocky Mountains.
Camerawork: Hasselblad Xpan, 90mm lens, Fuji Velvia 50, f11, 81B warm up filter and polarizer. Shutter speed not recorded
Technique: I made sure that the sun was behind some clouds at the time I pressed the shutter release. The polarizer dealt with any distracting reflections.
Post capture: None.
Inspiration: The Paint Pots is a great place, with lovely ochre-coloured water, but I just couldn't get an overall picture with the Xpan format that would be interesting. Instead I started looking for details when I came across this pattern in a little puddle of water. The texture looks like bits of crocodile skin to me. The light wasn't too bright and, together with the polarizer, it was possible to capture the scene without any distracting reflections.
Style: I like landscape photography most, varying from the grand vistas to details within that landscape.
Aspiration: Being able to spot a photo opportunity wherever I am, besides the obvious vistas or small details. Seeing; having a creative eye.

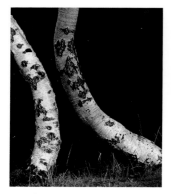

Dancing trees
Alan Simpson
Page 141

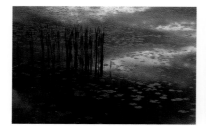

Reeds, Vermont
Lynn Tait
Page 143

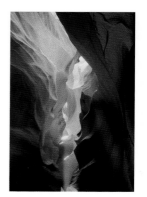

Sand sculptures
Melanie Foster
Page 144

Shaft of light
John J Egan
Page 145

Creating tension

CW: *As a general rule, my preference is always to see where a tree comes from and where it goes to.* DW: *I'm slightly uncomfortable about the way the left-hand trunk runs out of the frame before it reaches the corner. There is a tension in the top left corner, but not a good tension. It would feel more complete if it bridged the corner. I think I might have been tempted to tilt the camera slightly, since there is no obvious sign of where 'up' is. Otherwise it's very satisfying, quite stark and sparse.*

The point of focus?

JC: *Reflections are an especially rich source of inspiration. In Lynn's images the colours of sunlit woodland and sky appear painted on the water's surface. Juxtaposed against the space-defining patterns of lily pads, both pictures occupy that intriguing place between figurative representation and pure abstraction.* EE: *Imagine this picture shot at a much smaller aperture, with the clouds also in sharp focus, and we can see the importance that depth of field plays in a subtle image like this. Compare this to her other image, in which the reflection is the point of focus. Which works best?*

Balancing exposure

DW: *Melanie could perhaps have put a 1 stop ND grad over the top left, where the highlights have burnt out, but it would be difficult to do without making it obvious.* EE: *The brightness of that part of the picture is made more noticeable because of the contrasting darkness of the bottom right corner. Viewed close up, there is detail in that part of the transparency, but is there enough when the picture is viewed at a distance or after it has been reproduced in a book?*

A single visit is never enough!

JC: *Colour is but one of many visual gifts Antelope Canyon offers the artist. It may be stone, but these surfaces are alive with wave after wave of movement. The play of light changes endlessly with the daily passage of the sun. Photographically-speaking, this is one of landscape's holy places.*

Location: Dancing trees at Hodge Close, Cumbria, England.
Camerawork: *Canon EOS-1V, Canon 70–200mm f/4 L USM lens and Kodak Ektachrome Elite 100 film. Exposure not recorded.*
Technique: Shooting the light-coloured trunks against the darker background.
Post capture: Slide scanned, then levels, curves adjustments, sharpening and printing with Photoshop.
Inspiration: I was attracted by the light on these two tree trunks and the shape they made – they seemed to be dancing together!
Style: Landscape photography in 'interesting' light.
Aspiration: The ability to meter accurately in difficult lighting.

Location: Vermont, Canada.
Camerawork: *Canon EOS, Fuji Velvia 50.*
Technique: Made in the early morning – the most magical time for photography.
Post capture: None. I don't like changing anything, what I saw is what you get.
Inspiration: Early mornings give 'added value' because the light changes so quickly. Every minute there are different qualities of illumination and it is the best time to learn about light.
Style: I like to change the ordinary into the extraordinary. Extracting and interpreting a segment of the landscape and turning it into an abstract form.
Aspiration: Macro photography. I have a lens but don't quite know how to use it yet.

Location: Lower Antelope Canyon, Arizona, USA
Camerawork: Canon 1V, 17–40mm lens, Velvia 50, f16, 20-30 second exposure and no filtration.
Technique: I saw the light picking out the texture of the canyon walls, and hoped that the lines of striations would help the composition and make the picture glow.
Post capture: None.
Inspiration: As above, I loved the way the light swept down the curves of the wall. The light gives the wall relief, and shows the fluid nature of the canyon walls. It creates the vital element of mood.
Style: Landscape photography.
Aspiration: Mastering use of a large format camera and better visualization of the end result.

Location: Antelope Canyon, near Page, Arizona, USA.
Camerawork: Minolta Maxxum (Dynax) 7 SLR with 24–105 mm f3.54.5 lens, Fuji Velvia slide film, f11, about 30 seconds (bracketed) with no filtration.
Technique: I spent several hours capturing various lighting situations, sometimes enhanced by the dust raised by people walking that made the 'Shaft of Light' visible. I just let the camera's built-in light meter 'do its thing' and bracketed each shot.
Post capture: Slide was scanned and then adjusted to correct any colour changes made in the scanning process.
Inspiration: One goes to Antelope Canyon like a pilgrimage. This is a place that is about nothing other than light and its complement, shadow.
Style: I strive to capture the beauty of the light and the object that it illuminates.
Aspiration: To improve my ability to compose what I see and feel in such a way that it has an impact on those who view the image; that it conveys a message. I think I do that some of the time, but having read the books by Charlie, Joe and David, it is clear that I don't do it as well as is possible to do it.

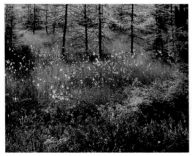

Glade after the rain
Chris Elliot
Page 146

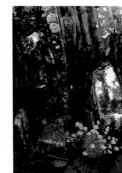

Rock and thrift at Doune
David Jackman
Page 147

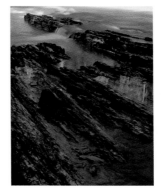

Kicking Horse River reflections
Roger Longdin
Page 149

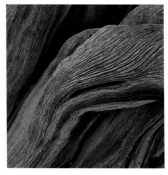

Bristlecone pine
Simon Miles
Page 151

Controlling contrast

CW: *This image has a stained glass feel to it, with light pouring through. In the immediate foreground there is a chaotic collection of shapes and colours that are reminiscent of a kaleidoscope. There is a sense of order and design, established by the back-lit larch, repeated by the delicate white candyfloss, and then, finally, ending at the photographers feet with a flourish of jolly red. Somehow the bulk of green to the right upsets the continuity of the pattern, yet the image is none-the-less hugely enjoyable. JC: High contrast lighting creates a hard, brittle atmosphere which can dominate an image. This is a rare example of a successful high contrast, into the light image, where the shadows and evenly balanced composition allow the bright colours to come forward.*

Location: Muskoka, Canada.
Camerawork: Canon IDS.
Technique: It was a miserable wet day, initially with little interest. I saw this scene, but the light was poor. On returning, there was some soft sunlight shining through the mist. The whole scene sparkled.
Post capture: Photoshop and Photokit.
Inspiration: The mixture of foliage and flowers, together with their jewel-like rain drops sparkling in the gentle breeze.
Style: Travel, landscape and the people I meet.
Aspiration: Improve my post processing and printing skills, but I always need to improve my compositions.

Using colour to create contrast

CW: *The contrast of rock, many millions of years old, with the newly flowered, humble, one-week-old thrift is quickly conveyed. The vertical wedges of rock assist in delivering the viewer straight down to the thrift, providing a straightforward story that is assimilated in a milisecond. There is some ambiguity in the reflections, yet the non-use of a polarizer was prudent, as the reflections of both the flowers and the rocks would have perhaps been lost, leaving them to merge with the submerged rock below. JC: Even in soft light, nature can throw up enough contrast to stretch the limits of transparency film. This image works through its cunning use of composition, and the contrast between bright lichens and flowers, and the dark rock.*

Location: Knoydart, Scotland.
Camerawork: Contax 167MT, 28–70 Vario Sonnar 3.5/4.5 lens, Fuji Velvia 50, f22 and no filtration.
Technique: Cloudy, overcast light. I checked the range between the highlights and shadows and tried to align the flowers on the bottom third.
Post camera: Small adjustments made with levels, post scanning.
Inspiration: A free period to roam among rock pools – the overcast light was helpful.
Style: Landscape photography.
Aspiration: Selection and composition.

Form and motion

EE: *There is a balance in this picture, between the light and shade, that looks so natural and which I find so satisfying. I see no evidence of technique, no obvious use of a graduate filter, for example. It is the sheer depth of colour in the shadows that I find especially striking. As a black and white photographer, I wonder how colour photogaphers work with transparency films. They have such a limited ability to handle anything other than average subject brightness ranges, without ND graduate filtration and the need to make complicated exposure decisions. JC: Here, a long exposure has the effect of simplifying the form of falling water, and contrasting its motion to the hard rock over which it flows.*

Location: Kicking Horse River, Canadian Rockies.
Camerawork: Linhof Technicarden 5x4, Fuji Velvia 50 at 40 and 81B filter.
Technique: I cut out the brightly lit trees on the far riverbank, concentrating on the cool tones, reflections and diagonals closer up.
Post capture: Cibachrome print.

Black and white in colour

CW: *This image is all muscular to me, with sinews and tensions expressed throughout. There is a good, challenging feeling that the material may be either made of timber or stone. Perhaps it is best not to ask which it is, although there are those who would need to know. However, their hunger for literal explanation may haul them down to a less appreciative and satisfying conclusion. JC: Harold Evans once said of news photographs, 'If your photographs aren't good enough, you're not close enough.' The same could be said of landscape photography. But this is not just putting the camera nearer the subject. We need to cultivate emotional closeness, a genuine feeling for the subject, an empathy and a love for it. It is that love which will inspire us to truly see the beauty of nature.*

Location: Bryce Canyon, USA.
Camerawork: Hasselblad 6x6cm with 100mm Planar lens, Fuji Velvia 50, 1 second exposure, f32 and no filtration.
Technique: There is a quality of light to be found inside the canyons of the American Southwest that I have not encountered anywhere else. Bounced sunlight reflects from the orange sandstone, picking up the warm hues of the rock and bathing the subject in a beautiful soft glow. This photograph was made in such conditions. However, I had to work fast as the sun moves surprisingly quickly overhead and, before long, the light was gone.
Post capture: Basic levels adjustment to achieve the correct density for print. Slight crop to give the image a vertical emphasis which, I felt suited the dynamics of the picture.
Inspiration: The bristlecone pines of the American Southwest provide some wonderful subject matter. I isolated a small section of the trunk which seemed to flow nicely through the frame. The tree is bathed in the soft warm glow of bounced light reflected off the orange sandstone wall a few feet behind me. The special quality of this type of light is fundamental to the look and feel of the image which seems to glow with colour.

CONTACTS

Many thanks to all the photographers on this page who submitted work which unfortunately we were unable to include. Their wesbite or email address can be found on page 3.

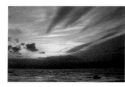
Debs Allan

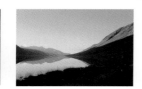
Jane Davies

Ian Harvey

David Knott

Andrea Norrington

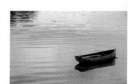
Matthew White

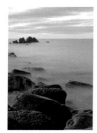
Philip Banfield

Pete Downing

Andrew Hollebone

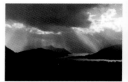
Peter Lewis

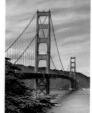
Lisa Pitchford

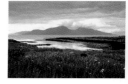
Tony Whyte

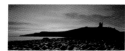
Henrietta Byrne

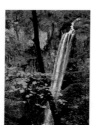
Frederick Fearn

Bruce Lloyd

Veronica Read

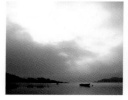
Roy Woodcock

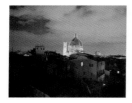
Eliseo J Carmona

Nadia Isakova

Jane Macklam

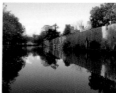
David Richman

Tanya Wrey

Robert H Cassen

Barbara Fleming

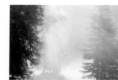
Malcolm Jones

Nick Mansell

David Silver

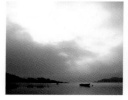
Robert Wright

Adrian Chitty

Louise Govier

Hugh Kavanagh

Keith Suddaby

Hazel Coffey

Jan-David Hartsuijker

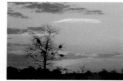
Alan Kinroy

Laura Mastick-Hayward

Adrian Swales